50 YEARS OF
FOOTBALL
IN FOCUS

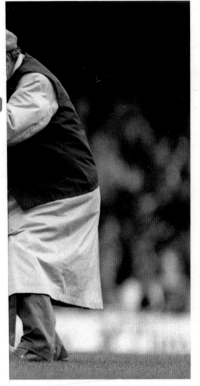

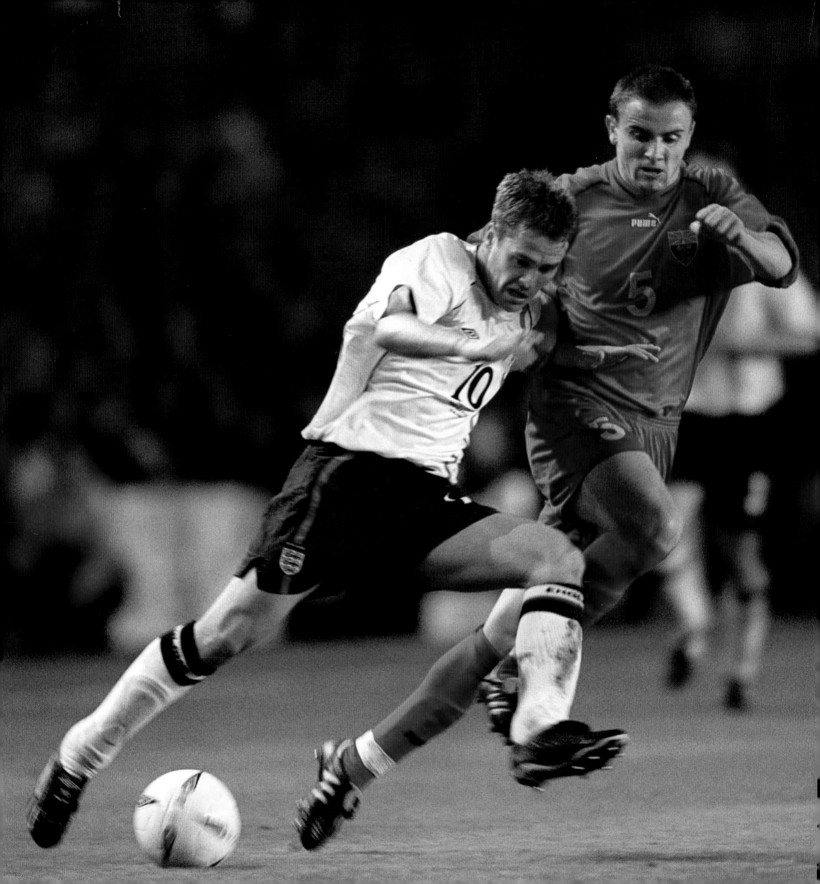

50 YEARS OF
FOOTBALL
IN FOCUS

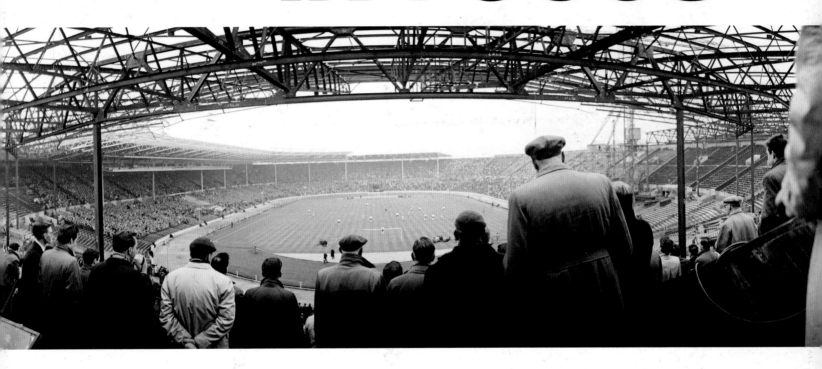

AMMONITE
PRESS

First Published 2010 by
Ammonite Press
an imprint of AE Publications Ltd,
166 High Street, Lewes, East Sussex BN7 1XU

Text © AE Publications Ltd
Images © Offside Sports Photography
Copyright © in the Work AE Publications Ltd

ISBN 978-1-906672-77-5

The rights of Alan Wares to be identified as the author of this work have been
asserted in accordance with the Copyright Designs and Patents Act 1988,
Sections 77 and 78.

While every effort has been made to obtain permission from the copyright
holders for all material used in this book, the publishers will be pleased to hear
from anyone who has not been appropriately acknowledged, and to make a
correction in future reprints.

British Cataloguing in Publication Data. A catalogue record of this book is
available from the British Library.

Author: Alan Wares
Editor: John Thynne
Managing Editor: Richard Wiles
Picture research: Offside Sports Photography
Design: Richard Dewing Associates

Typeset in Myriad MM
Colour reproduction by GMC Reprographics
Printed and bound in China by Hing Yip Printing Co. Ltd
www.ammonitepress.com

CONTENTS

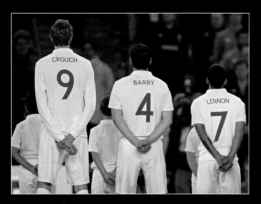

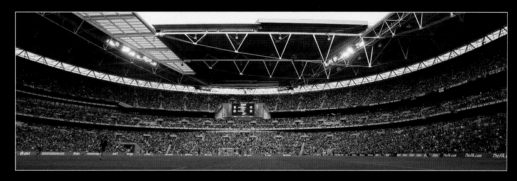

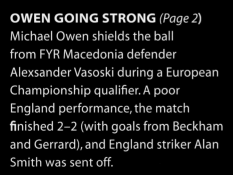

OWEN GOING STRONG *(Page 2)*
Michael Owen shields the ball
from FYR Macedonia defender
Alexsander Vasoski during a European
Championship qualifier. A poor
England performance, the match
finished 2–2 (with goals from Beckham
and Gerrard), and England striker Alan
Smith was sent off.

Date: **16th October, 2002**
Venue: **St Mary's, Southampton**

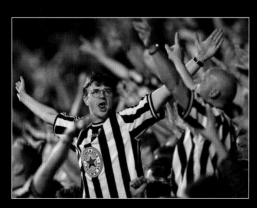

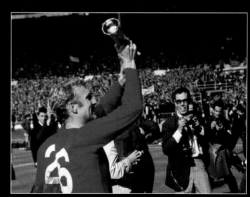

Introduction

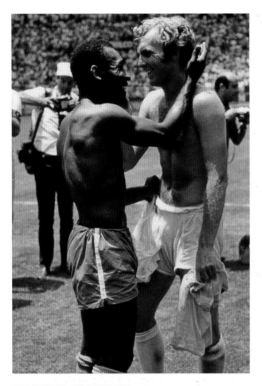

MUTUAL RESPECT

Bobby Moore and Pelé greet each other with an embrace of mutual respect following their epic World Cup encounter in the Summer of 1970. It was a game that had everything – a world-class save by Gordon Banks, a perfectly-timed cultured tackle by Moore on Jairzinho and a howling miss by England's Jeff Astle.

Date: **7th June, 1970**
Venue: **Estadio Jalisco, Guadalajara, Mexico**

"The Beautiful Game". It fits the description of football perfectly.

No-one is quite sure where or with whom the phrase actually originated. Many have claimed first use. The Brazilian World Cup-winning star Valdir Periera (aka Didi) is believed by some to have first mentioned it. British commentator Stuart Hall has also laid claim to its first use back in 1958. Whoever it was, the most famous protagonist is undoubtedly Pelé, who referred to it in the title of his 1977 autobiography *My Life and the Beautiful Game* – and has used it many times since.

Ever since the Football League was formed in 1888, football has been a national obsession in Great Britain, talked about in equal measure at work, in the local pub or over the garden fence. It touches the lives of everyone at some point, from the die-hard club man to the tortured England fan to the late-night TV highlights watcher. This book, which features more than 250 sensational images from the Offside photo archive, should appeal to all.

Legendary exponents of the game such as Tottenham's Danny Blanchflower, Fulham's Johnny Haynes, Liverpool's Kenny Dalglish and Manchester United favourites Denis Law, George Best and Bobby Charlton are given due exposure in the 'Players' section, as are more modern icons including Paul Gascoigne, Ian Rush, Alan Shearer and Wayne Rooney.

Of course, football is not just about the players. Arguably just as important are the sheepskin-jacketed, suit-wearing, instruction-bawling managers. Master strategists, mentors and morale builders, they often upstage the action on the pitch and this book features some of the greatest leaders in the game's history. Pages are devoted to Sir Matt Busby, Jock Stein – the first man to take a British club to European Cup victory, the great Brian Clough of Nottingham Forest, Sir Bobby Robson and many, many more.

England's glorious World Cup final of 1966 is remembered in the 'Matches' section, as are Manchester United's 4-1 victory over Benfica in the 1968 European Cup final and Arsenal's 3-2 win over United in the 1979 FA Cup final at Wembley. It's not just about

champagne moments though – this part of the book reflects the weekly struggle of sides throughout the Football League in their quest for glory or simple survival.

And let's not forget the places where it all happens – the aging-yet-atmospheric stadia and state-of-the-art footballing facilities such as the new Wembley. The sad sight of a derelict Valley stadium in 1988, an artificial pitch at Preston North End and a resplendent, roofed Millennium Stadium in Cardiff feature in series of poignant portraits from the last 50 years or so.

But The Beautiful Game would be meaningless without people – fans – to witness it. A flying scissor-kick, a crafty nutmeg, a body swerve or subtle shimmy to lose your opponent all count for nothing if not watched, appreciated and admired. The final section of *Football in Focus* is dedicated to the fans. Without the die-hard support of hundreds of thousands of football followers, the game would be little more than a recreational activity. Evocative black and white images of besuited Wolves supporters outside their beloved Molineux ground in 1959, and Rangers fans in full voice on New Year's Day at Ibrox, contrast with a mass of red at Anfield's Kop, or blue as Chesterfield come oh-so-close to reaching the FA Cup final in 1997. Gents in flat caps at Darlington, sombrero-wearing England fans, ecstatic Kettering supporters… they're all here.

And if you can't witness the action yourself, what's the next best thing? Getting someone to witness it for you. Here's where Offside comes in: formed in 2001 by ex-Fleet Street snapper Mark Leech, the agency's team of professional photographers is dedicated to keeping alive quality football photography. Offside – the last agency to stop using film amid the rush to digitize – has an idiosyncratic take on the sport, as revealed in this unique collection of images. *Football in Focus* is a showcase of the football photographer's art, a mesmerising collection that captures the skill, the drama, the pleasure and the pain of Britain's national sport.

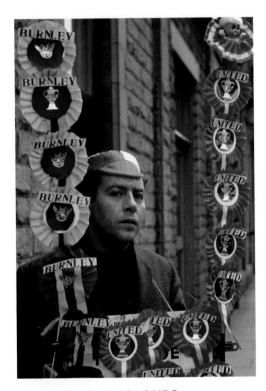

CHOOSE YOUR COLOURS
The unruly excess of some soccer fans was always matched by the loyal fervour of the majority. In the days when pinning your rosette to your chest was deemed statement enough.

Date: **4th February, 1967**
Venue: **Turf Moor, Burnley**

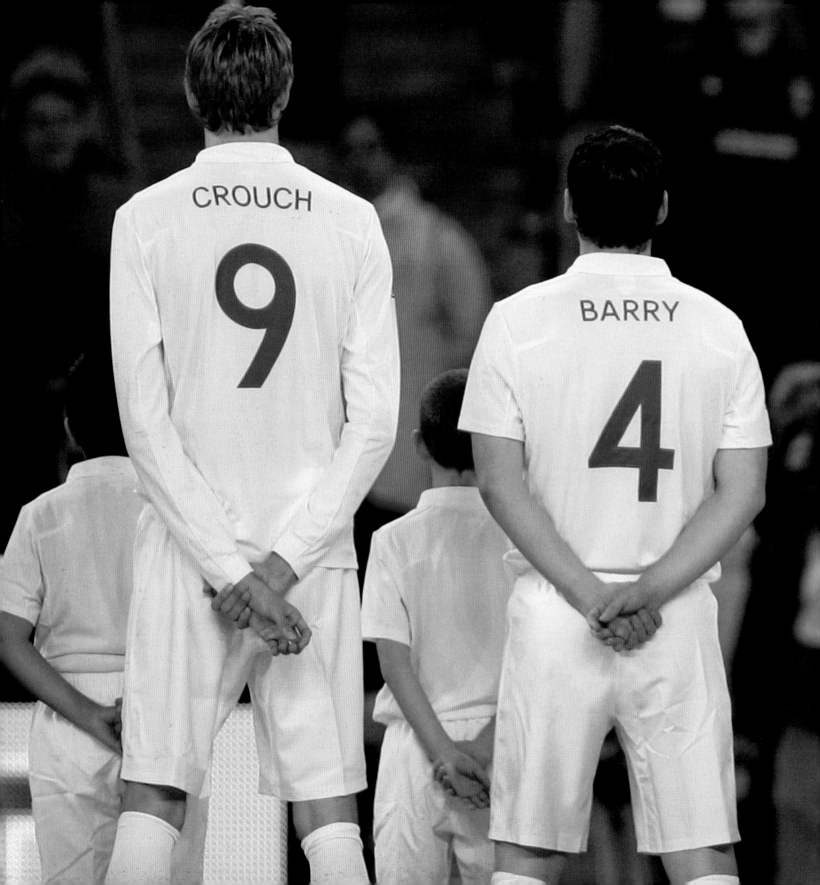

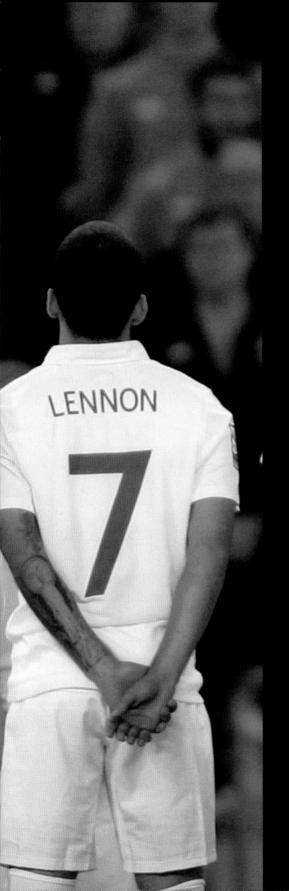

1 THE PLAYERS

Football is a sport replete with on-pitch heroes and villains, there to be loved, despised, pitied, worshipped, or even laughed at by the supporters. This chapter takes an affectionate look at the charismatic, the contemptible, the perennial jokers and the consummate professional players who have graced and disgraced the institution of British football over the past 50 years.

"I LOOK DOWN ON HIM BECAUSE I AM UPPER-CLASS..."
Peter Crouch, Gareth Barry and Aaron Lennon line up for the national anthems before England play Belarus in a World Cup qualifying match. The prolific Crouch helped himself to two goals as England ran out 3–0 winners.

Date: **14th October, 2009**
Venue: **Wembley Stadium, London**

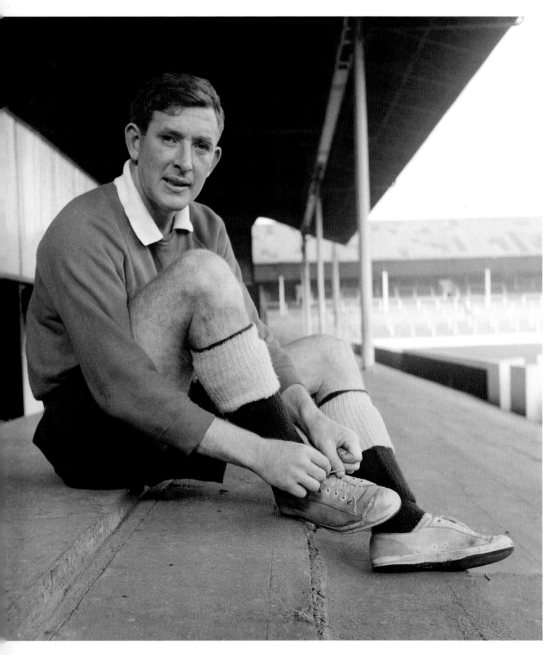

SPURS' GREATEST

Tottenham Hotspur skipper Danny Blanchflower ties up his plimsolls in preparation for training at Spurs' ground. Blanchflower played for Glentoran, Barnsley and Aston Villa before signing for Tottenham in 1954, and was captain during their finest years.

Date: **18th August, 1959**
Venue: **White Hart Lane, London**

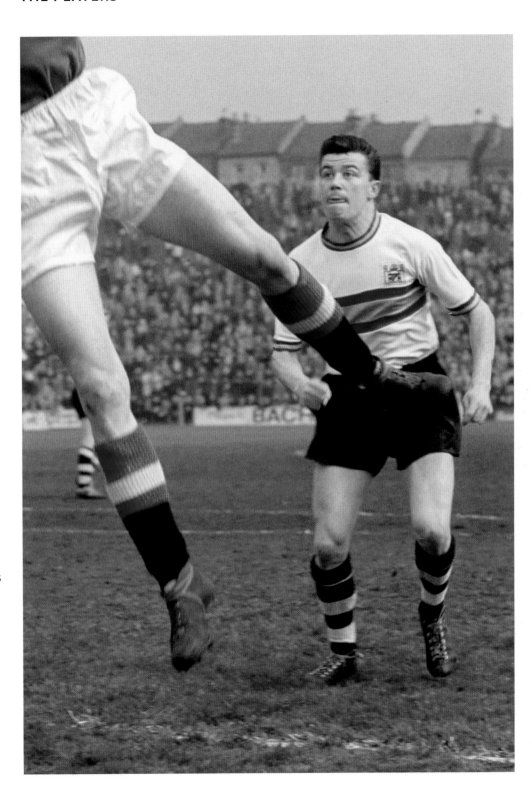

BUDGIE

John 'Budgie' Byrne of Crystal Palace in action against Wrexham in a Fourth Division encounter. Budgie scored 31 goals during the 1960–61 season, helping the Eagles to win promotion. He was soon to be called up by England, ultimately netting eight goals in 11 appearances for his country. It wasn't long before the First Division beckoned, and Byrne was bought by West Ham United for the then British transfer record fee of £65,000.

Date: **21st January, 1961**
Venue: **Selhurst Park, London**

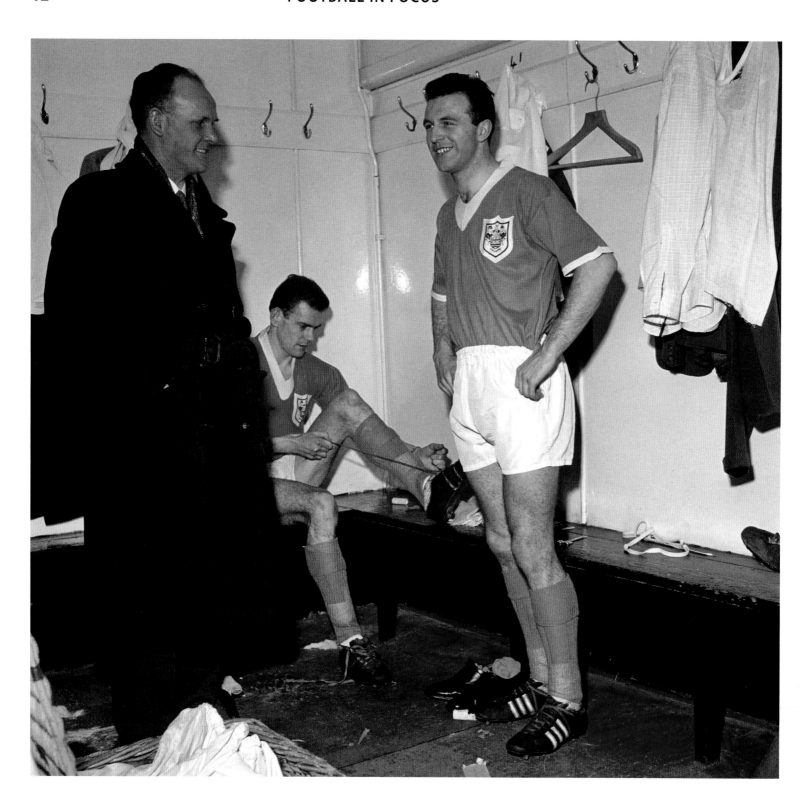

MANAGER AND CAPTAIN

England manager Walter Winterbottom talks to Jimmy Armfield, who captained both Blackpool and England, in the changing room before a First Division match at Chelsea. Ray Charnley is tying up his bootlaces. Armfield later became a pundit on BBC Radio Five Live.

Date: **11th February, 1961**
Venue: **Stamford Bridge, London**

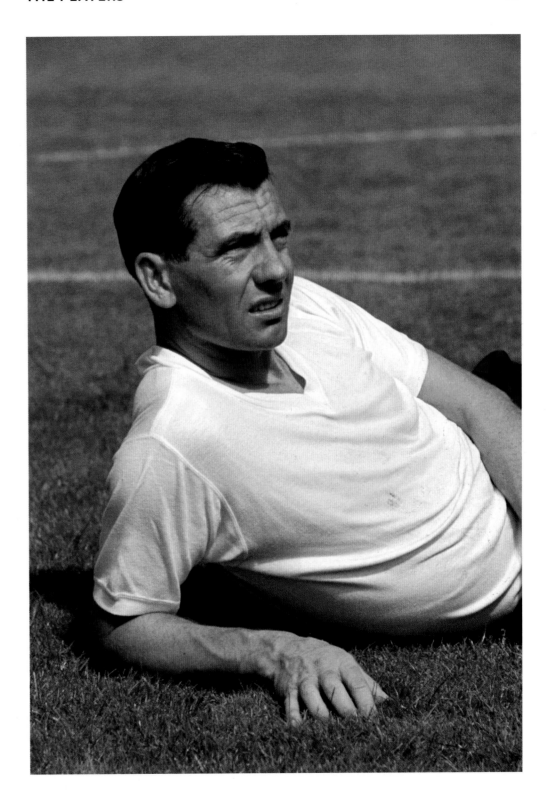

THE MAESTRO

Johnny Haynes of Fulham relaxes in the sunshine during an England training session at Highbury. Haynes was the first British footballer to earn £100 a week, following the Professional Footballers' Association's campaign to abolish the maximum wage – set at £20 per week.

Date: **27th September, 1961**
Venue: **Highbury, London**

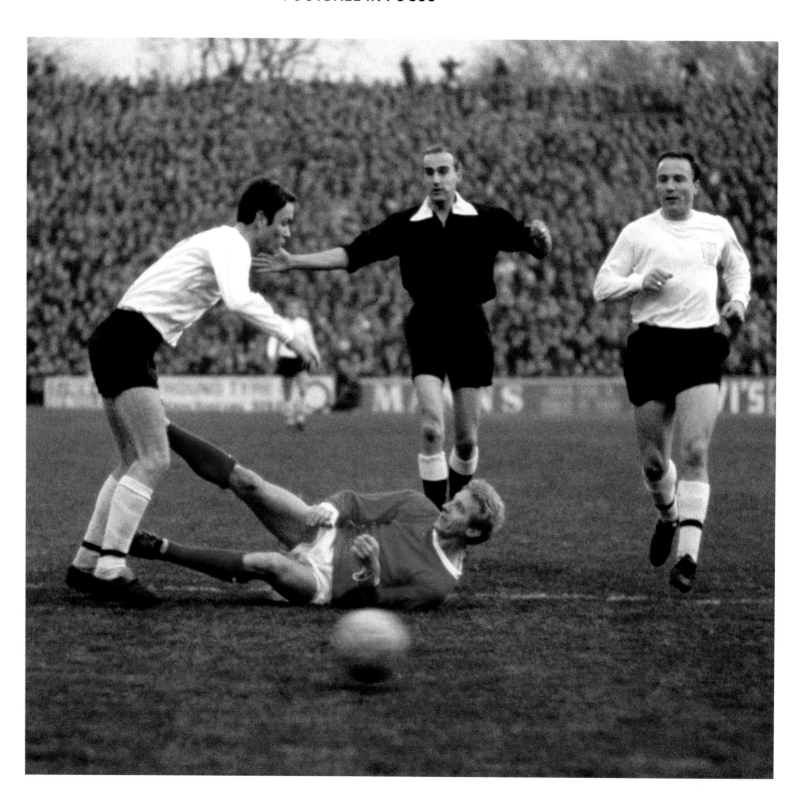

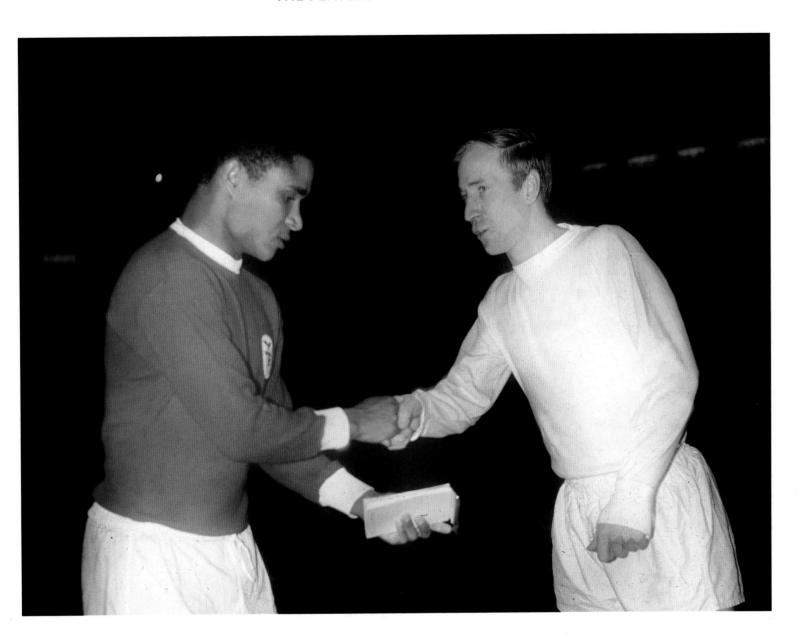

BREAKING THE LAW

Denis Law (in red) of Manchester United is fouled during a 2–1 defeat at Fulham. Future England World Cup winner George Cohen (R) looks on.

Date: **5th September, 1964**
Venue: **Craven Cottage, London**

BOBBY AND THE BLACK PANTHER

Two of the greatest footballers of the 1960s – Eusebio of Benfica and Portugal (in red) with Bobby Charlton of Manchester United and England. Both players were stars for their club and country, especially during the 1966 World Cup.

Date: **2nd February, 1966**
Venue: **Old Trafford, Manchester**

ENGLAND MARCH ON

Geoff Hurst wheels away, having scored the winning goal for England in a bad-tempered World Cup quarter-final match against Argentina. During the match Argentina's Antonio Rattin famously refused to walk after being sent off by German referee Rudolf Kreitlein. He was eventually persuaded by police and other officials to leave the pitch.

Date: **23rd July, 1966**
Venue: **Wembley Stadium, London**

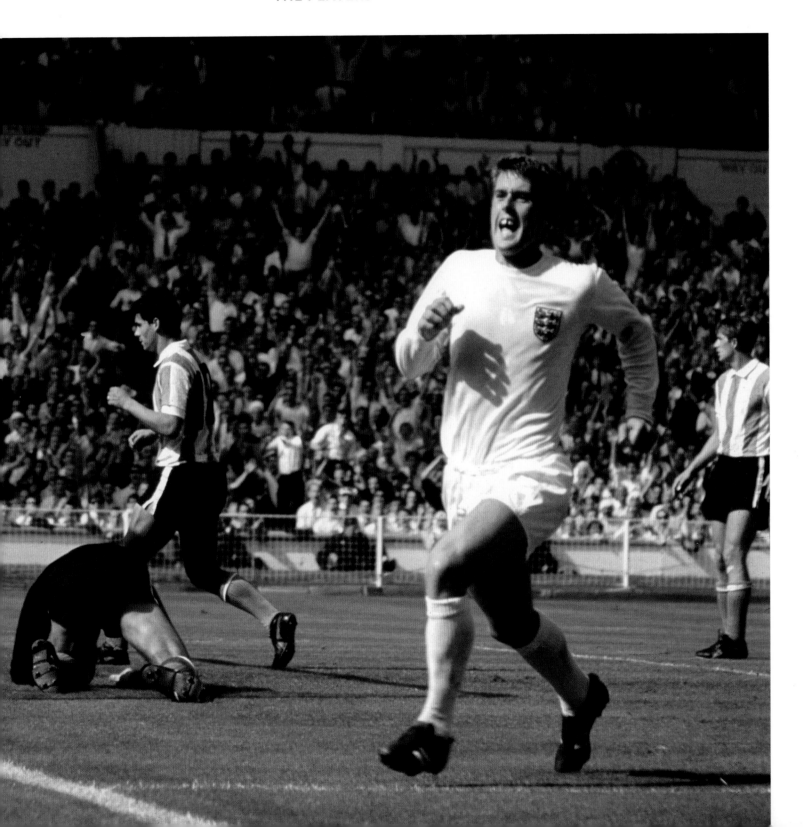

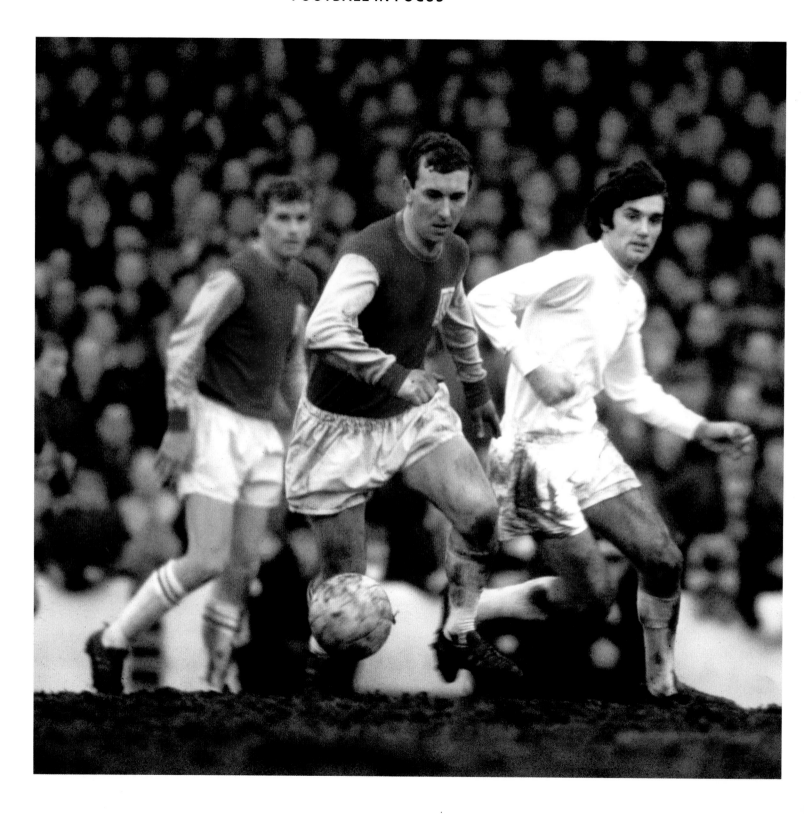

BEST IN SHOW

On a cold February afternoon, Burnley's Brian O'Neill shepherds the ball away from Manchester United's George Best (in white).

Date: **4th February, 1967**
Venue: **Turf Moor, Burnley**

THE SAINT

Ian St John of Liverpool controls the ball on the side of his leg during a warm-up before the match against Fulham. St John, who played nearly 350 league matches for Liverpool, is equally as well known for co-hosting the *Saint and Greavsie* football show with former England star Jimmy Greaves during the 1980s.

Date: **25th February, 1967**
Venue: **Craven Cottage, London**

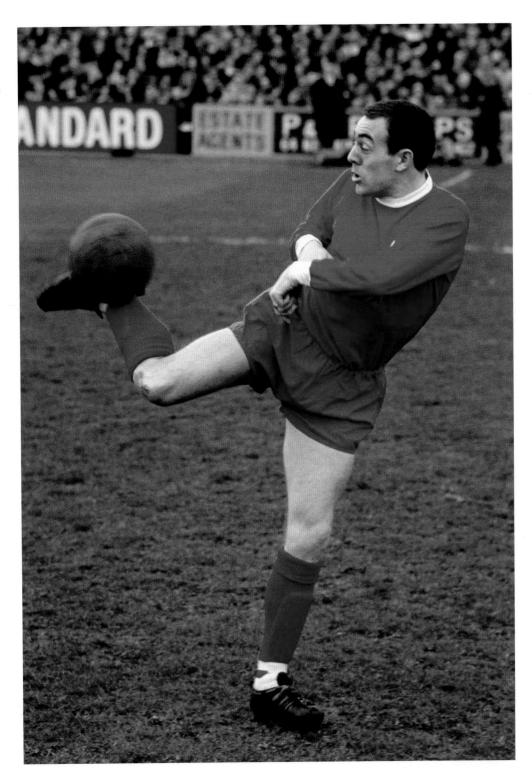

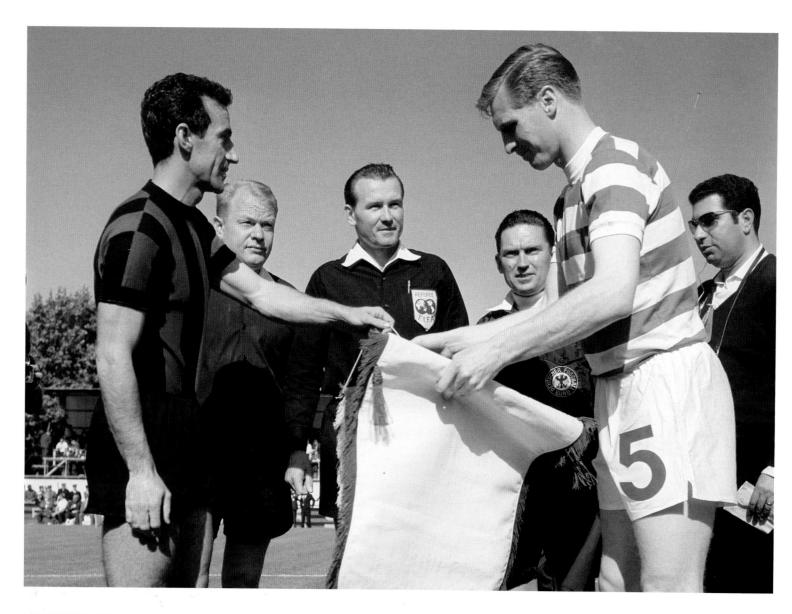

LISBON LIONS

Internazionale captain Armando Picchi exchanges pennants with Celtic captain Billy McNeill ahead of the 1967 European Cup Final, watched closely by West German referee Kurt Tschenscher. Inter went one up after seven minutes, and subsequently parked the proverbial bus in front of goal.

However, Celtic kept battering away at their opponents before Tommy Gemmell and Steve Chalmers pulled the match round and gave Scotland its first European Cup.

Date: **25th May, 1967**
Venue: **Estadio Nacional, Lisbon, Portugal**

CHARITABLE APPLAUSE

Some of the Leeds United team with the FA Charity Shield, having beaten 1969 FA Cup winners Manchester City at Elland Road. (L–R) Gary Sprake, Norman Hunter, Billy Bremner, Johnny Giles and Allan Clarke.

Date: **2nd August, 1969**
Venue: **Elland Road, Leeds**

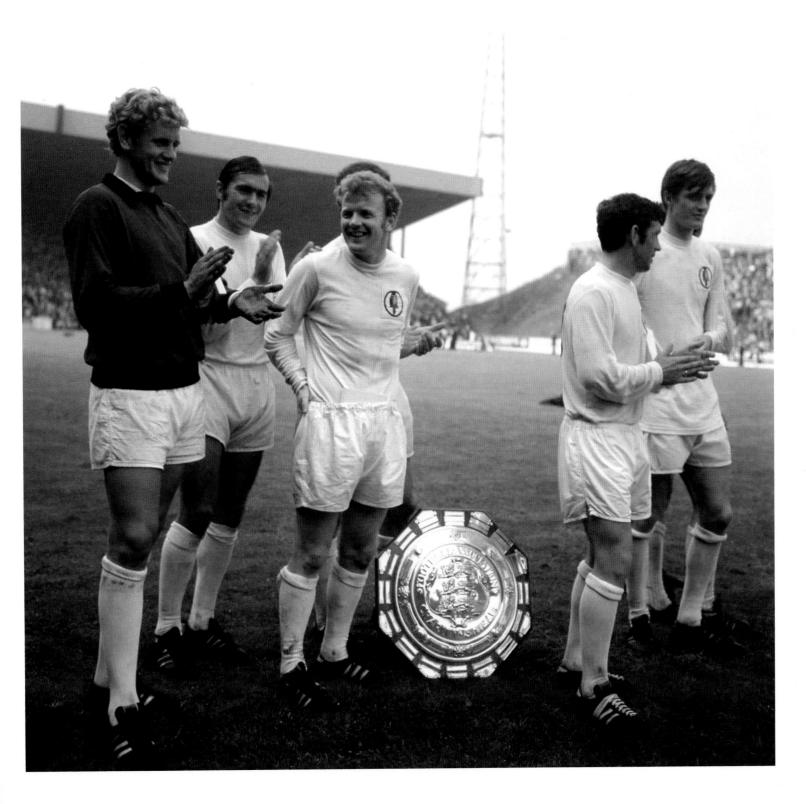

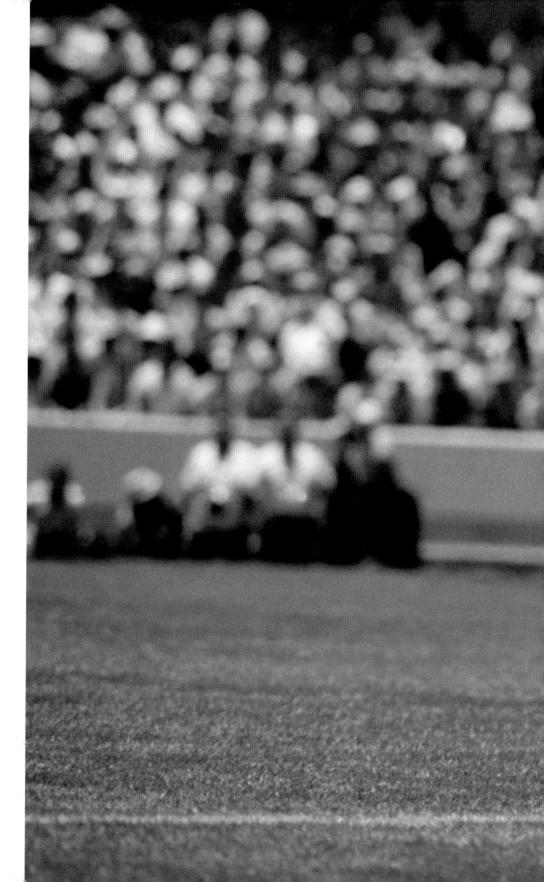

MOORE'S DISAPPOINTMENT

Bobby Moore reflects on the 1–0 defeat suffered at the hands of Brazil in the 1970 World Cup, a game that had everything – a world-class save by Gordon Banks, a perfectly-timed tackle by Moore on Jairzinho and a howling miss by England's Jeff Astle.

Date: **7th June, 1970**
Venue: **Estadio Jalisco, Guadalajara, Mexico**

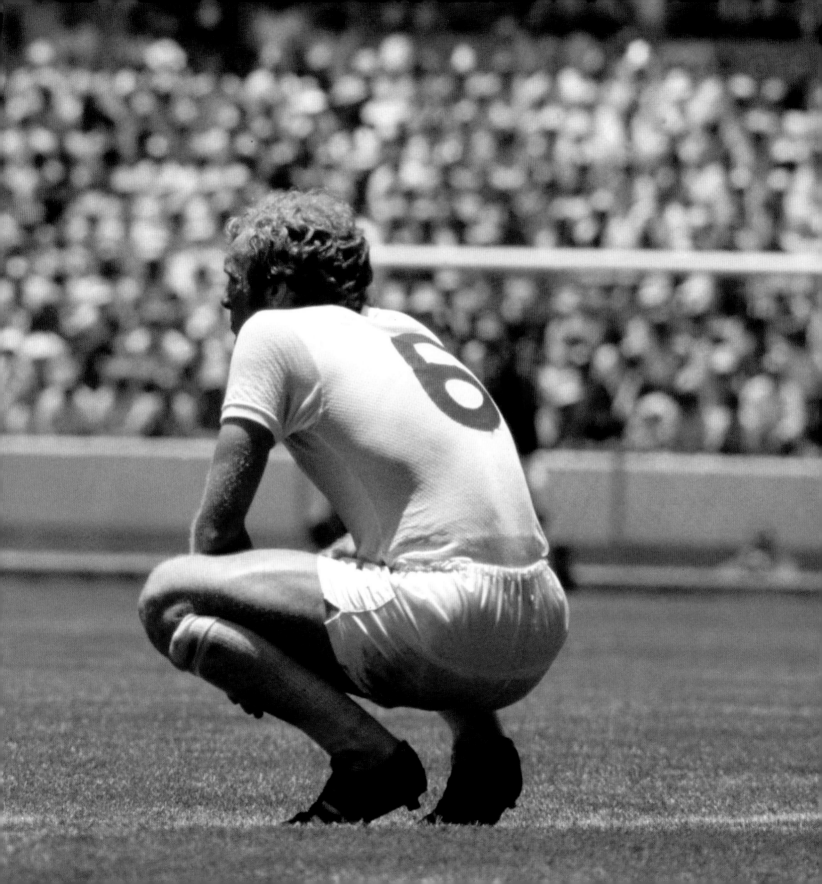

LEEDS' LAST LINE

Leeds United goalkeeper David Harvey makes a watchful save against Arsenal in front of thousands of fans standing in Highbury's Clock End.

Date: **11th September, 1971**
Venue: **Highbury, London**

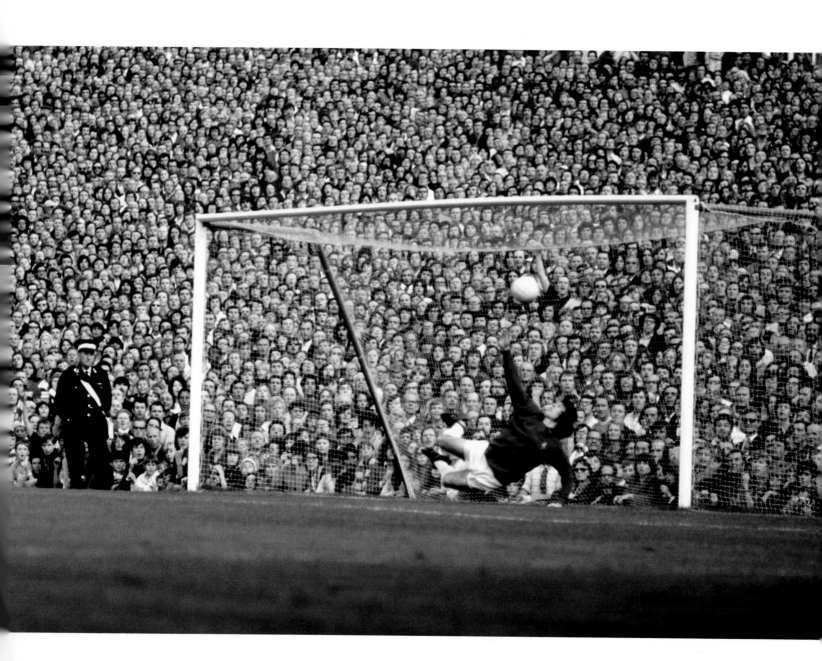

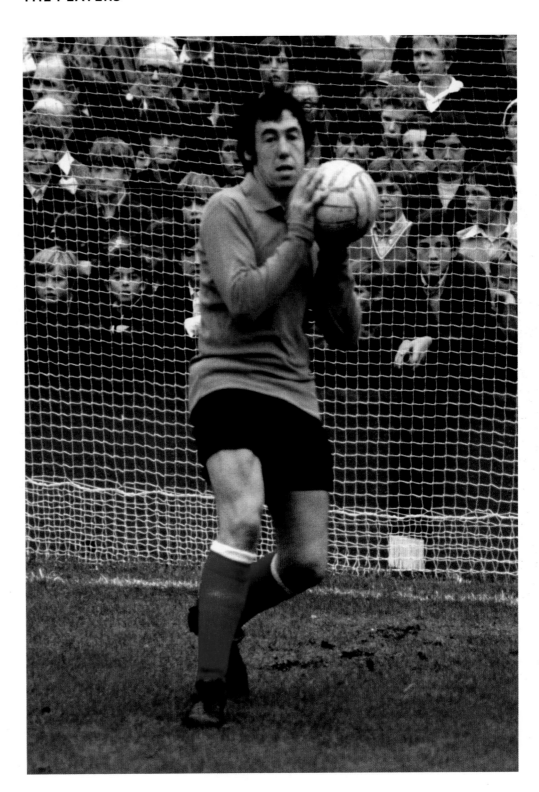

ENGLAND'S No 1
Stoke City and England goalkeeper
Gordon Banks in action against West
Ham at Upton Park. Arguably the best
goalkeeper England ever produced, the
Yorkshireman had his career cut short in
1972 when he lost the sight in one eye
following a car crash.

Date: **25th September, 1971**
Venue: **Boleyn Ground, London**

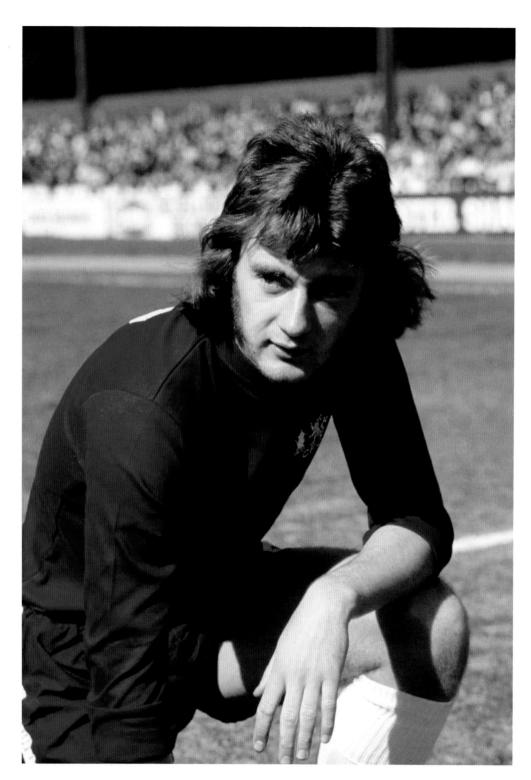

BLUE BOY

Chelsea's Alan Hudson poses for the camera on the Stamford Bridge pitch before playing against Arsenal in a match the visitors won 2–1. A talented and highly skilled ball-playing midfielder, Hudson also played for Stoke City and Arsenal, winning two caps for England in 1975.

Date: **16th October, 1971**
Venue: **Stamford Bridge, London**

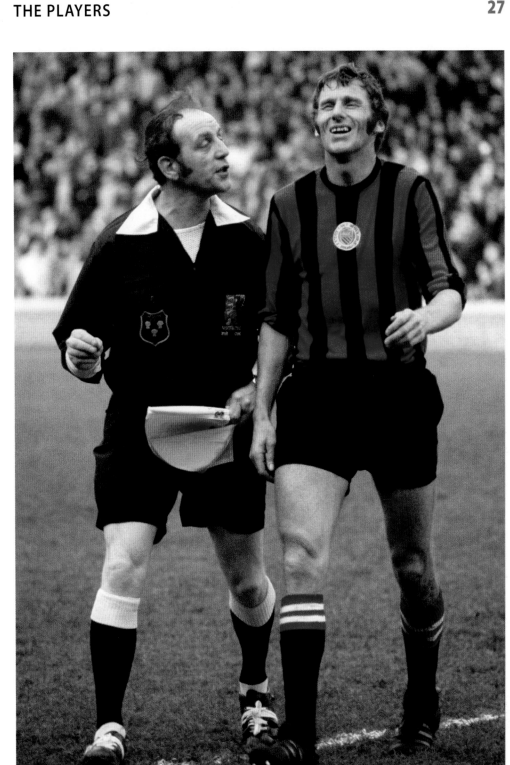

BY THE BOOK

An incredulous-looking Manchester City captain, Tony Book is quietly spoken to by the linesman during a First Division clash with Huddersfield Town.

Date: **30th October, 1971**

Venue: **Leeds Road, Huddersfield**

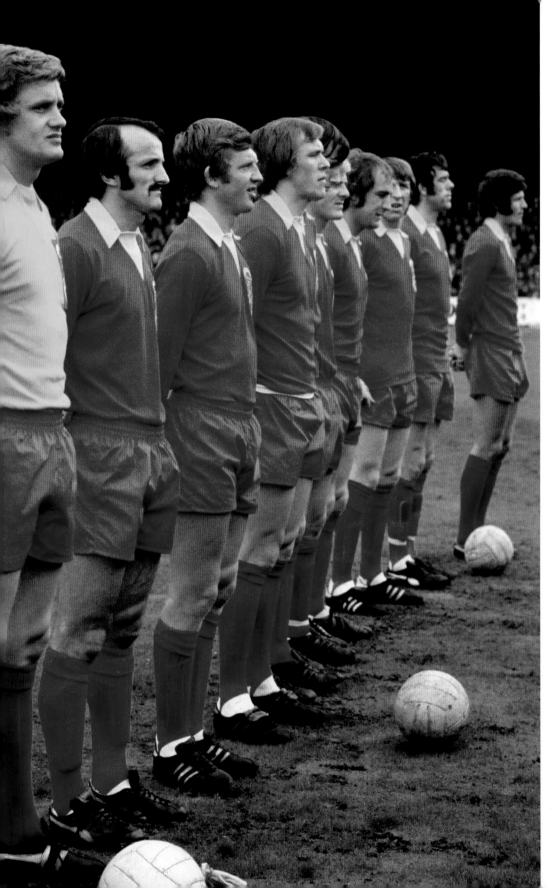

WELSH LINE-UP

The Wales team line up for the national anthem before their British Championship (also known as the Home Internationals) match against England in Cardiff. England ran out comfortable 3–0 winners, with goals from Emlyn Hughes, Rodney Marsh and Colin Bell.

Date: **20th May, 1972**
Venue: **Ninian Park, Cardiff**

CRAZY HORSE

Full-back Emlyn Hughes is warmly congratulated by captain Bobby Moore (No 6) after opening England's scoring against Wales. When playing for Liverpool in the 1960s, Hughes had earned the nickname 'Crazy Horse' after an illegal rugby tackle on Newcastle United winger Albert Bennett, although manager Bill Shankly had seen his potential.

Date: **20th May, 1972**
Venue: **Ninian Park, Cardiff**

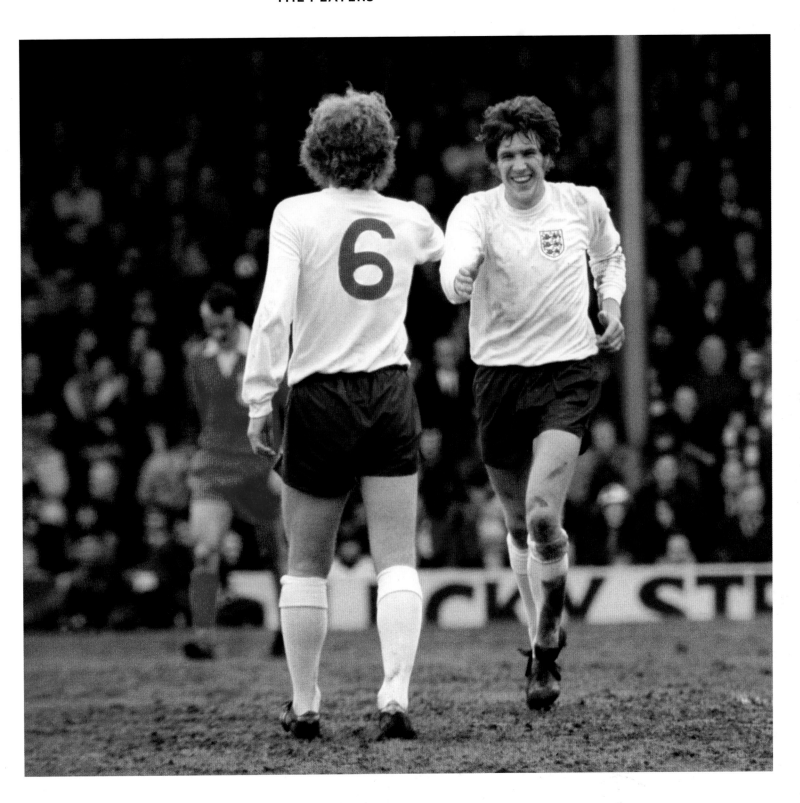

CHERRY 'ARRY

Harry Redknapp, recently transferred from West Ham United, poses for the camera before one of his first matches for AFC Bournemouth. Redknapp became manager of the Cherries in 1983, leading the team to a third-round victory over Manchester United in the FA Cup of 1984 and promotion to the Second Division following a superb 1986–87 season.

Date: **26th August, 1972**
Venue: **Vicarage Road, Watford**

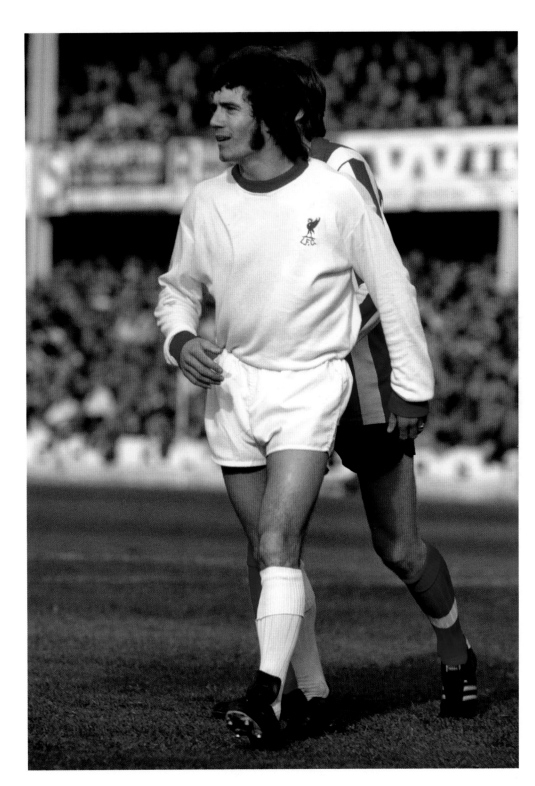

KEVIN AT THE DELL

In his second of six seasons at Liverpool, a 21-year-old Kevin Keegan (in his club's all-white away strip) is marked by a Southampton defender. The match ended all-square at 1–1.

Date: **14th October, 1972**

Venue: **The Dell, Southampton**

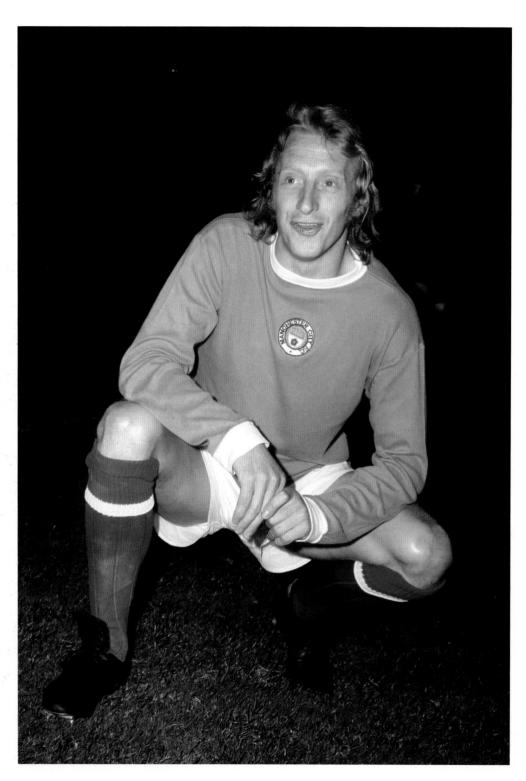

DENIS THE MENACE

Denis Law, aged 34 and in his second stint at Manchester City, prepares to take on Arsenal at Highbury, a match the hosts were to win 2–0. A month later, Law played his part in sending Manchester United down to the Second Division with a back-heeled winner in the derby match at Old Trafford.

Date: **23rd March, 1974**
Venue: **Highbury, London**

PANTO TIME

Football has been known to be a pantomime from time to time. L–R: Leeds United's Billy Bremner, Norman Hunter and Jimmy Armfield take to the stage to perform in a production of *Cinderalla*.

Date: **2nd January, 1976**
Venue: **Leeds**

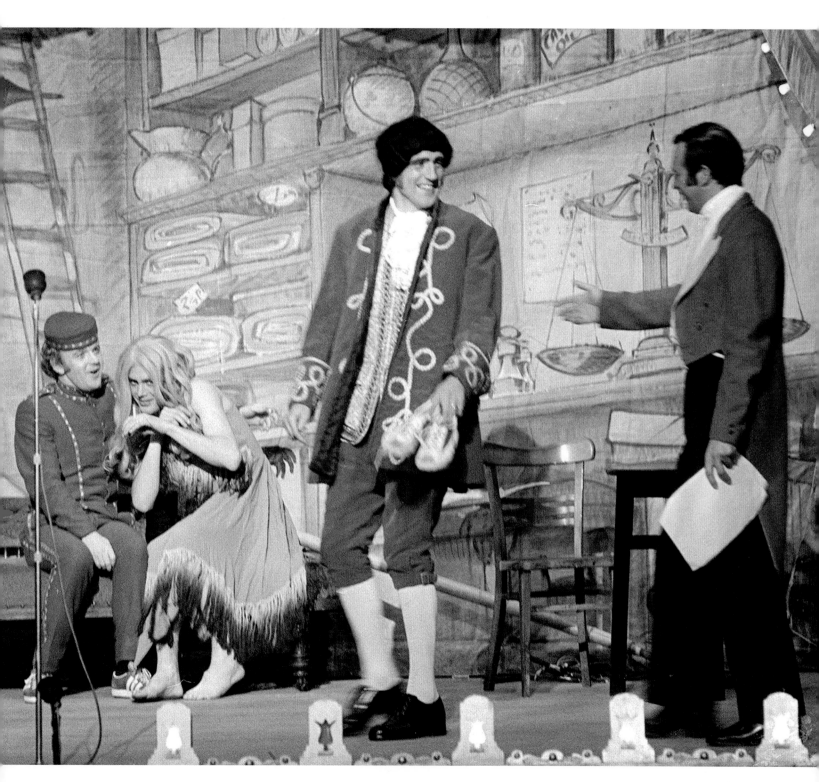

CHIPPY

Rising star Liam Brady (R) of Arsenal in action against Manchester City. Brady would become one of the most exciting and cultured footballers seen in England. In 1980, he left Highbury to play in Italy for Juventus, Sampdoria, Inter and Ascoli. Brady's nickname, 'Chippy' referred not to his ability to chip the ball but to his alleged fondness for fish and chips.

Date: **4th September, 1976**
Venue: **Highbury, London**

BIG JOE

Joe Royle of Manchester City has a wry grin on his face as he is marked by Newcastle United's David Craig in the fifth round of the FA Cup. Five seconds later Royle had put the ball in the net.

Date: **29th January, 1977**
Venue: **St James' Park, Newcastle**

TAKE A BOW, SON

Bouffant-haired Andy Gray of Aston Villa before an end-of-season clash with Tottenham Hotspur. Gray's goals in the 1976–77 season helped Villa win the League Cup and fourth place in the First Division. That year he also became the first player to receive both the PFA Player of the Year and Young Player of the Year awards at the same ceremony – a feat only matched by Cristiano Ronaldo 30 years later.

Date: **30th April, 1977**
Venue: **White Hart Lane, London**

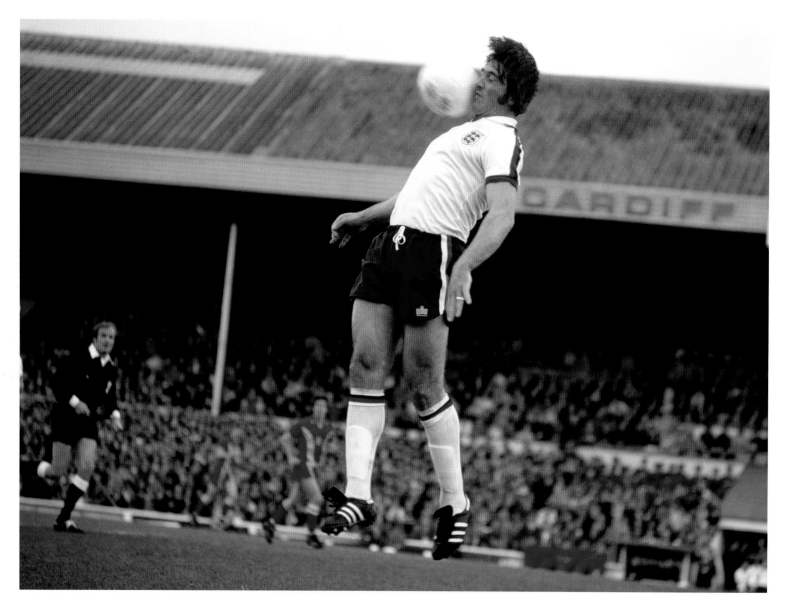

CHEEK CONTROL
Everton and England striker Bob Latchford receives a ball in the face during a match against Wales.

Date: **13th May, 1978**
Venue: **Ninian Park, Cardiff**

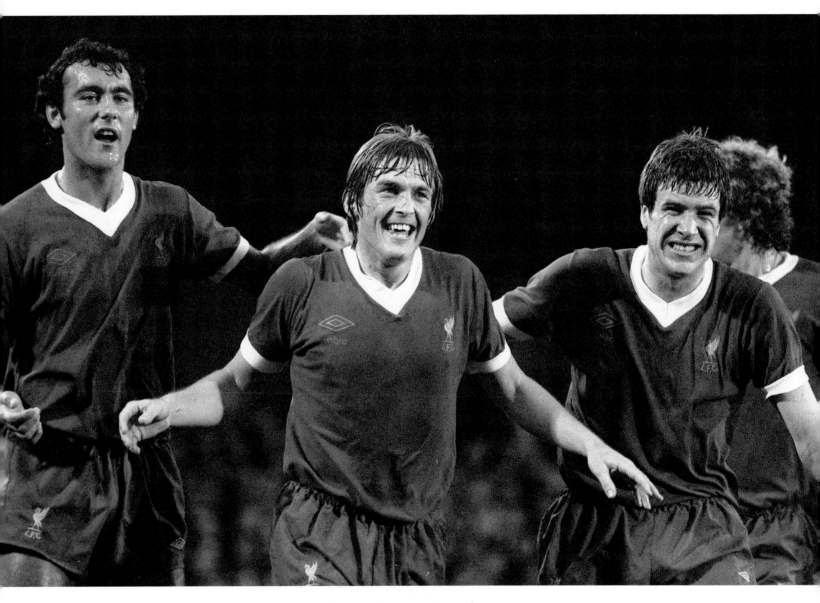

SWEATY CELEBRATIONS

Ray Kennedy, Kenny Dalglish and Emlyn
Hughes are drenched in a balmy August
evening sweat as they celebrate Liverpool's
goal in an early-season encounter at Bobby
Robson's Ipswich Town.

Date: **22nd August, 1978**
Venue: **Portman Road, Ipswich**

DEEP CONCENTRATION

Liverpool and Scotland defender Alan Hansen chews on his tongue before the Wales v Scotland Home International match in Cardiff. The match finished 3–0 to Wales.

Date: **19th May, 1979**
Venue: **Ninian Park, Cardiff**

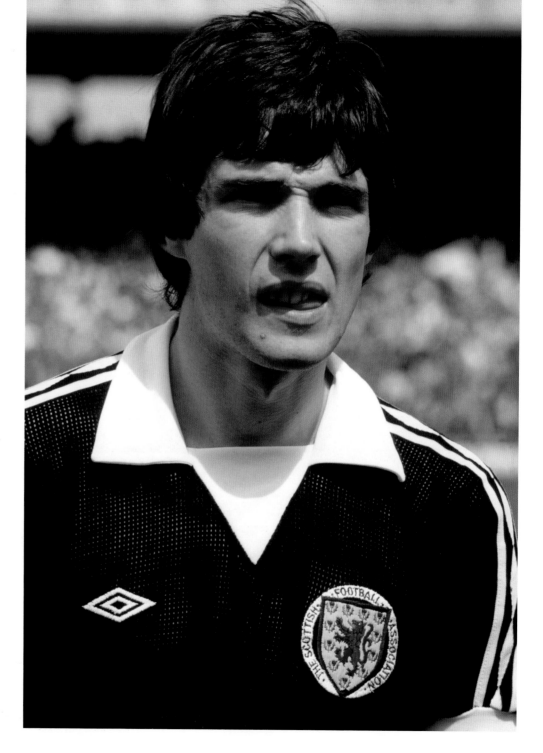

BIG JOHN

Wales and then-Swansea City striker
John Toshack on the ball in a Home
International Championship match against
Scotland in Cardiff. Toshack played 40
times for Wales, scoring 12 goals.

Date: **19th May, 1979**
Venue: **Ninian Park, Cardiff**

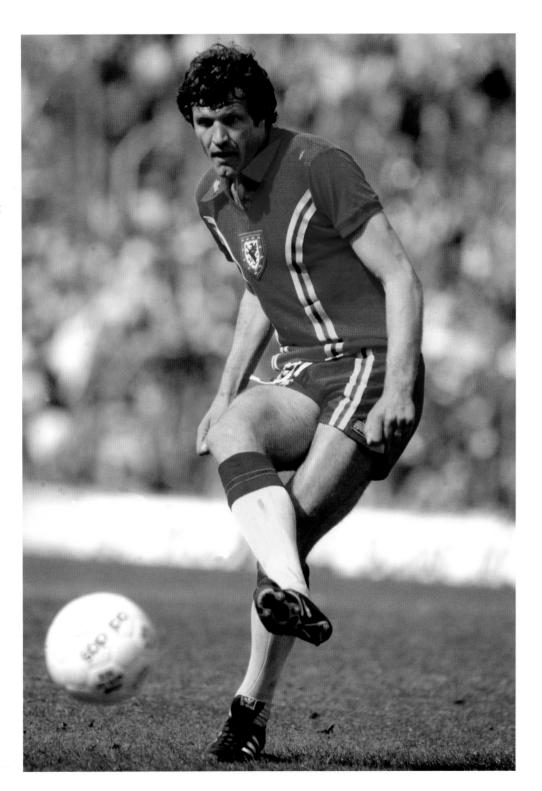

TWO ALL?

Coventry City's Tommy Hutchison exchanges pleasantries with a Southampton opponent in a First Division game at The Dell – a match the visitors went on to win 3–2.

Date: **13th October, 1979**
Venue: **The Dell, Southampton**

SIX OF THE BEST

Ipswich Town striker Paul Mariner celebrates a 6–0 win over Manchester United, a match in which Gary Bailey, the United keeper, saved three penalties.

Date: **1st March, 1980**
Venue: **Portman Road, Ipswich**

BURNS CALLING

The terrifying sight of Kenny Burns of European champions Nottingham Forest in a First Division clash with Brighton & Hove Albion. Burns had scooped the Football Writers' Association Player of the Year award two years earlier, when Forest won the league.

Date: **29th March, 1980**
Venue: **Goldstone Ground, Hove**

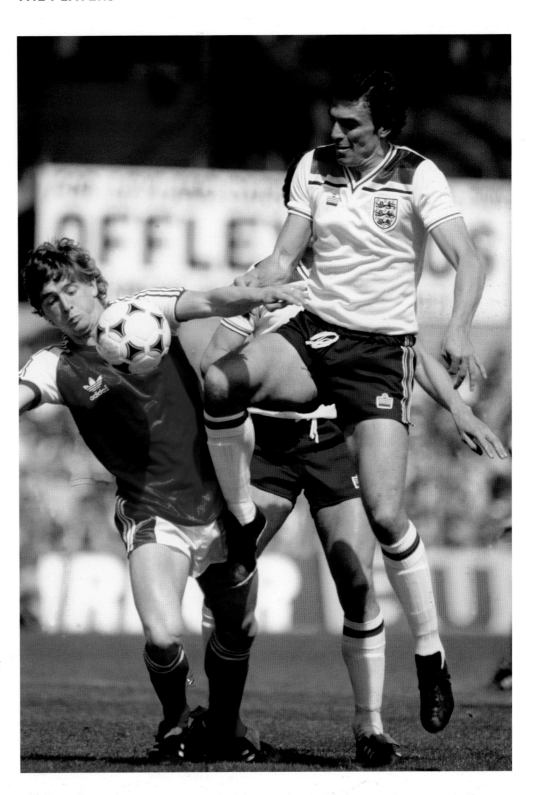

MIDFIELD MAGICIAN

England's Trevor Brooking takes the ball off Wales' Ian Walsh. The Crystal Palace striker scored Wales' second as they thrashed the visitors 4–1.

Date: **17th May, 1980**
Venue: **Racecourse Ground, Wrexham**

RED FOR NO 9
Scotland's big No 9, Joe Jordan is
crestfallen as he is sent off against Wales, in
a match the hosts go on to win 2–0.

Date: **16th May, 1981**
Venue: **Vetch Field, Swansea**

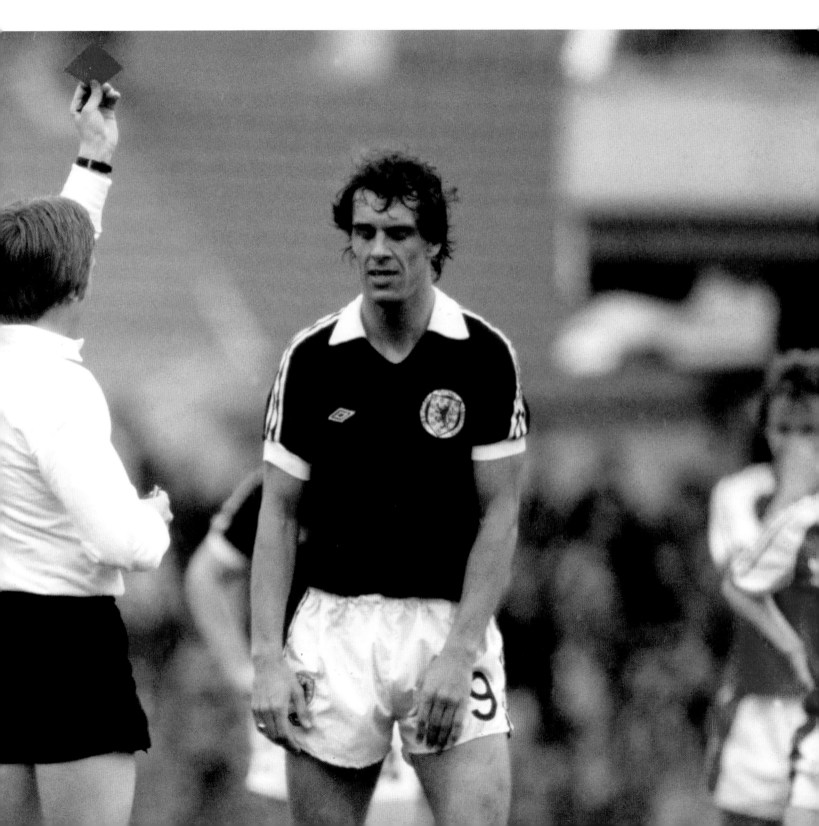

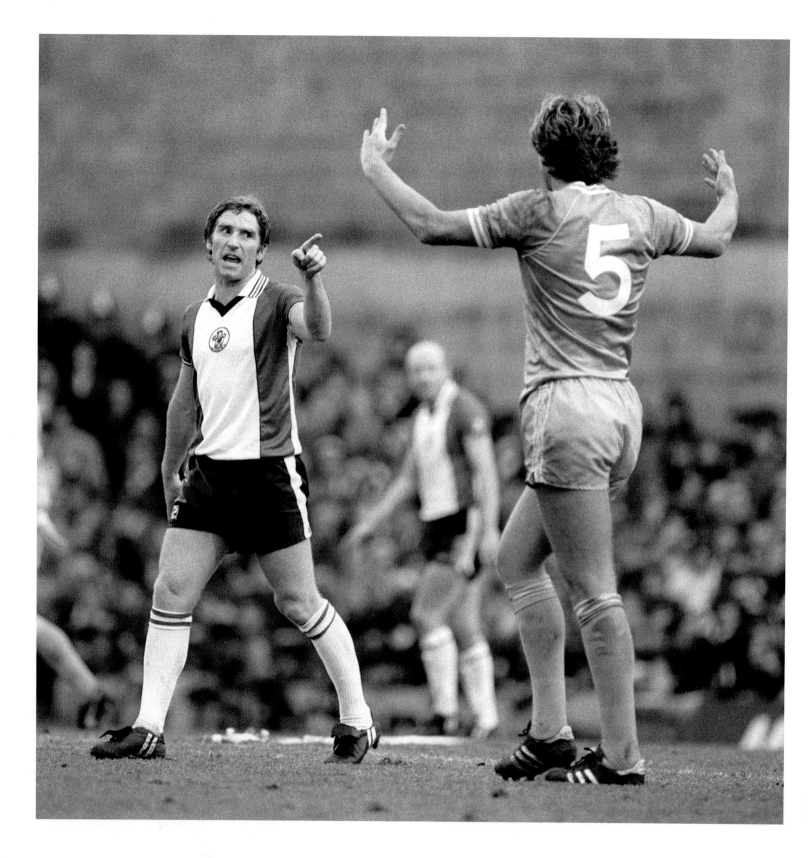

OFF THE BALL INCIDENT

World Cup winner Alan Ball, by now Southampton's veteran fiery midfielder, points an accusatory finger at Manchester City defender Kevin Bond. Southampton won this encounter 2–1.

Date: **6th February, 1982**
Venue: **The Dell, Southampton**

TEAM TALK

Aberdeen manager Alex Ferguson fires off words of encouragement to striker Mark McGhee at the end of 90 minutes in the Scottish Cup Final. They obviously had the desired effect as Aberdeen went on to score three extra-time goals to beat Rangers 4–1.

Date: **22nd May, 1982**
Venue: **Hampden Park, Glasgow**

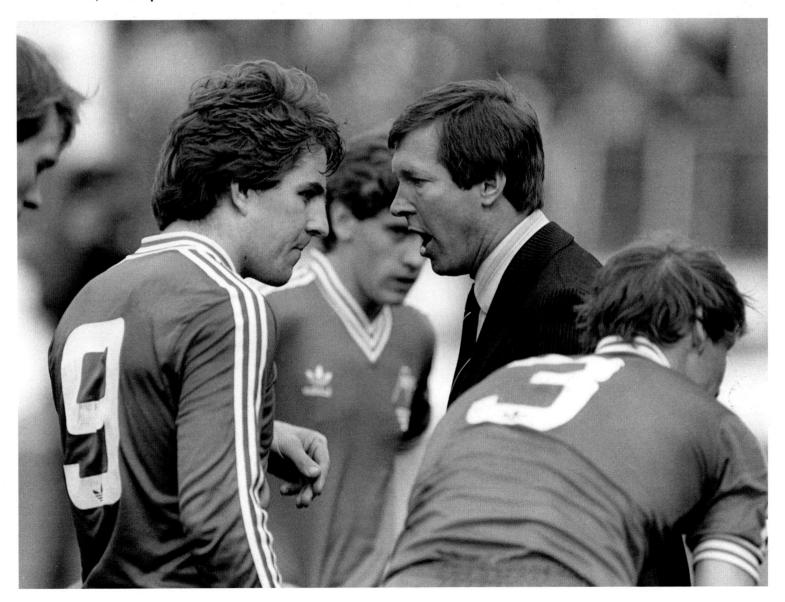

MILAN MAN

Luther Blissett poses during a pre-season photocall at AC Milan, having recently signed from Watford. The striker made his debut for England against West Germany in 1982, ultimately winning 14 caps for his country and scoring three times. Blissett's name had been adopted by anarchists, performers and squatters' collectives across Europe as an umbrella nom de plume for radical thought and theory.

The 'Luther Blissett Project' (LBP) started in Italy in 1994, and in 1999, 'Luther Blissett' wrote an international bestseller. Blissett himself has got in on this, reading from the LBP manifesto on TV, stating that *"anyone can be Luther Blissett simply by adopting the name Luther Blissett".*

Date: **12th September, 1983**
Venue: **Milan, Italy**

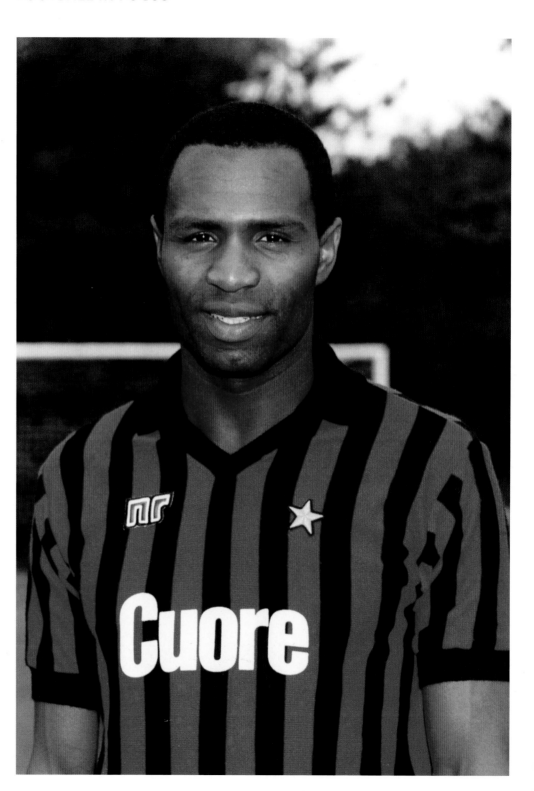

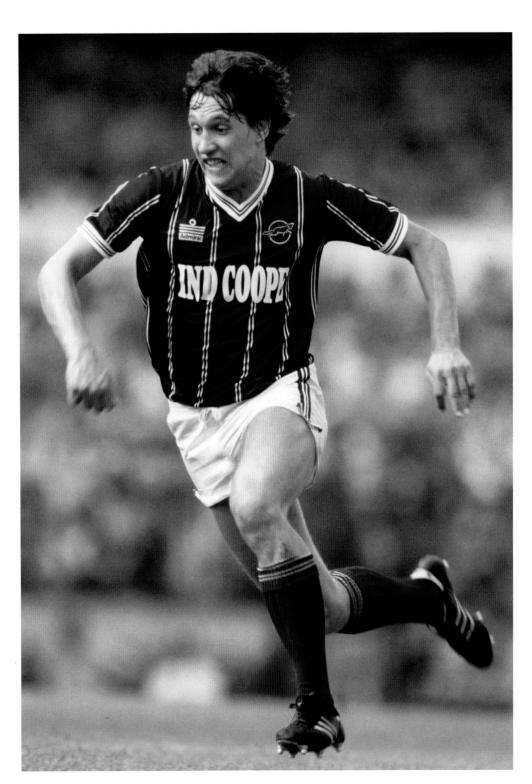

NEVER BEEN BOOKED

Leicester City's Gary Lineker in full flow during a First Division match against Tottenham Hotspur that finished 2–2. This was his final season at the club, where he had a scoring ratio of a goal every other game; in the summer of 1985, he was transferred to Everton for £800,000.

Date: **27th August, 1984**
Venue: **White Hart Lane, London**

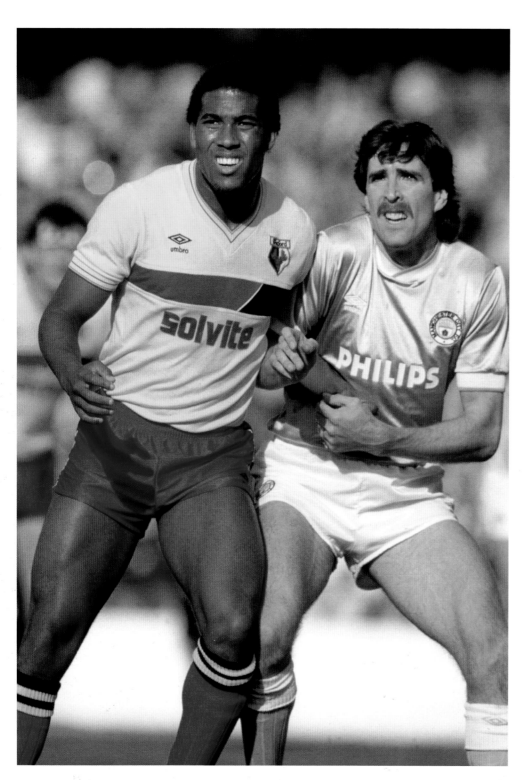

JOSTLING FOR POSITION

Watford and England winger John Barnes (L) tussles with Manchester City captain Paul Power in a First Division match that was won 3–2 by the home side. Note the very short shorts.

Date: **12th October, 1985**
Venue: **Vicarage Road, Watford**

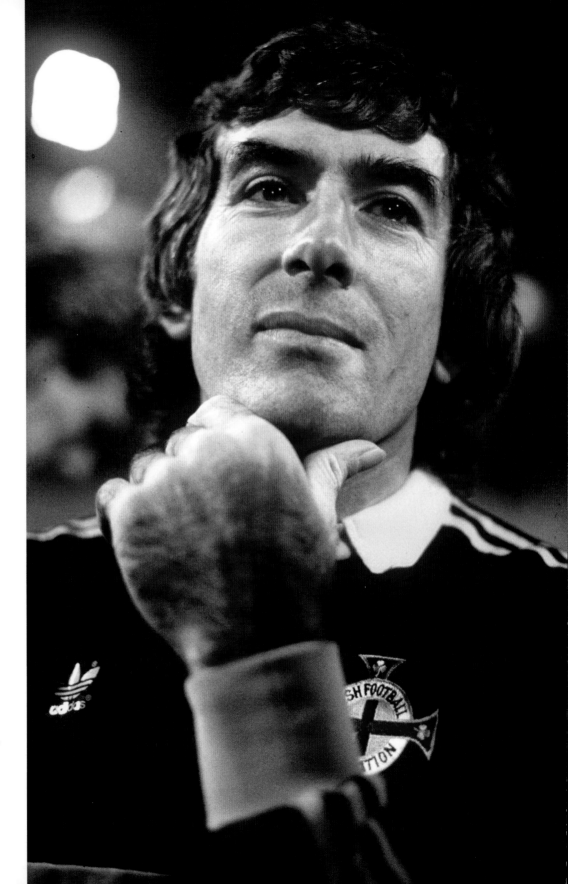

BIG PAT

The imposing figure of Northern Ireland goalkeeper Pat Jennings, before a World Cup qualifying match against England. Jennings kept a clean sheet in a 0–0 draw, and both countries went on to play in the following year's tournament in Mexico.

Date: **13th November, 1985**
Venue: **Wembley Stadium, London**

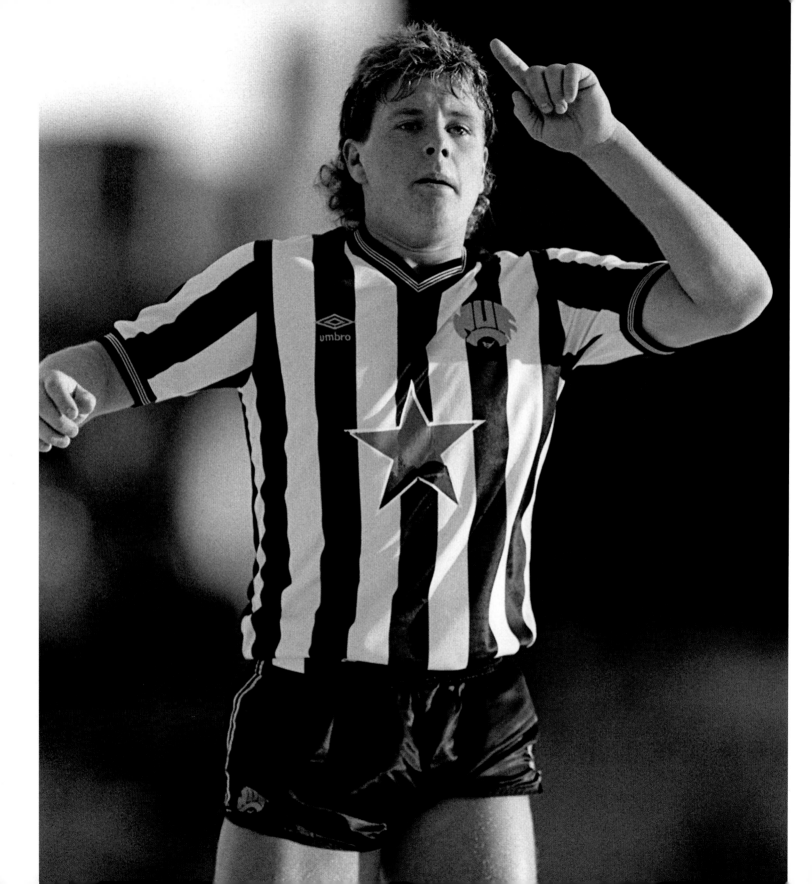

YOUNG GAZZA

Newcastle United teenager Paul Gascoigne sports the Magpies' hotpants and fashionable mid-80s mullet during this First Division match at Nottingham Forest.

Date: **8th February, 1986**
Venue: **City Ground, Nottingham**

UNHAPPY EASTER

Graeme Souness (R) is sent off on his debut for Rangers having fouled Hibernian's George McCluskey (second L). The Hibs striker also had to leave the pitch to have his knee stitched.

Date: **9th August, 1986**
Venue: **Easter Road, Edinburgh**

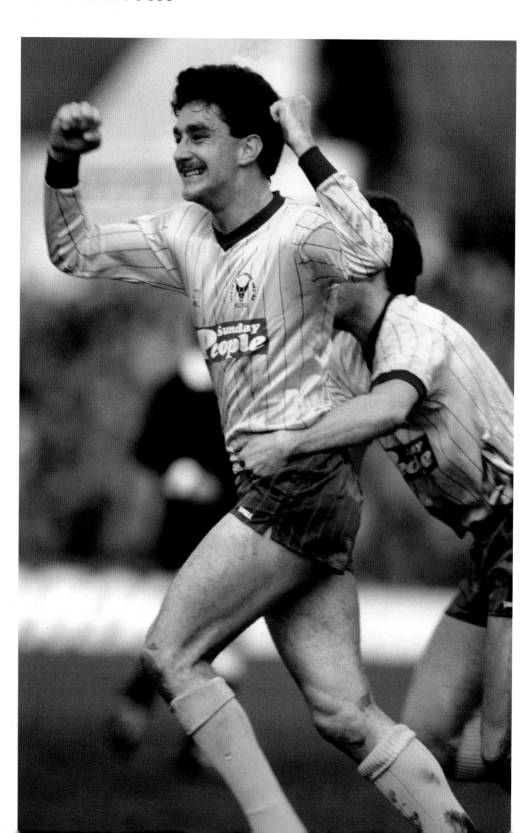

OXFORD JOHN

The prolific John Aldridge celebrates scoring for Oxford United in the second of their three seasons in the top flight. Aldridge netted 90 goals in 138 starts for Oxford before moving to Liverpool in January 1987.

Date: **13th September, 1986**
Venue: **Manor Ground, Oxford**

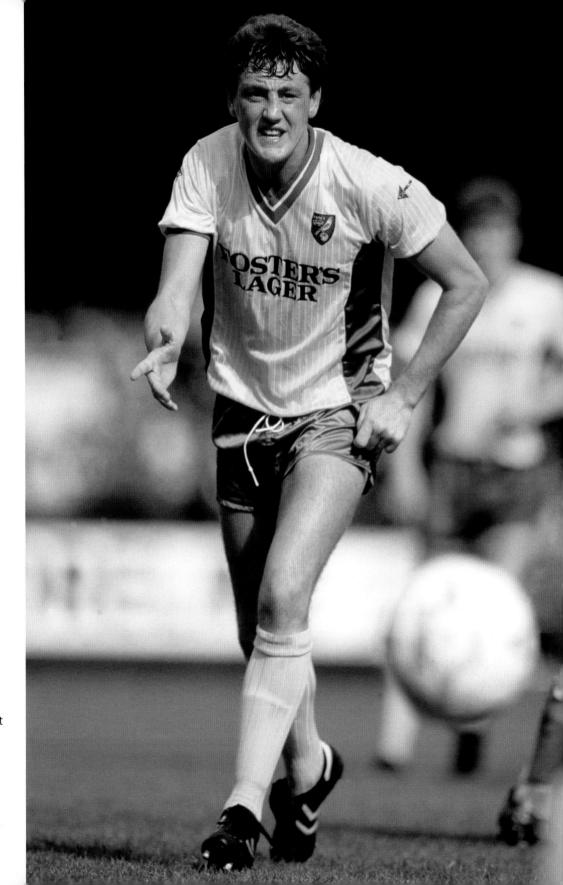

CAPTAIN CANARY

Norwich City's Steve Bruce keeps an eye on proceedings in a First Division match against West Ham United. Bruce, who went on to captain Manchester United to many trophies, was voted into the Norwich City Hall of Fame by the club's fans in 2002.

Date: **18th October, 1986**
Venue: **Carrow Road, Norwich**

WRIGHT STUFF

Relative latecomer, Ian Wright of Crystal Palace, celebrates scoring in a Second Division 2–1 win over Oldham Athletic. Wright would have four more seasons at Selhurst Park, playing in an FA Cup Final, before a highly successful move to Arsenal.

Date: **25th April, 1987**
Venue: **Selhurst Park, London**

RUSH IN ITALY

Ian Rush in a rare game for Juventus at Pisa. Rush's move from Liverpool to Turin was short-lived and not a great success. *"I couldn't settle in Italy – it was like living in a foreign country,"* Rush was allegedly quoted as saying.

Date: **8th November, 1987**
Venue: **Arena Garibaldi – Stadio Romeo Anconetani, Pisa, Italy**

CHARGING BULL

Wolverhampton Wanderers' Steve Bull skips past the Leyton Orient defender on the way to collecting the Fourth Division Championship. Bull scored 306 goals in 561 games for Wolves in all competitions during 13 seasons at Molineux. He also made 13 appearances for England, mostly under Bobby Robson, netting four times.

Date: **8th November, 1987**
Venue: **Brisbane Road, London**

JONES BLOCK

Wimbledon's Vinnie Jones attempts to block a shot by Manchester United captain Bryan Robson at Wimbledon's Plough Lane. This match finished all-square at 1–1.

Date: **22nd October, 1988**
Venue: **Plough Lane, London**

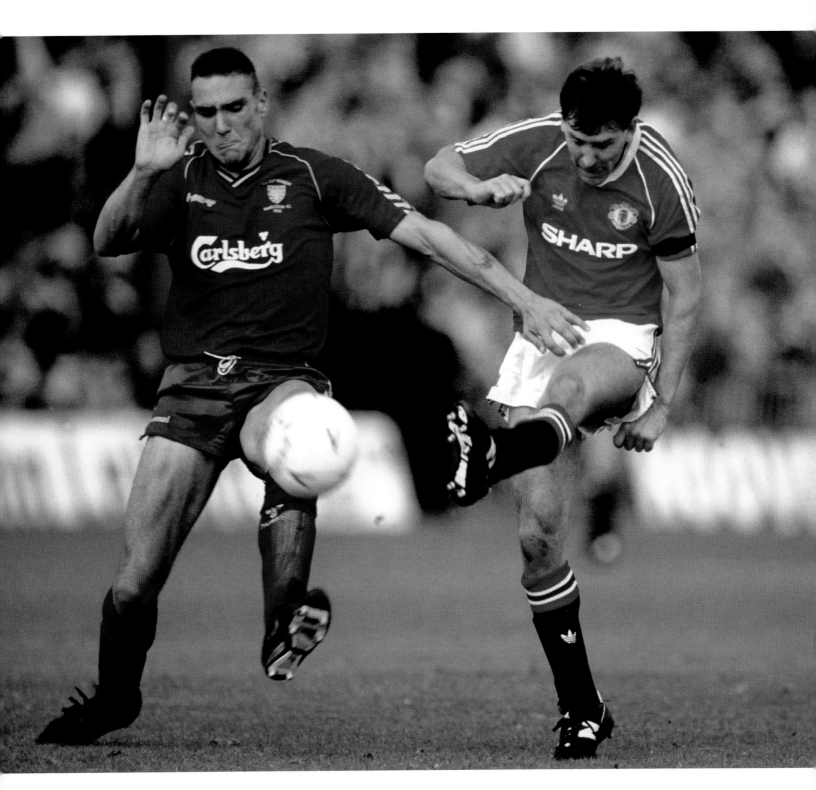

PRE-GIGGS SUCCESS

Ryan Wilson, 15, walks down the steps at Wembley Stadium having played for England Schoolboys against Belgium Schoolboys. On his 16th birthday, he changed his name to Ryan Giggs, and went on to play more than 60 times for Wales. Giggs' eligibility to play for England was based on where he went to school – not his parents' or grandparents' nationalities.

Date: **11th March, 1989**
Venue: **Wembley Stadium, London**

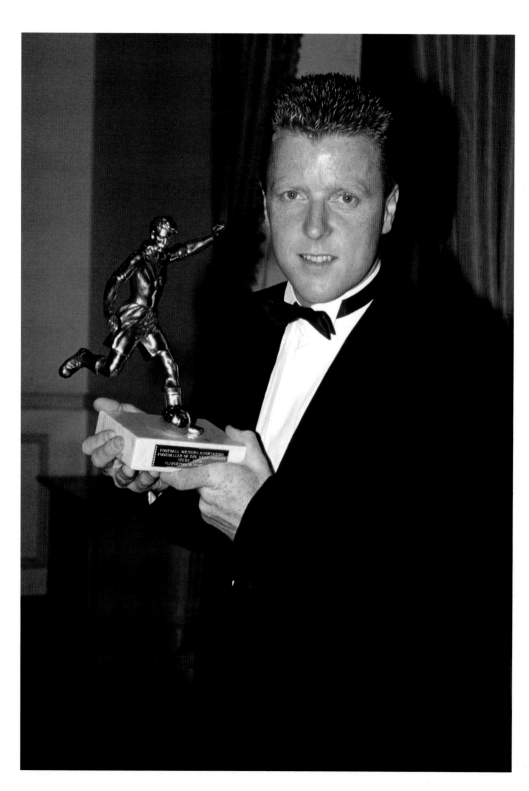

SCRIBES' CHOICE
Liverpool's Steve Nicol, looking resplendent at a black tie event, proudly shows off his Football Writers' Association award for Player of the Year 1988-89.

Date: **18th May, 1989**
Venue: **London**

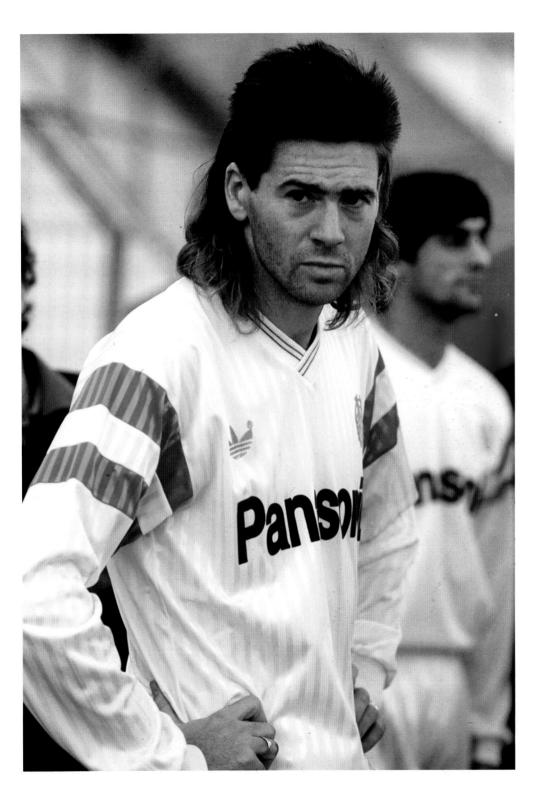

MAGIC CHRIS

The mullet-haired Chris Waddle waits on the sidelines in this French First Division match between Olympique Marseille and Nice. While playing for l'OM, Waddle won three successive French championships. Such was his popularity at the club that 'Magic Chris' was voted the fans' second favourite player of all-time, behind Jean-Pierre Papin during the club's centenery celebrations in 1998.

Date: **17th December, 1989**

Venue: **Stade Vélodrome, Marseille, France**

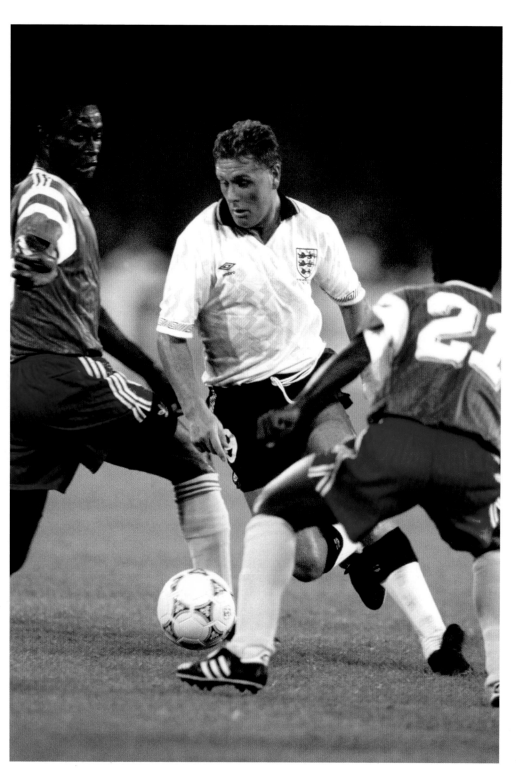

SUBLIME GAZZA

England's Paul Gascoigne skips past Cameroon's Emmanuel Maboang (No 21) in the 1990 World Cup quarter-final. England eventually won 3–2 after extra time.

Date: **1st July, 1990**
Venue: **Stadio San Paolo, Naples, Italy**

HEADS UP

Aston Villa's England international, David Platt, heads the ball towards the Banik Ostrava goal as the home side progresses in the 1990–91 UEFA Cup competition.

Date: **19th September, 1990**
Venue: **Villa Park, Birmingham**

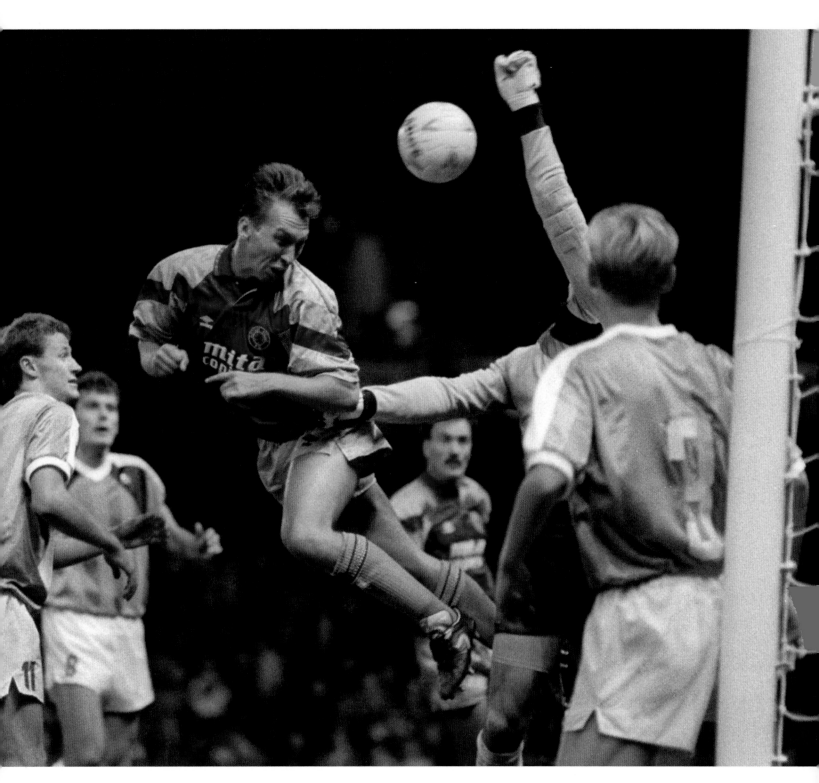

CAMBRIDGE DION

Cambridge United's Dion Dublin in action in a Second Division match against Leicester City. Cambridge finished the season in fifth place – their highest-ever league position – as many clubs struggled with manager John Beck's 'long-ball' style of play.

Date: **9th September, 1991**
Venue: **Abbey Stadium, Cambridge**

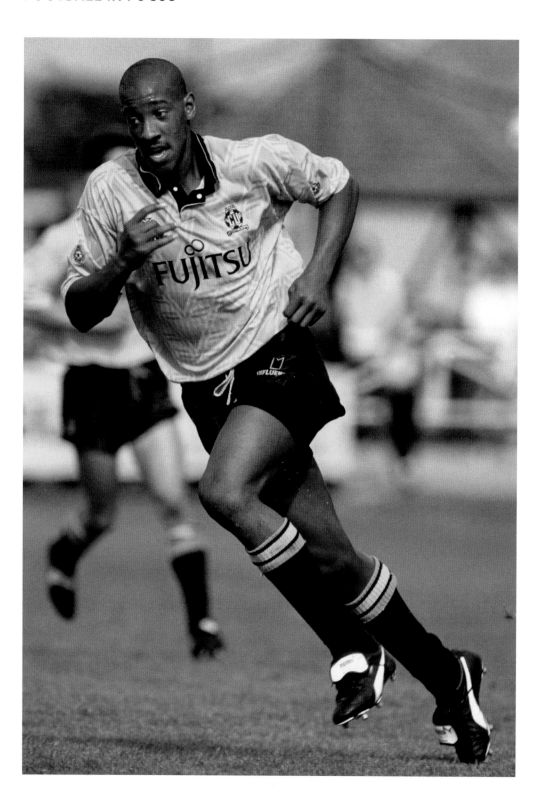

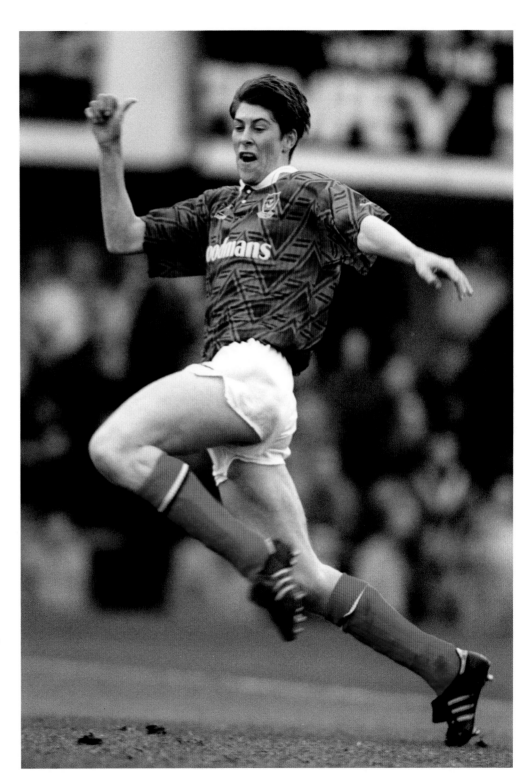

SICKNOTE ON THE RUN

The spindly frame of Portsmouth winger Darren Anderton in an FA Cup fourth round match against Leyton Orient. Pompey went on to take Liverpool to an FA Cup semi-final replay. Dubbed 'Sicknote' due to his numerous injury problems, Anderton left Fratton Park at the end of the season and spent the next 12 years at Tottenham Hotspur.

Date: **25th January, 1992**
Venue: **Fratton Park, Portsmouth**

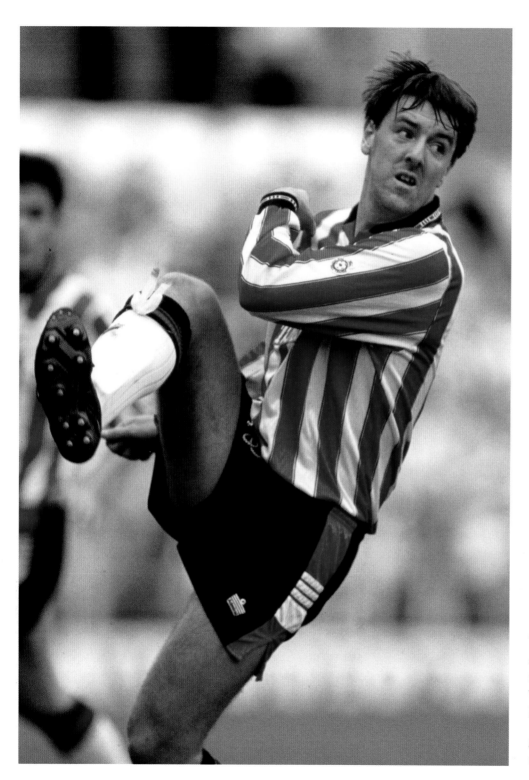

LE GOD

Southampton's Matt Le Tissier, scorer of an entire compendium of amazing goals. 'Le God', as he was referred to by Saints' fans, won PFA Young Player of the Year in 1990, and was at his peak in the mid-1990s, scoring 30 goals from midfield in one season. He is Southampton's second highest goalscorer ever, behind Mick Channon.

Date: **18th April, 1992**
Venue: **The Dell, Southampton**

YOUNG STRIKER

Alan Shearer of Southampton is closely marked by Nigel Pearson of Sheffield Wednesday (R). Carlton Palmer in the background looks on.

Date: **18th April, 1992**
Venue: **The Dell, Southampton**

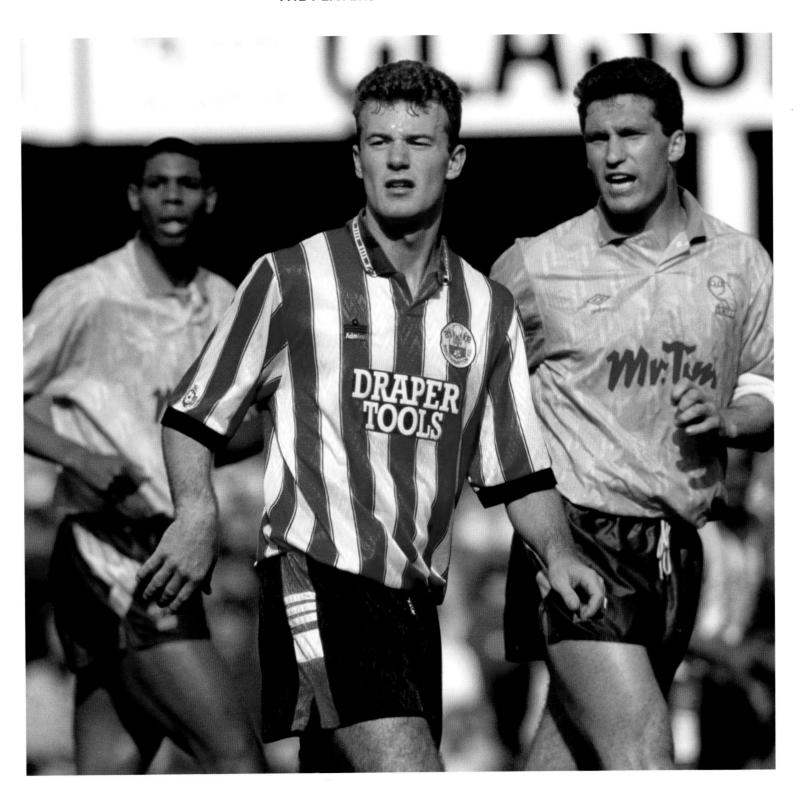

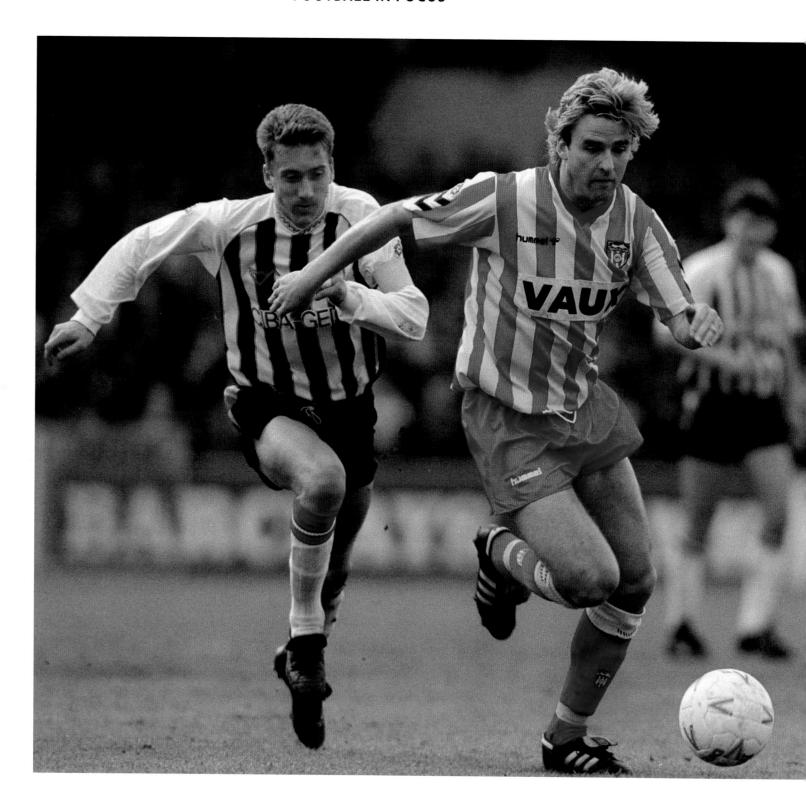

BUDGIE MK II

John Byrne of Sunderland breaks clear of the Grimsby Town defence a month before his side's FA Cup final appearance. Byrne was endeavouring to become the first player since Peter Osgood in 1970 to score in every round of the cup. Sadly, despite an early chance from six yards out, he could not complete the full set at Wembley.

Date: **18th April, 1992**
Venue: **Blundell Park, Cleethorpes**

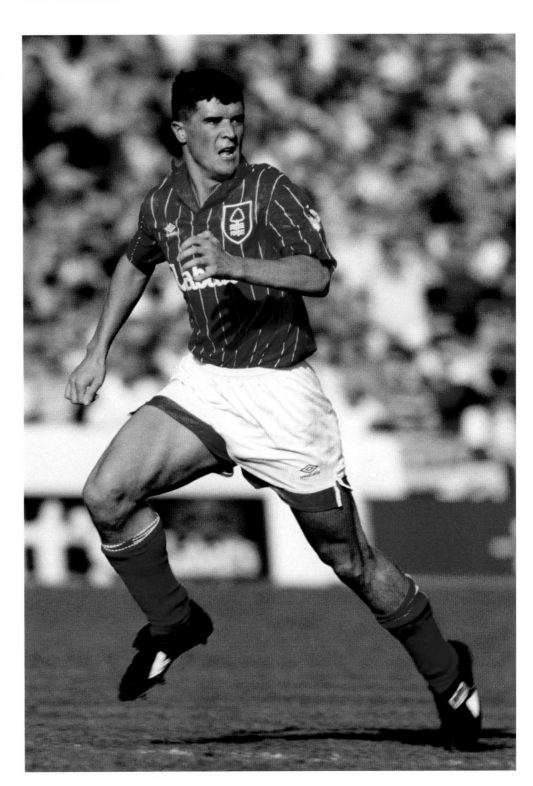

KEANE FOOTBALLER

A focused Roy Keane, a week after his 21st birthday, playing for Nottingham Forest during a 1–0 victory in the newly-formed Premier League against Liverpool.

Date: **16th August, 1992**
Venue: **City Ground, Nottingham**

GLASGOW RAIN-GERS

Rangers goalkeeper Andy Goram contemplates the match against Marseille going on ahead of him in a torrential downpour at Ibrox. This fixture was Rangers' first group match in the newly renamed UEFA Champions League (formerly the European Cup).

Date: **28th November, 1992**
Venue: **Ibrox Stadium, Glasgow**

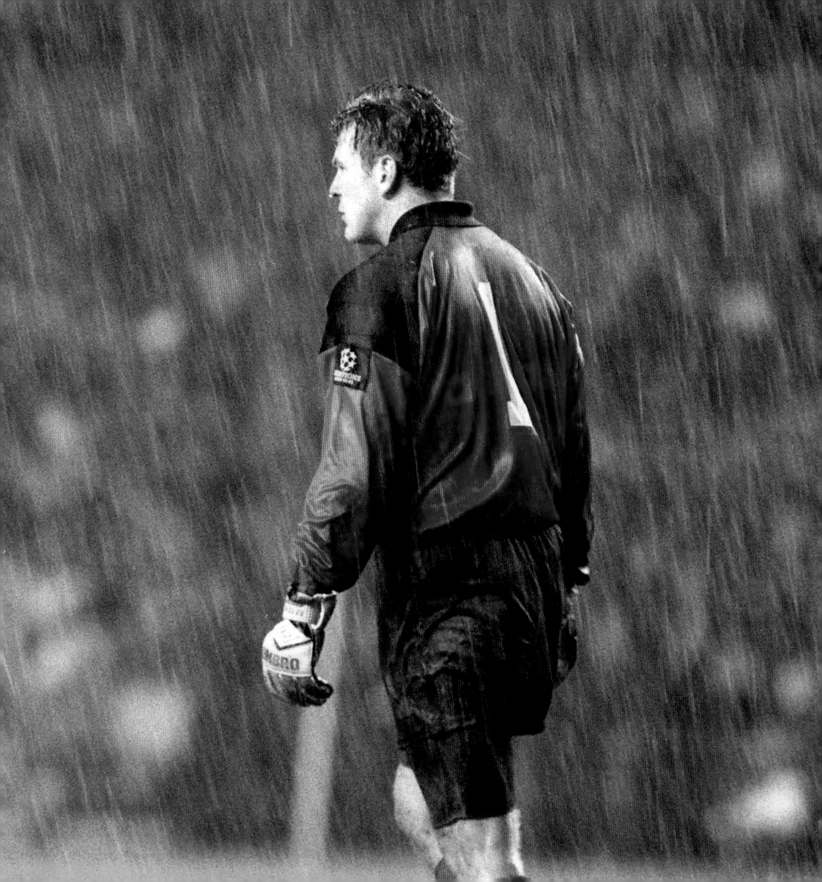

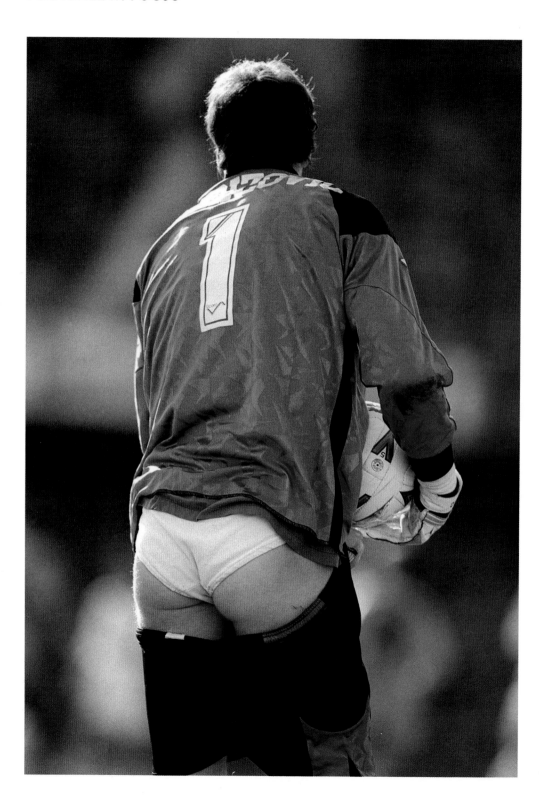

BIG OGGY

Coventry City goalkeeper Steve Ogrizovic suffers the indignity of having his shorts torn during a First Division match with current league title holders Leeds United.

Date: **25th September, 1993**
Venue: **Highfield Road, Coventry**

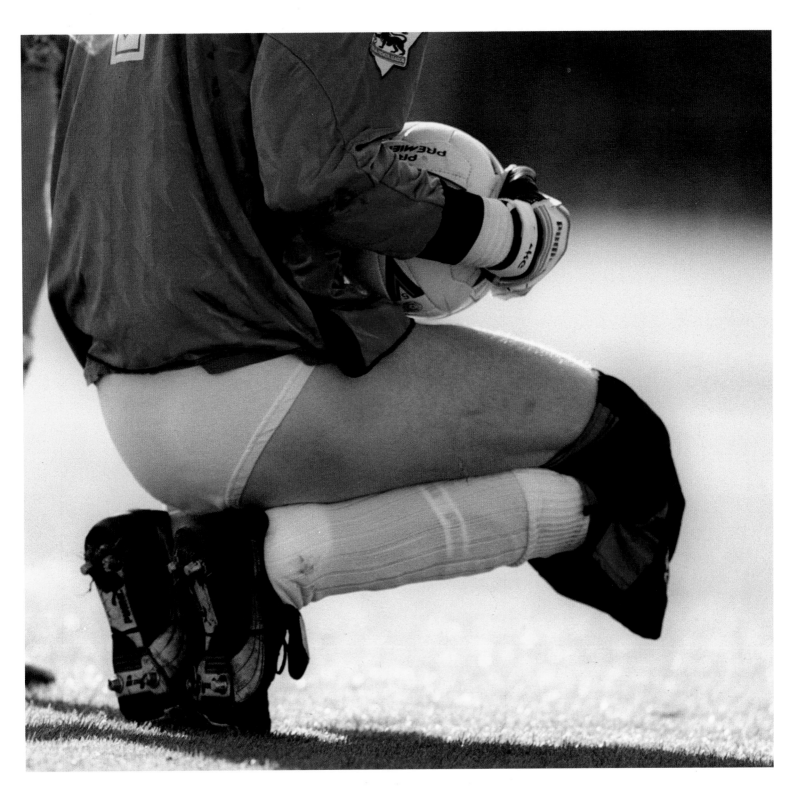

HEAD SPRAY

Aston Villa defender Ugo Ehiogu heads a very wet ball away against opponents Nottingham Forest.

Date: **20th October ,1994**
Venue: **Villa Park, Birmingham**

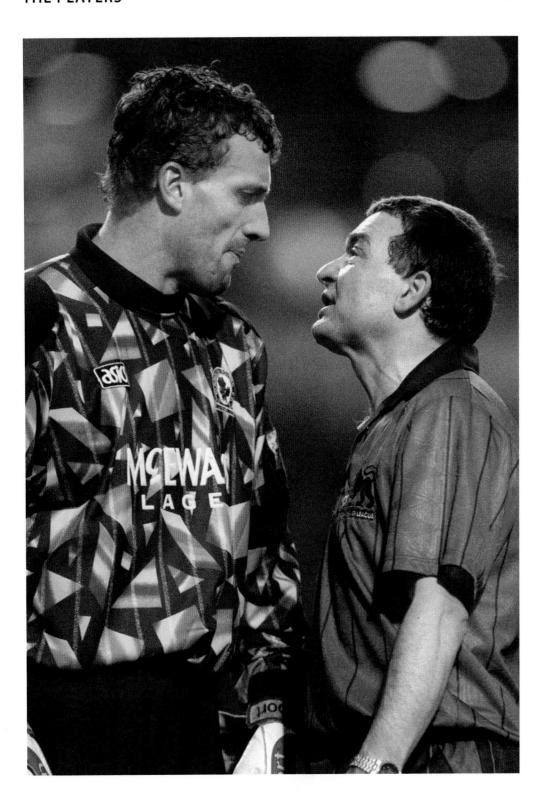

TALL TIM

Blackburn Rovers goalkeeper Tim Flowers towers over referee Joe Worrall as he receives a lecture from the man in charge during a Premiership clash with Nottingham Forest. Flowers was smiling in the end as he kept a clean sheet and Rovers won 3–0.

Date: **14th January, 1995**
Venue: **Ewood Park, Blackburn**

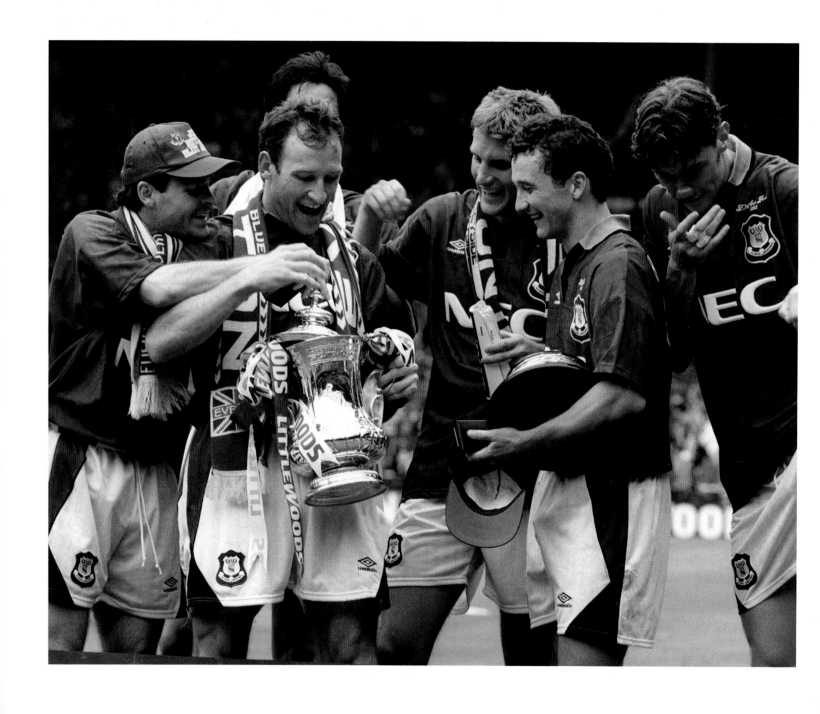

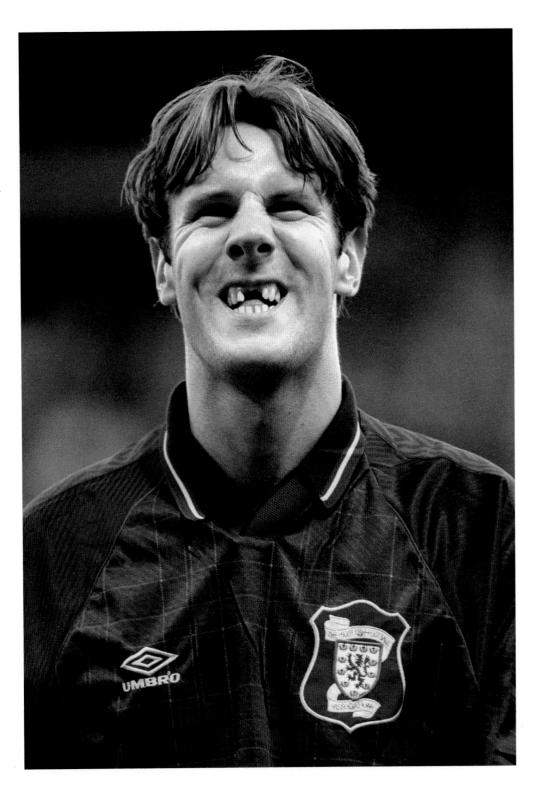

TOFFEE NOSE

Dave Watson holds the FA Cup for Everton after their 1–0 win over Manchester United. Paul Rideout's 30th-minute headed goal was enough to send the blue half of Merseyside home happy. Note Duncan Ferguson's blue nose.

Date: **20th May, 1995**
Venue: **Wembley Stadium, London**

BURLEY GAP

Scotland midfielder Craig Burley displays his missing front teeth in a European Championship qualifying match against Greece at Hampden Park. Hard to tell if it's a smile or a grimace – probably the former as Scotland won 1–0.

Date: **16th August, 1995**
Venue: **Hampden Park, Glasgow**

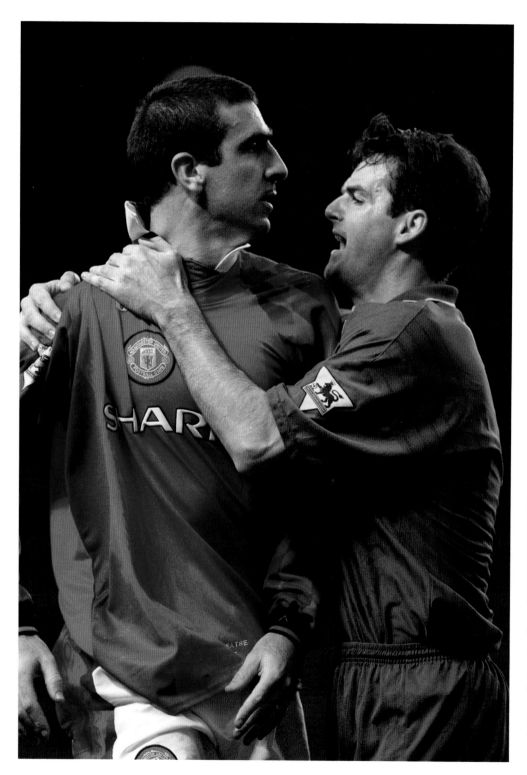

TENSIONS RISING

Chelsea's Steve Clarke tries to calm Manchester United's talented yet tempestuous Eric Cantona.

Date: **2nd November, 1996**
Venue: **Old Trafford, Manchester**

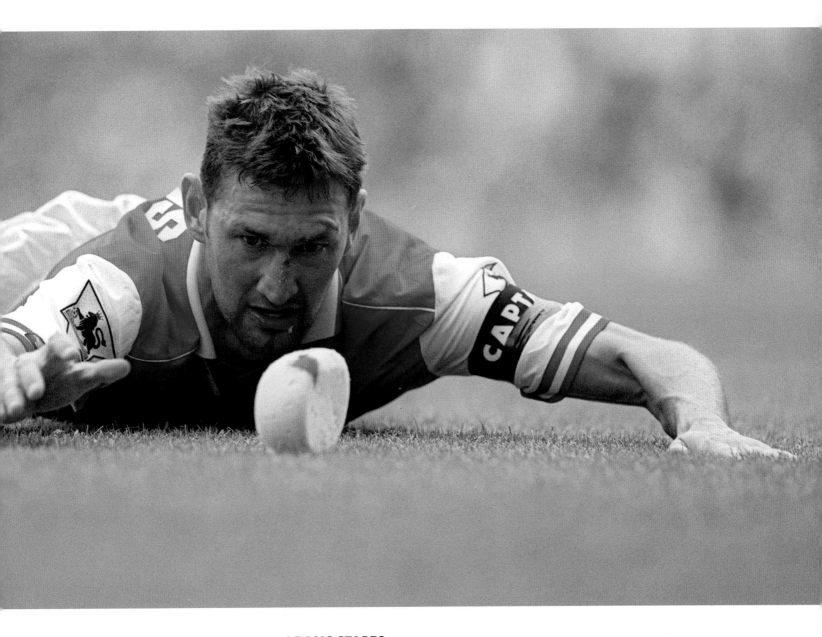

ADAMS STARES
Arsenal captain Tony Adams, flat out on his stomach, stares in bewilderment at the blood-stained sponge he has been holding to nurse a head wound.

Date: **3rd May, 1997**
Venue: **Highbury, London**

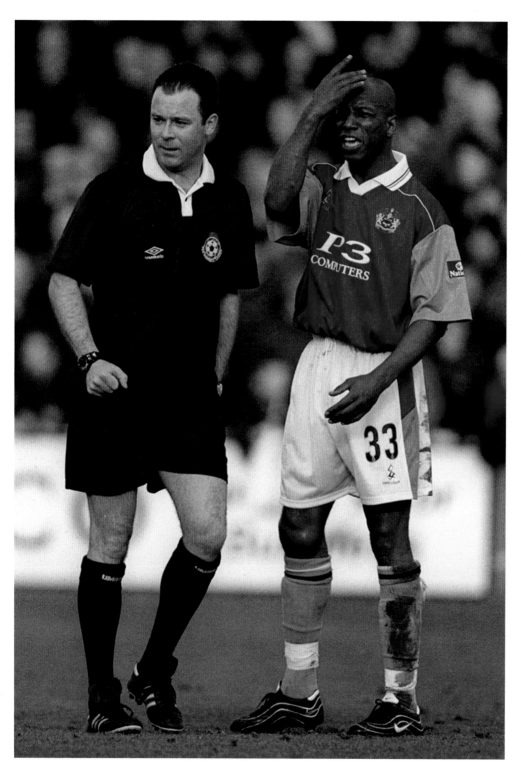

WRIGHT OFFERS HIS ADVICE

Ian Wright, playing for Burnley against Colchester United in Division 2, gives – not for the first time – some advice to a match official. In this instance, the recipient is future Premier League referee Rob Styles.

Date: **26th February, 2000**
Venue: **Layer Road, Colchester**

LINO AND DI CANIO

Linesman Roy Burton looks terrified as West Ham United's Paolo Di Canio reaches over to kiss him on the forehead during a Premiership clash with Coventry City. The Hammers fans look on approvingly.

Date: **22nd April, 2000**
Venue: **Boleyn Ground, London**

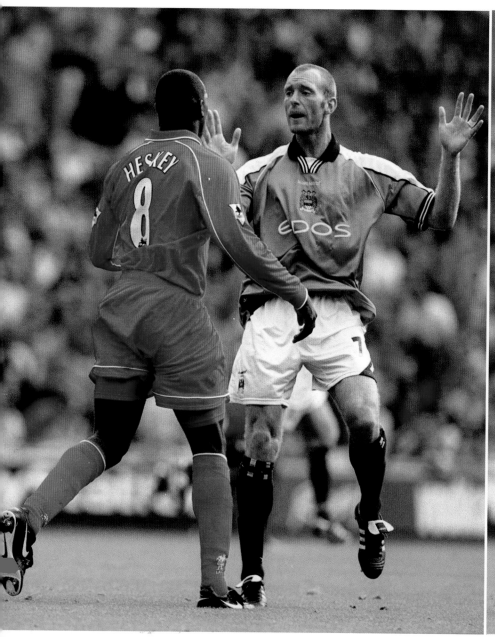
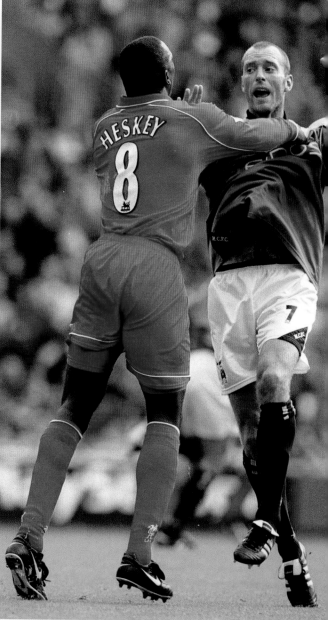

CLASH OF THE GIANTS

Liverpool's colossal centre-forward Emile Heskey and Manchester City's not-insignificantly-sized Spencer Prior indulge in a little handbags-at-dawn tomfoolery before calming down, making up and bursting out laughing.

Date: **9th September, 2000**
Venue: **Anfield, Liverpool**

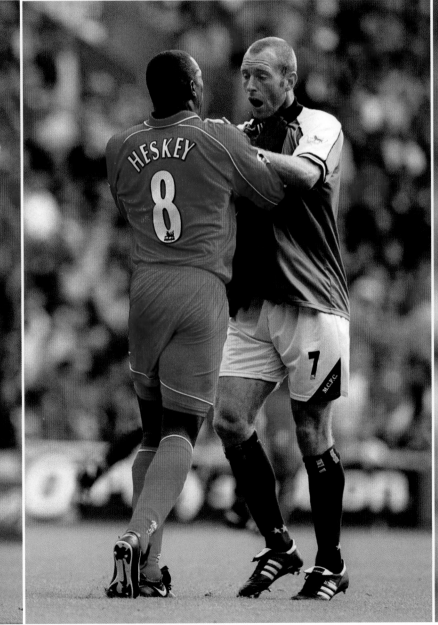
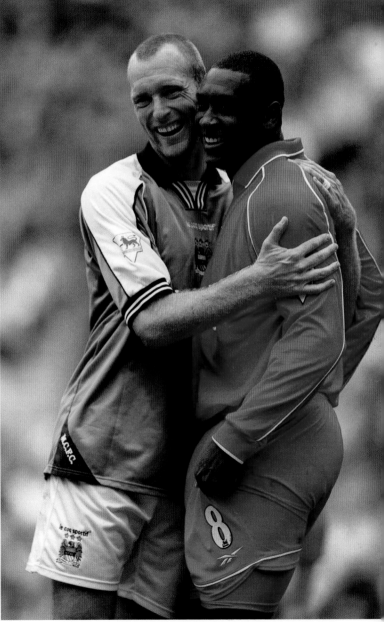

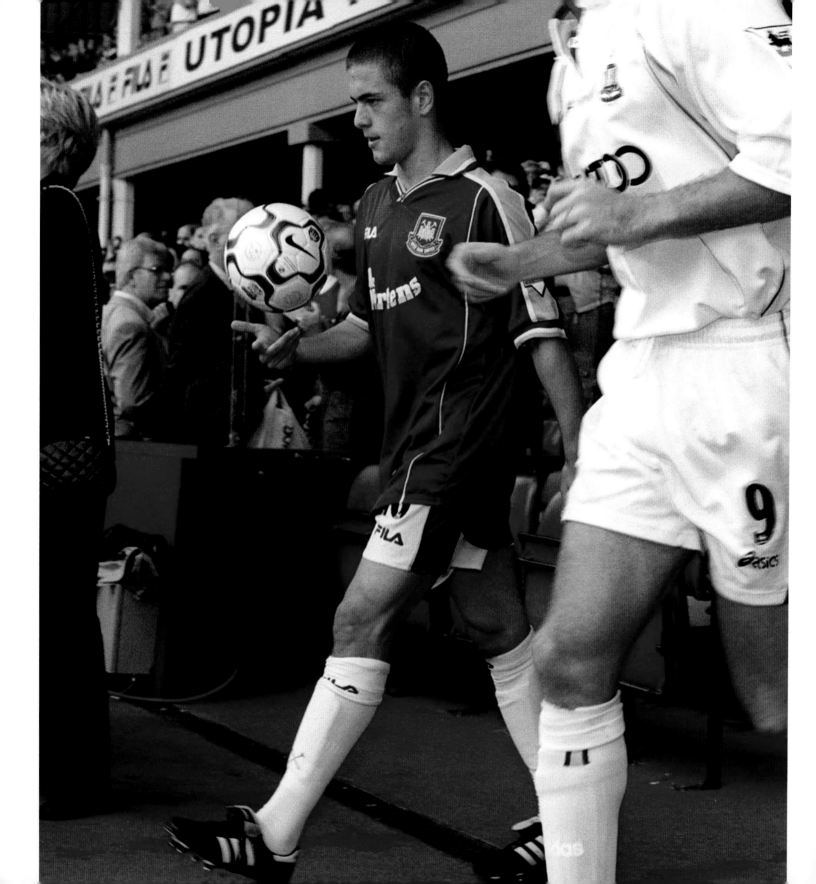

TEENAGER JOE

An 18-year-old Joe Cole of West Ham United marches proudly onto the field against Bradford City, before a Premiership League game that finished 1–1.

Date: **30th September, 2000**
Venue: **Boleyn Ground, London**

POYET-RY IN MOTION

Tottenham Hotspur's Uruguayan international midfielder Gus Poyet outmuscles Manchester United's centreforward Andrew Cole for the ball. Poyet had spent the first half of his career in France and Spain before moving to London to join Chelsea and subsequently on to Spurs.

Date: **29th September, 2001**
Venue: **Boleyn Ground, London**

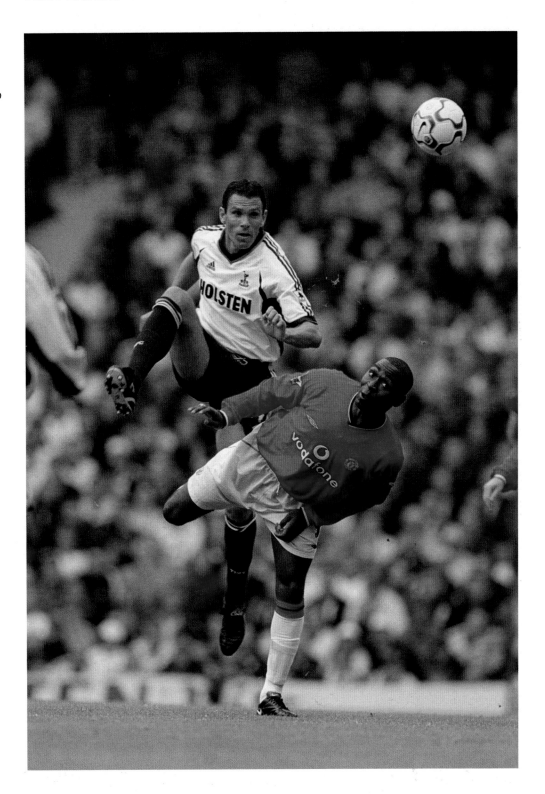

ENGLAND 1 SWEDEN 0

Two celebrations of the same goal. Right, Sol Campbell (No 6) celebrates heading England into the lead against Sweden in the 2002 World Cup. Rio Ferdinand (No 5) is chasing him. Meanwhile, David Beckham, below, who delivered the inch-perfect corner, drops onto one knee in unrestrained glory.

Date: **2nd June, 2002**
Venue: **Saitama, Japan**

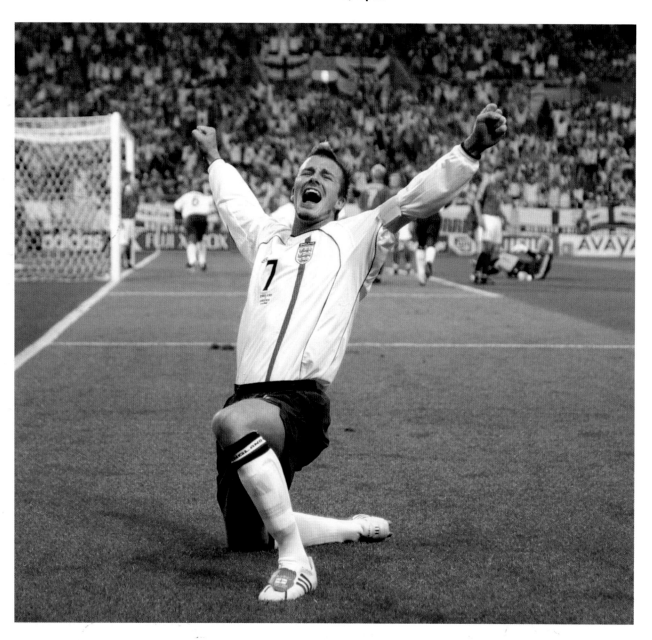

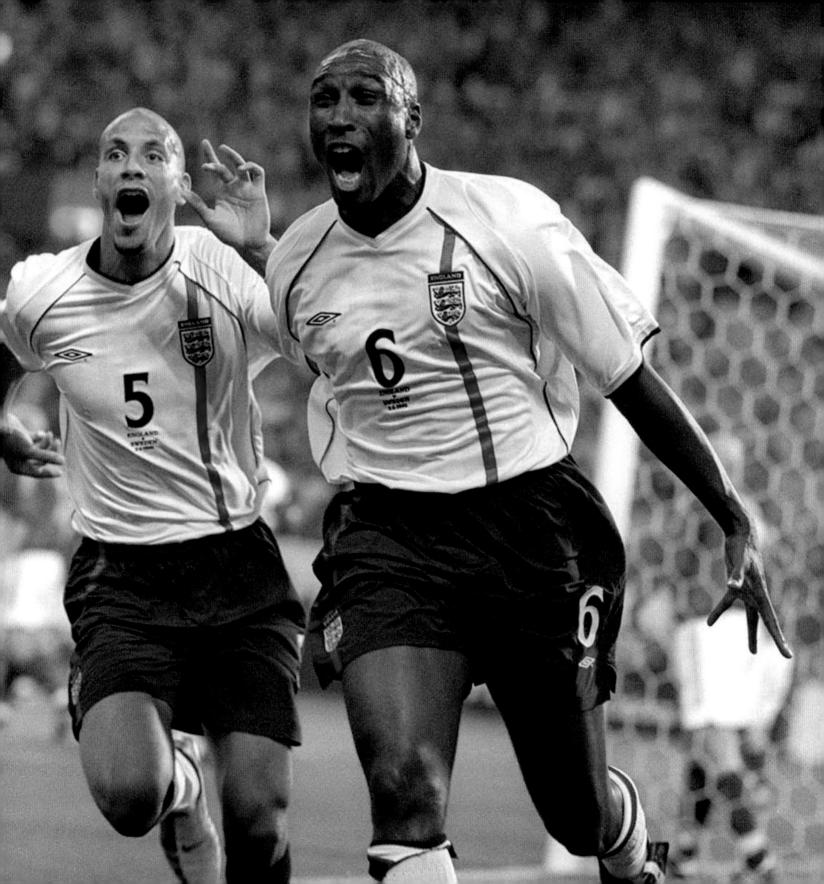

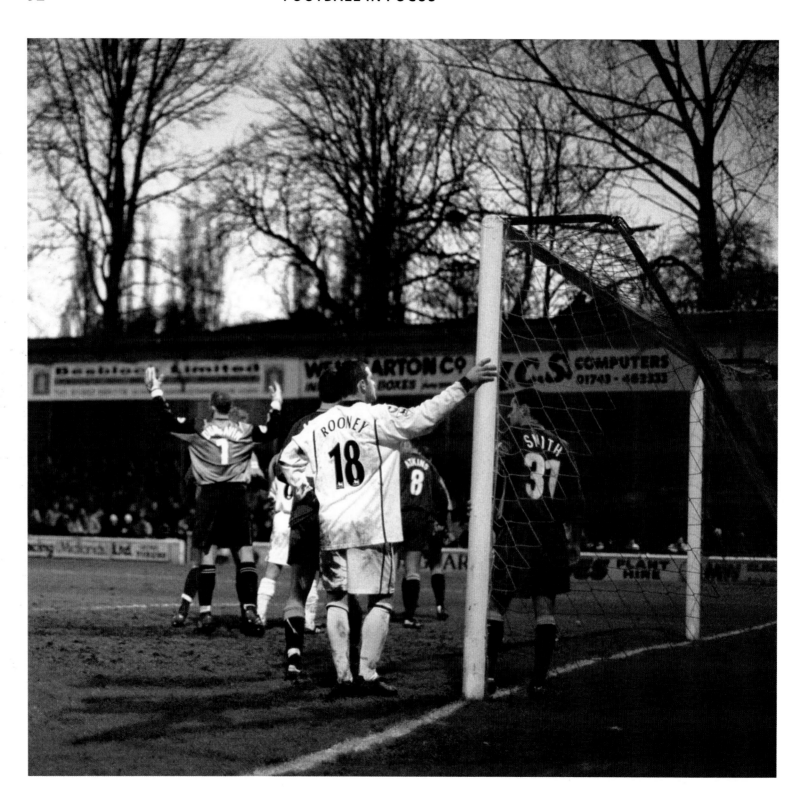

JUNIOR ROONEY

Seventeen-year-old Wayne Rooney of Everton hangs on to the post, while waiting for a corner. This match produced one of the huge FA Cup shocks, as Shrewsbury Town, 18th in the fourth tier of English football, knocked out Everton, fifth in the Premiership, by two goals to one.

Date: **4th January, 2003**
Venue: **Gay Meadow, Shrewsbury**

THIERRY TERROR

Arsenal's Thierry Henry carries the ball after scoring, as his side recovers from 3–2 down to win 5–3 against Middlesbrough. Henry, France's all-time leading international goalscorer, controversially handled the ball before scoring against Ireland in a World Cup qualifying play off in 2009.

Date: **28th August, 2004**
Venue: **Highbury, London**

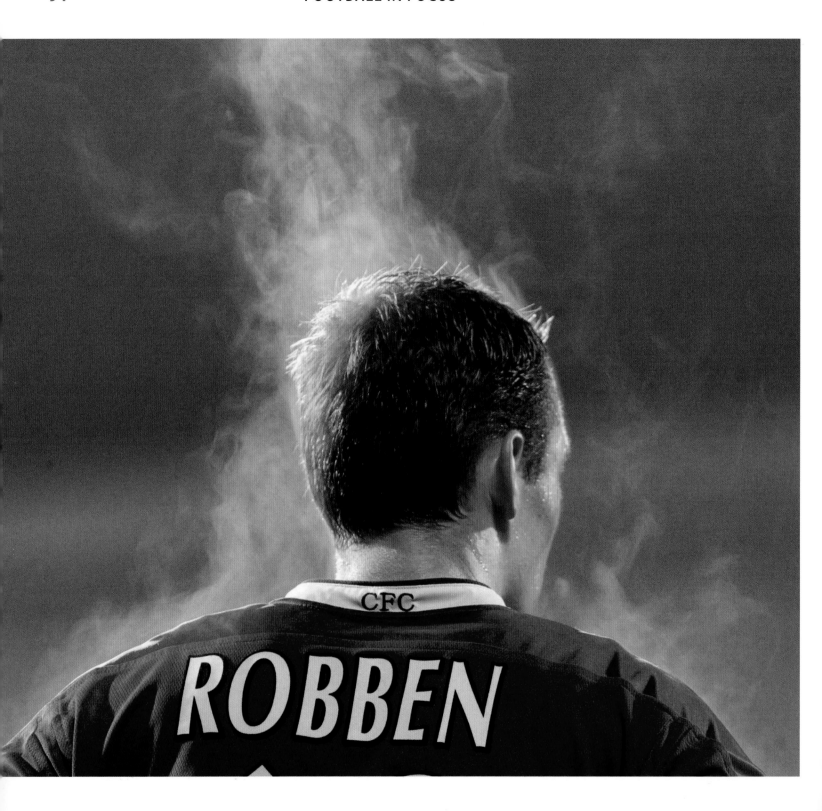

HEAD OF STEAM
Chelsea's Dutch winger Arjen Robben lets off steam during a cold west London League Cup quarter-final tie with neighbours Fulham.

Date: **30th November, 2004**
Venue: **Craven Cottage, London**

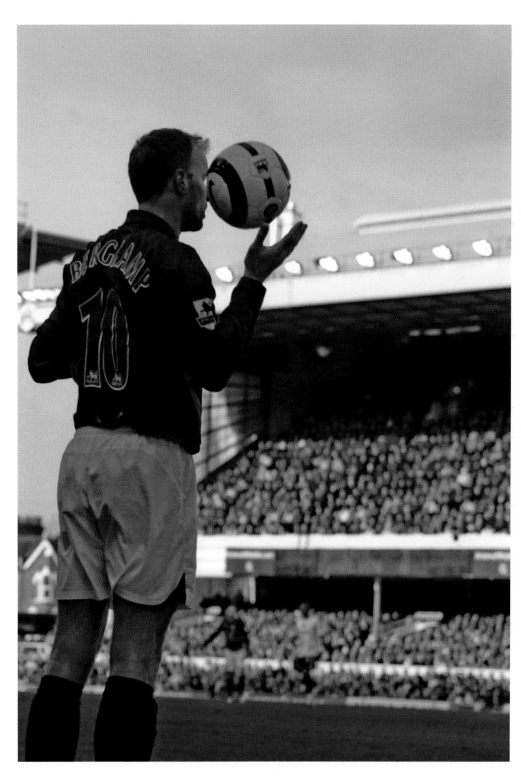

EYE ON THE BALL
One of Arsenal's greatest and most popular players, Dennis Bergkamp, waits to take a throw-in against Charlton Athletic during one of the last-ever matches at Highbury.

Date: **18th March, 2006**
Venue: **Highbury, London**

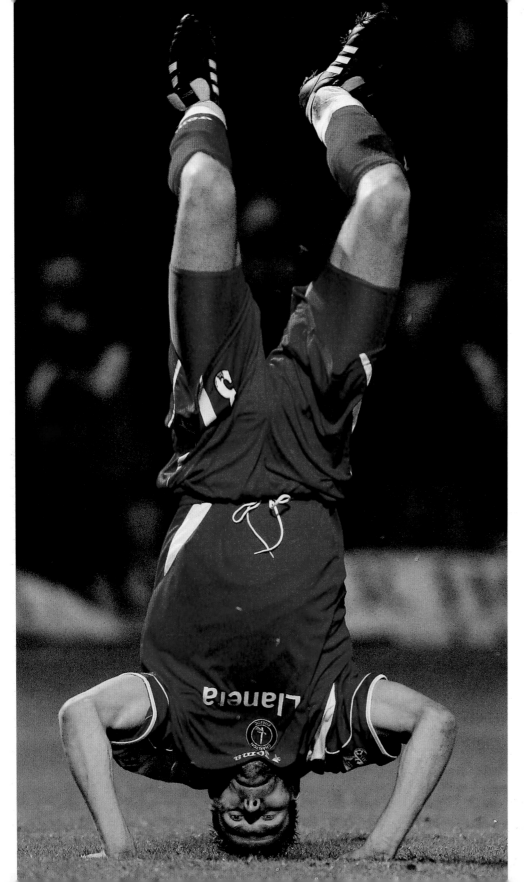

UPSIDE DOWN

Charlton Athletic's Hermann Hreidarsson celebrates scoring his winning penalty against Chesterfield in the Carling Cup with a spectacular somersault.

Date: **7th November, 2006**
Venue: **Saltergate, Chesterfield**

DEEP IN THOUGHT

Newcastle United and Republic of Ireland goalkeeper Shay Given indulges in a spot of meditation as he hangs from the crossbar during a Premiership match with Manchester United. The match was to finish 2–2. Given left Newcastle 18 months later to join Manchester City.

Date: **1st January, 2007**
Venue: **St James' Park, Newcastle**

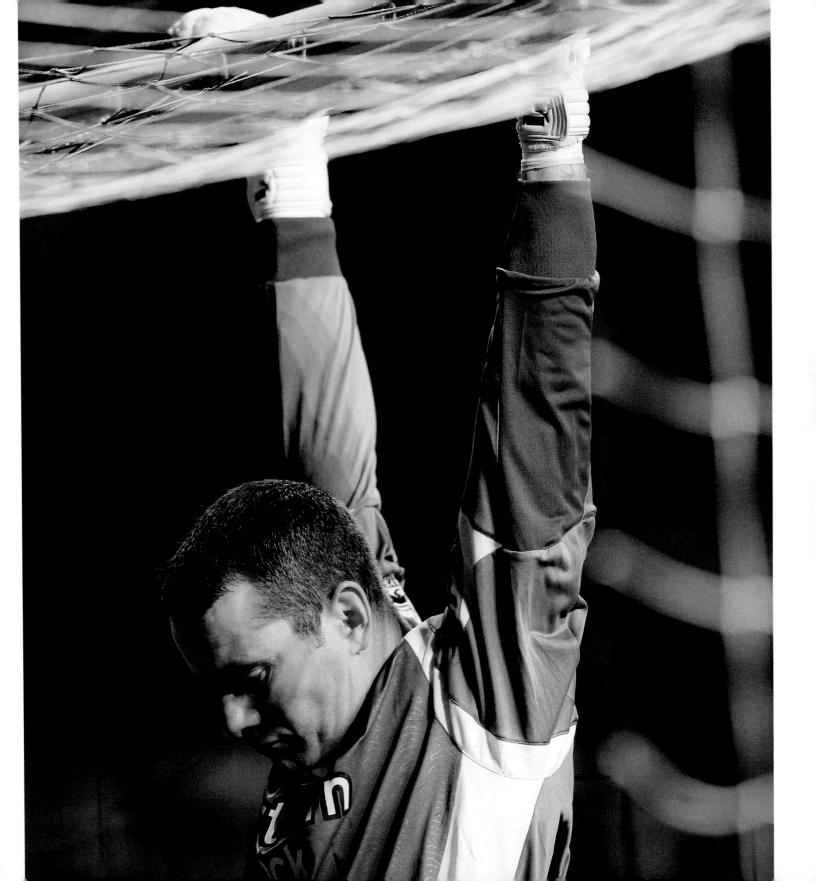

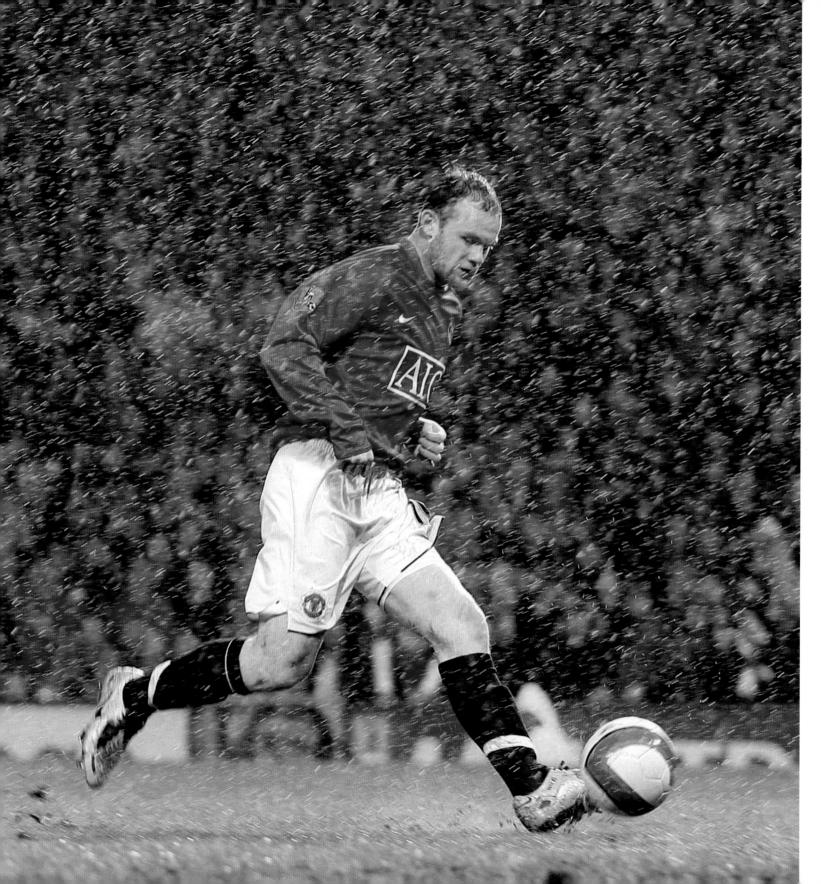

ROONEY RAINS SUPREME

Wayne Rooney on the ball in the driving rain in Manchester (there's a surprise), seen here scoring the third of Manchester United's four unanswered goals against Aston Villa.

Date: **29th March, 2008**
Venue: **Old Trafford, Manchester**

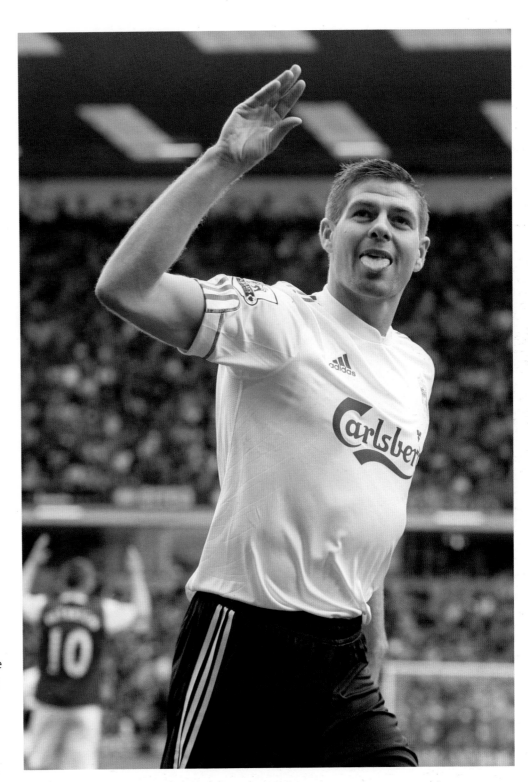

GERRARD SALUTE

Liverpool captain Steve Gerrard salutes the travelling support as he celebrates scoring the first of Liverpool's four goals against struggling Burnley.

ww **25th April, 2010**
Venue: **Turf Moor, Burnley**

2 THE MANAGERS

The gaffer – the man at the centre of everything – caught somewhere in the middle of a football club's hierarchy. He has complete control over and responsibility for his players – he was probably one once (and probably still wishes he was).

Meanwhile, he's obliged listen to the instructions and dictates of the directors, who many feel know little about running a football team. And he must also take plaudits and abuse in equal measure from the frequently fickle fans.

Who'd be a manager?

HOWARD'S WAY
Everton manager Howard Kendall celebrates his side's second League Championship in three seasons after their 1–0 win over Norwich City. With a week to spare, Everton are uncatchable and win the title by nine points from rivals Liverpool.

Date: **4th May, 1987**
Venue: **Carrow Road, Norwich**

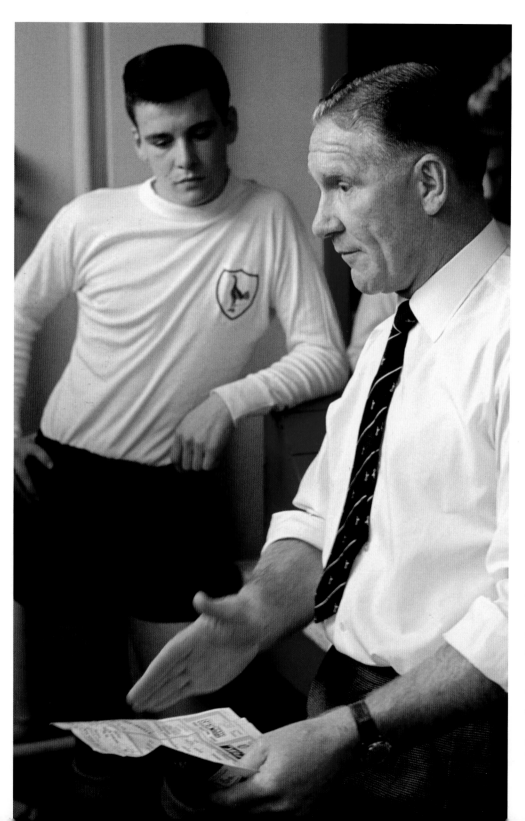

TOP OF THE BILL

Cyril Knowles (L) listens intently to a team talk from Tottenham Hotspur manager Bill Nicholson before the First Division clash with Manchester United.

Date: **26th September, 1964**
Venue: **Old Trafford, Manchester**

TEA WITH SHANKLY

The great Bill Shankly takes a cup of tea with some local Liverpudlians, having watched them play a street game from a flat above Eldon Grove. The Dockside kids beat a team from Everton 7–1. Shankly commented, *"It's not like Cologne or Brussels, but then there's no place like Eldon Grove".]*

Date: **1960s**
Venue: **Eldon Grove, Liverpool**

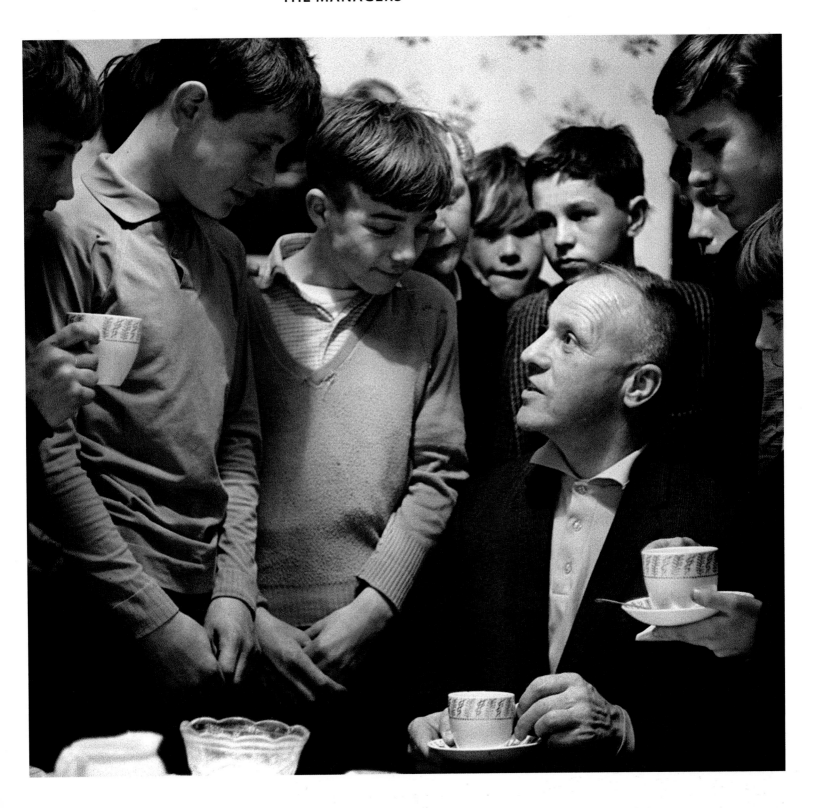

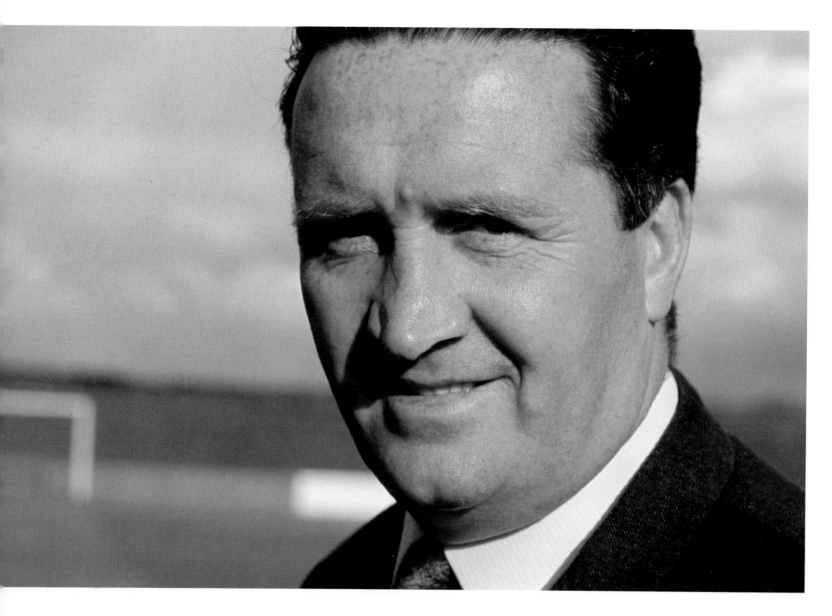

SCOTLAND LEGEND

Celtic manager Jock Stein. Stein had had a brief tenure in charge of Scotland before joining Celtic in 1965. He led the Bhoys to nine successive league championships and, significantly, to victory in the 1967 European Cup final – it was the first time a British club had achieved the feat. He died in 1985, minutes after guiding Scotland to a 1–1 draw with Wales and a play-off berth against Australia (which the Scots subsequently won) during qualification for the 1986 World Cup.

Date: **3rd August, 1967**
Venue: **Glasgow**

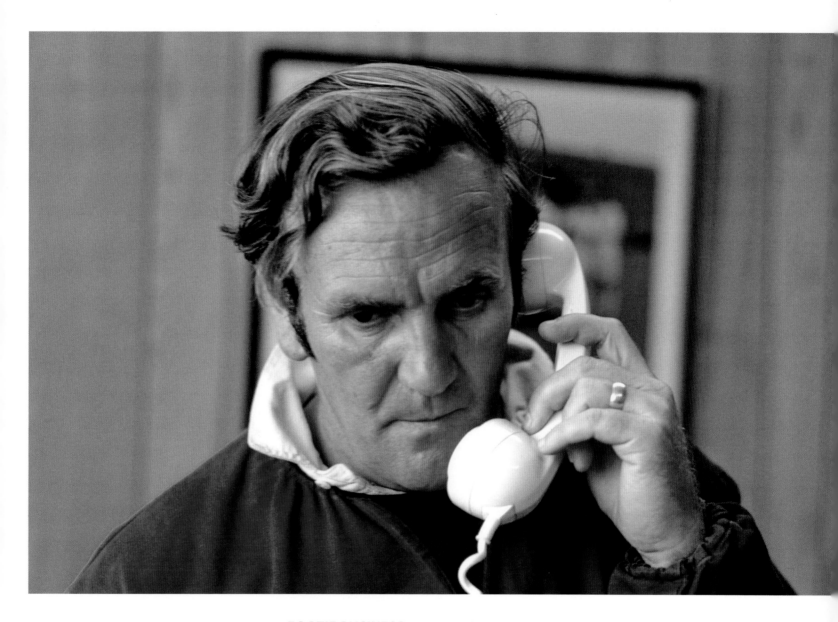

FOOTIE BUSINESS

Leeds United manager Don Revie talks in his office at Elland Road. Revie won eight trophies with Leeds during his 13 seasons as manager, including two league titles, before becoming England manager for three years.

Date: **31st July, 1972**
Venue: **Elland Road, Leeds**

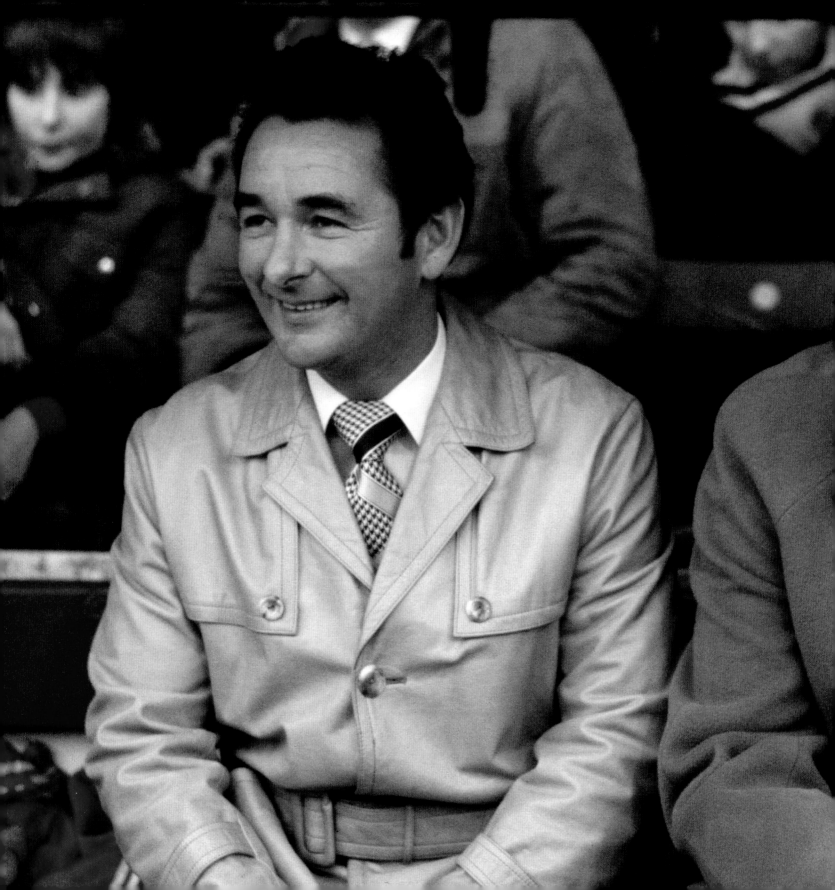

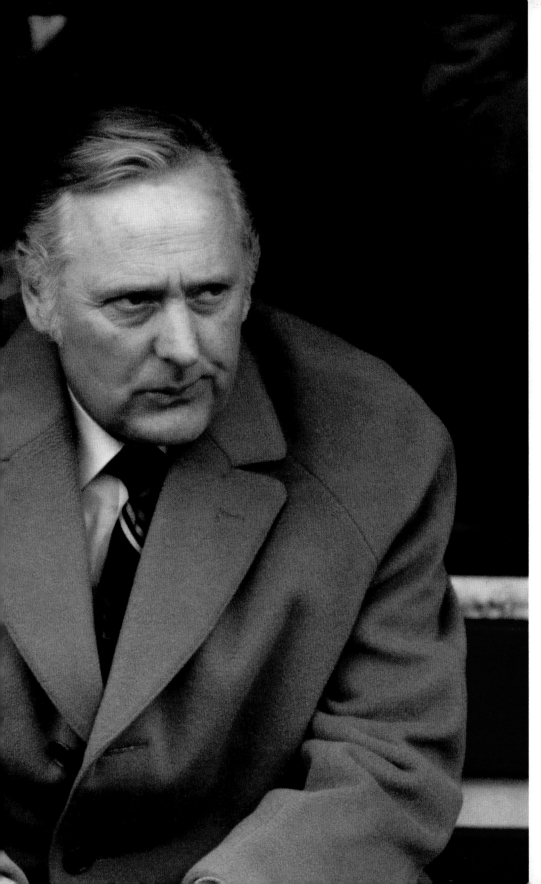

THE GREAT DOUBLE ACT

Brian Clough (L) and his assistant Peter Taylor – both at their most successful when working together – take their places in the Nottingham Forest dugout against Leeds United. Forest lost this match, but went on to win their first league title.

Date: **17th November, 1977**
Venue: **Elland Road, Leeds**

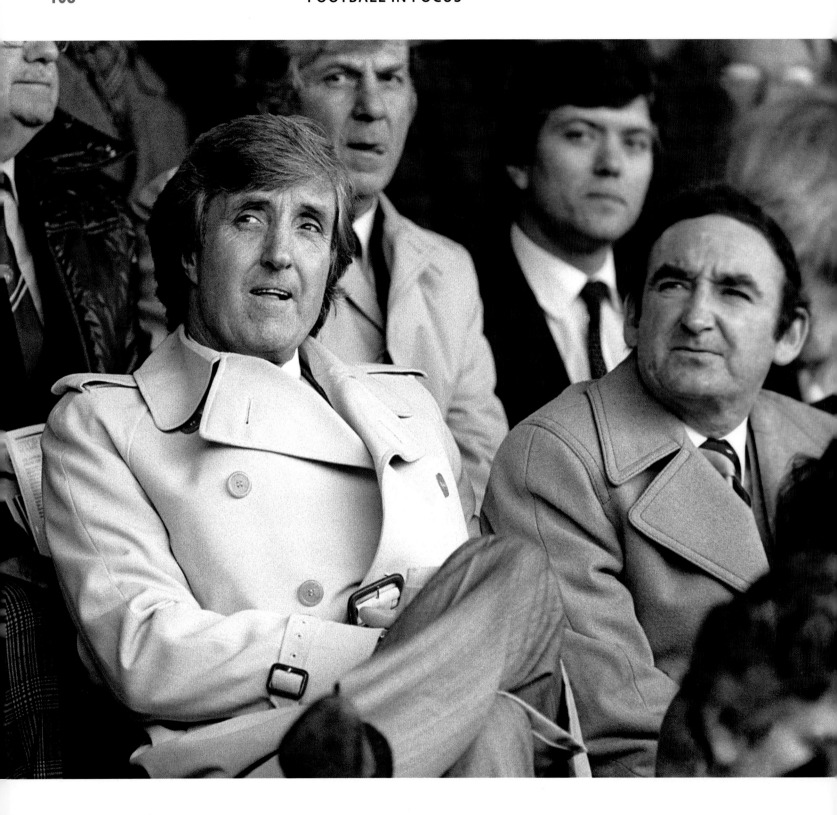

MY NAME IS BOND

Manchester City manager John Bond (L) sits with his chairman Peter Swales (rather than in the dugout) for a First Division match at his former club, Norwich City. The following month, they would be at Wembley for the FA Cup Final against Tottenham Hotspur. Bond had previously cut his managerial teeth at AFC Bournemouth, guiding them to promotion from the Fourth Division in 1971, and third place in the Third Division behind Aston Villa and Brighton & Hove Albion the following year.

Date: **4th April, 1981**
Venue: **Carrow Road, Norwich**

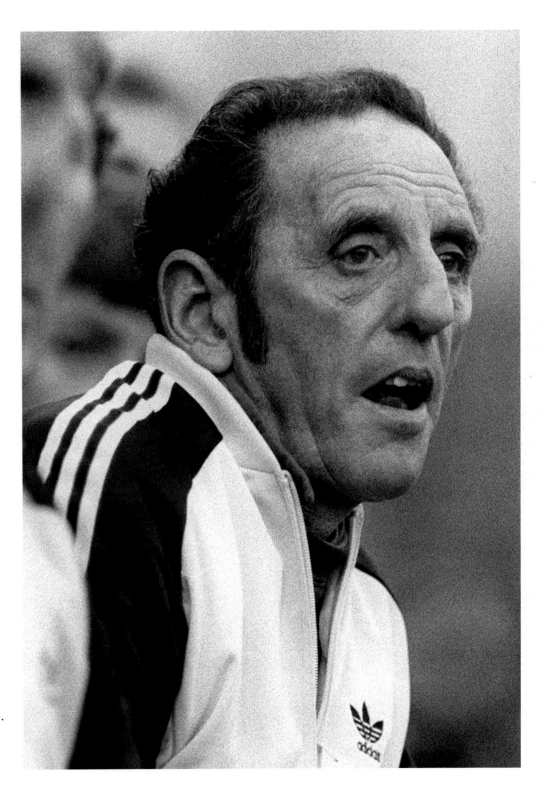

NICE ONE SIRREL

Notts County manager Jimmy Sirrel watches his team in action against West Ham United. Sirrel had two spells at Notts County, the first from 1969–75 during which he led them to the Fourth Division title and promotion from the Third to the Second. His later tenure (1978–82) saw the club promoted to the First Division in 1981.

Date: **24th October, 1981**
Venue: **Meadow Lane, Nottingham**

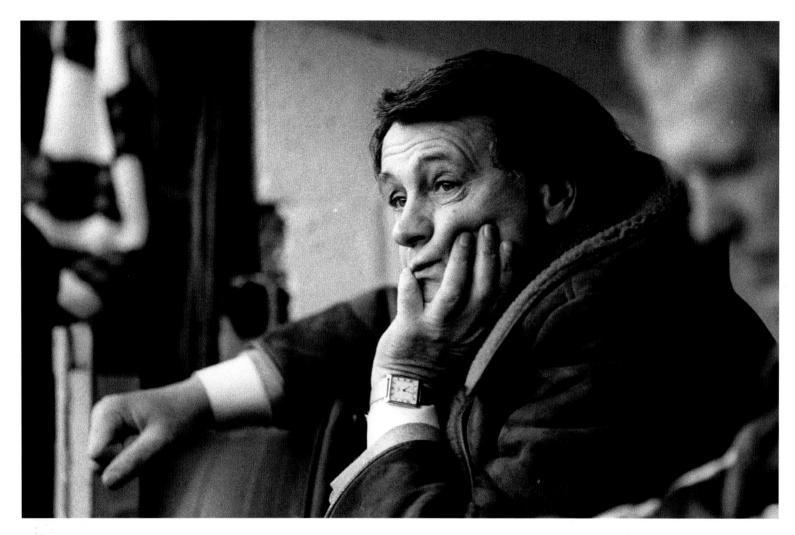

ROBSON LOOKS ON

Ipswich Town manager Bobby Robson looks on apprehensively from the dugout during his last season in charge at Portman Road, during a match against Luton Town.

Date: **23rd January, 1982**
Venue: **Kenilworth Road, Luton**

LIVERPOOL GIANT

The step up Bob Paisley made from the Liverpool backroom ensured smooth continuity after the success of predecessor Bill Shankly. Paisley's greatest moment arguably came in Rome in 1977, where Liverpool won the European Cup for the first time against Borussia Mönchengladbach.

Date: **18th September, 1982**
Venue: **Vetch Field, Swansea**

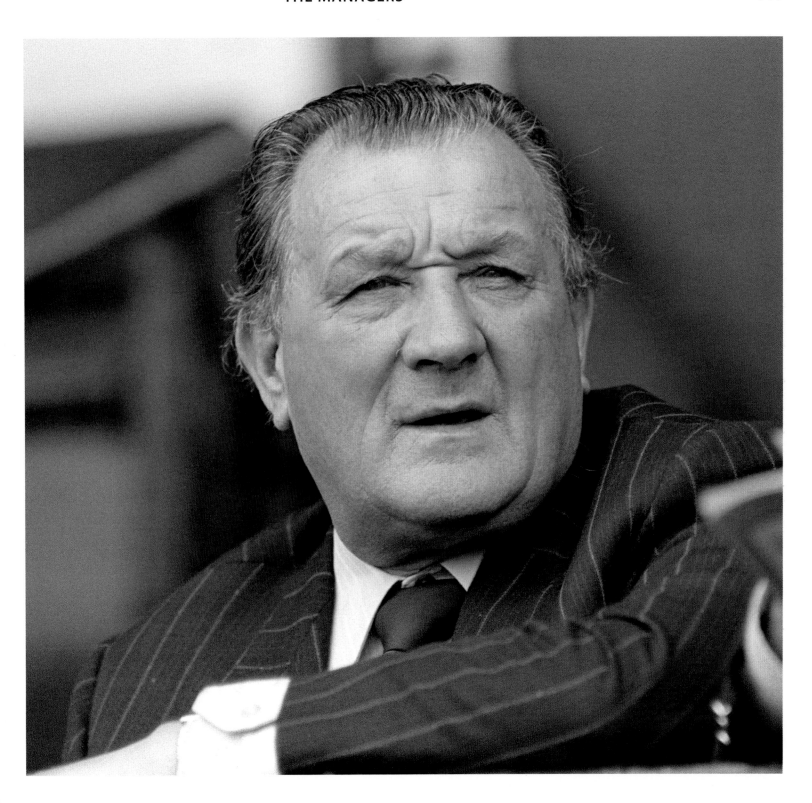

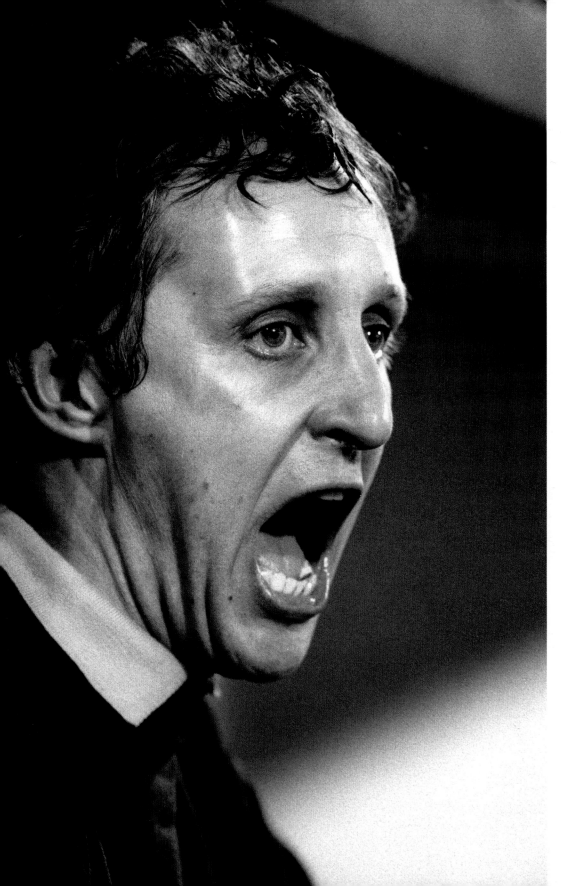

CATT CALLS

Brighton & Hove Albion manager Chris Cattlin bawls from the dugout during a fiercely-contested 1–1 draw with Crystal Palace. The former Huddersfield Town and Coventry City defender once famously fined himself for one of his team's poor performances.

Date: **2nd April, 1985**
Venue: **Selhurst Park, London**

HAIRDRYER TREATMENT

Manchester United's Alex Ferguson – never backwards in coming forwards – in only his second season at Old Trafford shows how to really bawl at his team during a First Division match with Luton Town.

Date: **3rd October, 1987**
Venue: **Kenilworth Road, Luton**

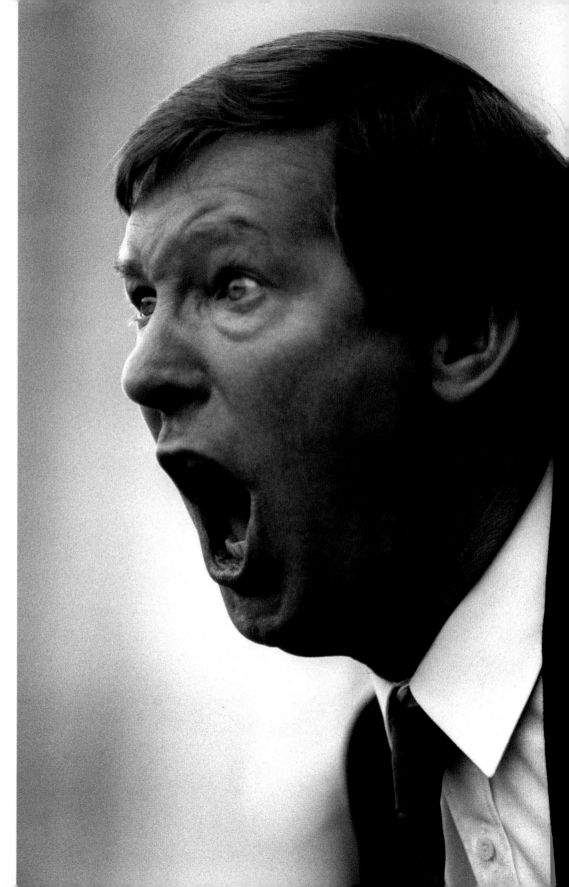

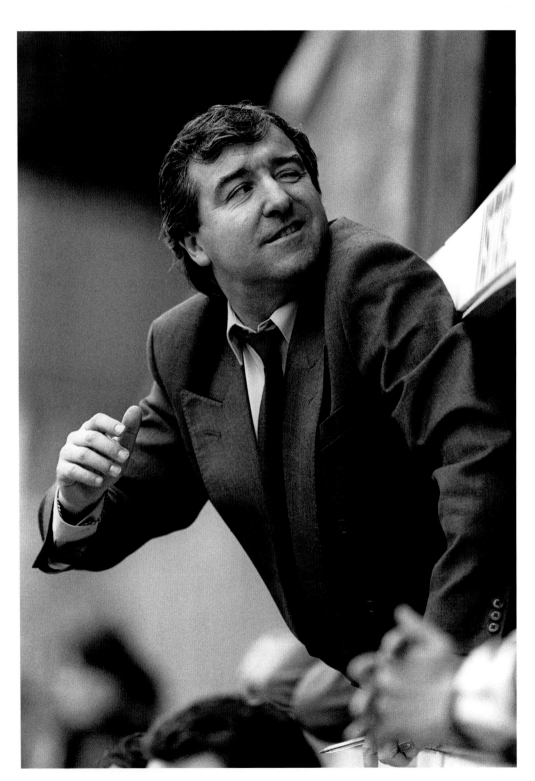

EL TEL

Author, businessman, cabaret artist and raconteur, as well as Tottenham Hotspur manager, Terry Venables gives a cheeky wink to some Spurs fans behind him as their side records a 5–0 win over Millwall. Venables won the Second Division title with QPR in 1983, before acquiring the sobriquet 'El Tel' upon moving to Catalan giants Barcelona a year later.

Date: **29th April, 1989**
Venue: **The Den, London**

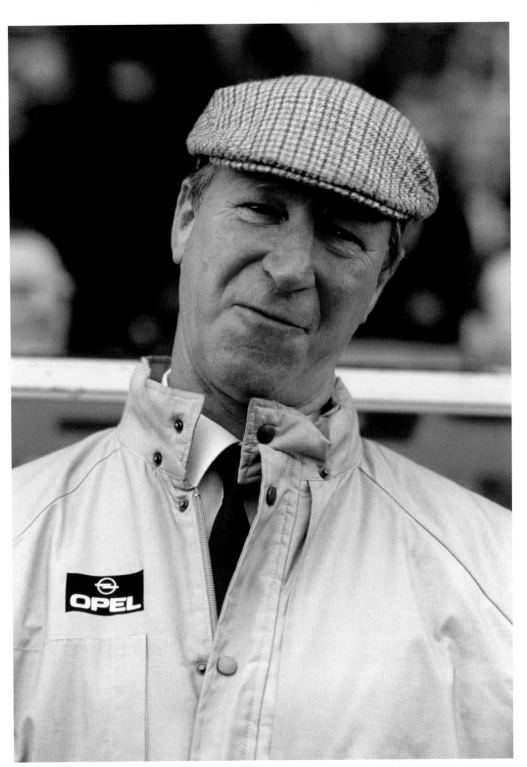

OUR JACK
Republic of Ireland boss Jack Charlton, a manager who took his charges to a European Championship finals and a World Cup quarter-final, exchanges pleasantries with the cameraman during an international with Northern Ireland.

Date: **11th October, 1989**
Venue: **Lansdowne Road, Dublin**

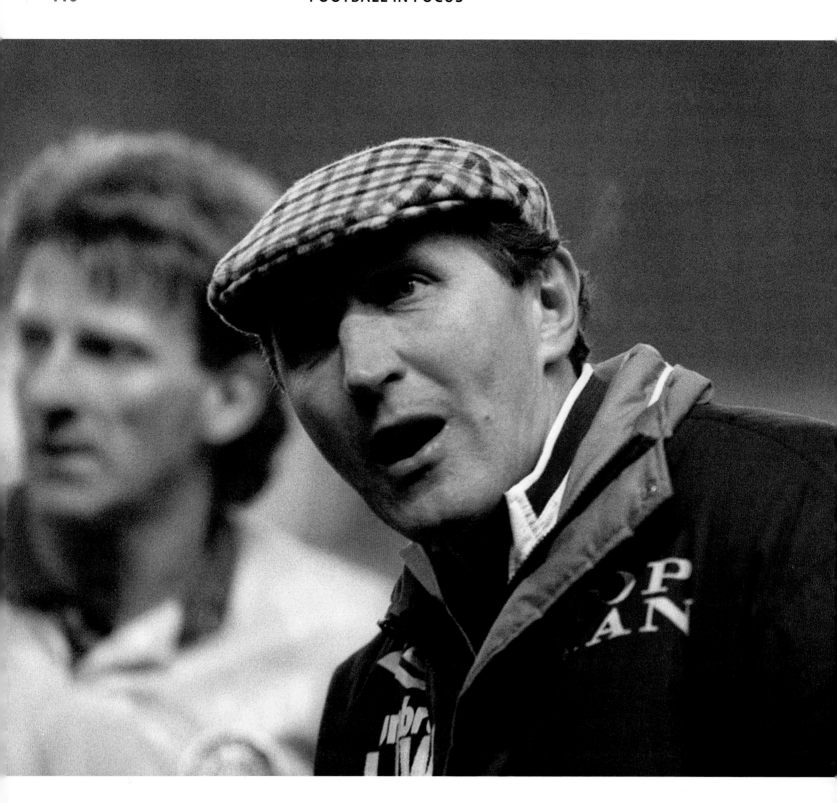

WILKINSON'S WORD

Leeds United manager Howard Wilkinson talks to his team before extra-time in an FA Cup match against Arsenal. The former Sheffield Wednesday and Brighton winger won the league with Leeds in 1992 – he is the last (as of 2010) English manager to take top honours in the highest tier of domestic football. Famous for his dour demeanour, Wilkinson was quoted as saying that if he were ever to be reincarnated, he'd like to come back as a personality.

Date: **27th January, 1991**
Venue: **Highbury, London**

MANCHESTER UNITED LEGEND

Sir Matt Busby – Manchester United manager for a quarter of a century – enjoys the ovation of the crowd as he steps onto the Old Trafford turf at his own testimonial match between United and an Ireland XI.

Date: **11th August, 1991**
Venue: **Old Trafford, Manchester**

MANAGEMENT CREWE

Milan-born Crewe Alexandra manager Dario Gradi issues instructions to his team against Wycombe Wanderers.

Date: **12th August, 1995**
Venue: **Adams Park, High Wycombe**

COME ON YOU FOXES

A hirsute Leicester City manager Martin O'Neill yells to his team in a Premiership match against Chelsea, won by the Londoners 3–1. O'Neill took Leicester to two League Cup trophies during his tenure at Filbert Street.

Date: **12th October, 1996**
Venue: **Filbert Street, Leicester**

WHAT HAPPENS NOW?
Both Liverpool manager Gerard Houllier (L) and assistant manager Phil Thompson look puzzled as they watch their team in the FA Cup at Huddersfield.

Date: **12th December, 1999**
Venue: **Alfred McAlpine Stadium, Huddersfield**

KEEGAN RESIGNS

England manager Kevin Keegan walks off the pitch and out of his job after Germany beat his lacklustre side 1–0 to bring the curtain down on 77 years of football at The Wembley Empire Stadium. The return match in Munich under a different management team results in a 5–1 win for England.

Date: **7th October, 2000**
Venue: **Wembley Stadium, London**

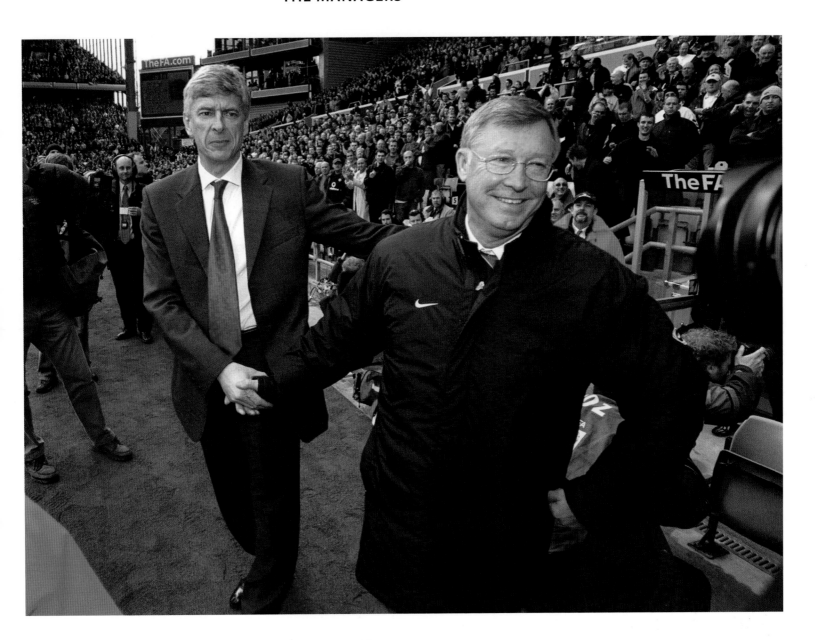

COLD SHAKE

A brief handshake between fierce managerial rivals. Arsenal's Arsène Wenger (L) and Manchester United's Sir Alex Ferguson ahead of an FA Cup semi-final at Villa Park.

Date: **3rd April, 2004**
Venue: **Villa Park, Birmingham**

LETTING OFF STEAM
Bolton Wanderers' manager 'Big' Sam
Allardyce lets off steam during a
Premiership match against Liverpool.

Date: **2nd January, 2006**
Venue: **Reebok Stadium, Bolton**

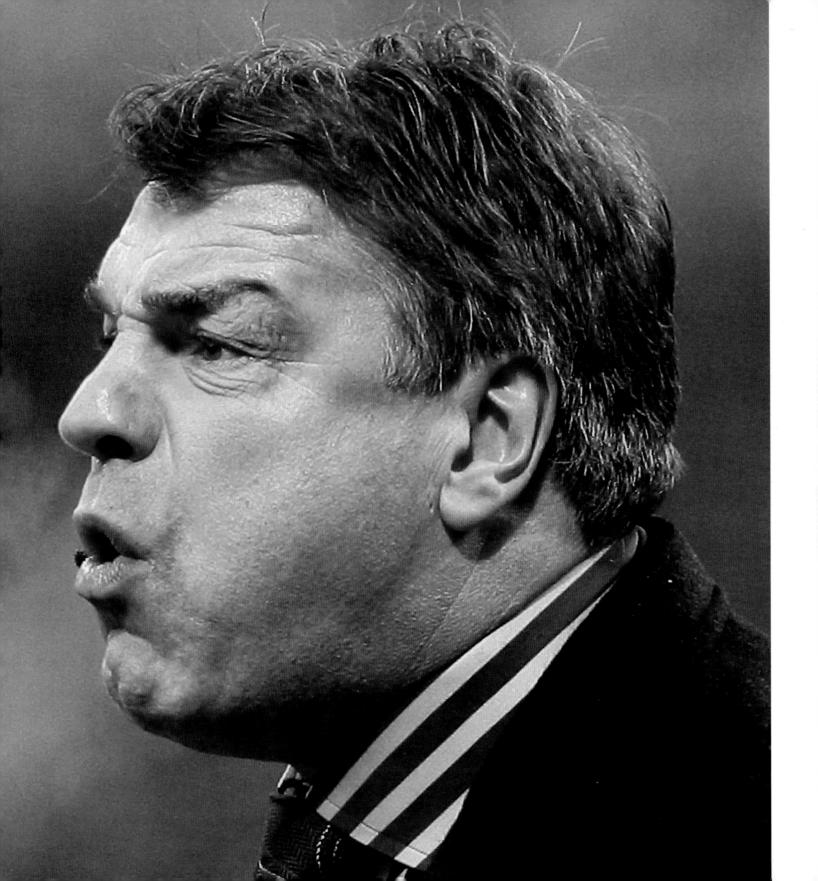

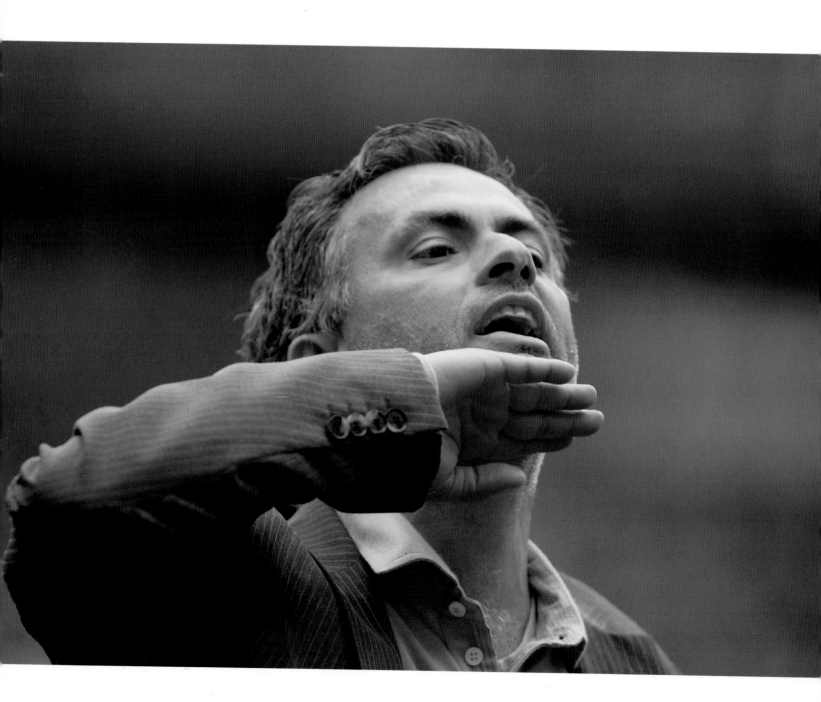

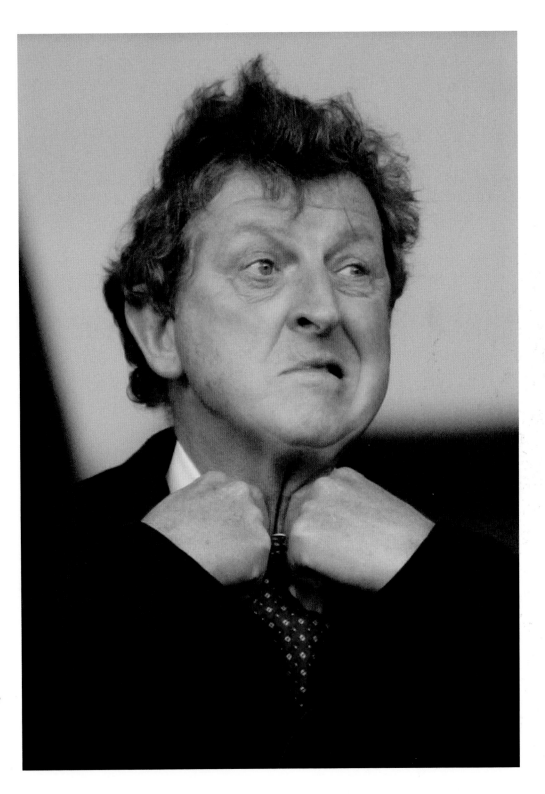

THE SPECIAL ONE

Jose Mourinho, the manager who brought Chelsea their first league title in 50 years during the 2004–5 season and retained the title in 2005–6, gestures to fans to 'keep your chins up' when the Blues fail to make it three in a row. Mourinho won six trophies in three years at Stamford Bridge.

Date: **6th May, 2007**
Venue: **Highbury, London**

TRICKY TIE

Much-travelled and much-respected Fulham manager Roy Hodgson struggles with the very important duty of straightening his tie. Hodgson has managed 14 club sides across seven countries, plus two national teams since he started management in 1976.

Date: **29th December, 2007**
Venue: **St Andrew's, Birmingham**

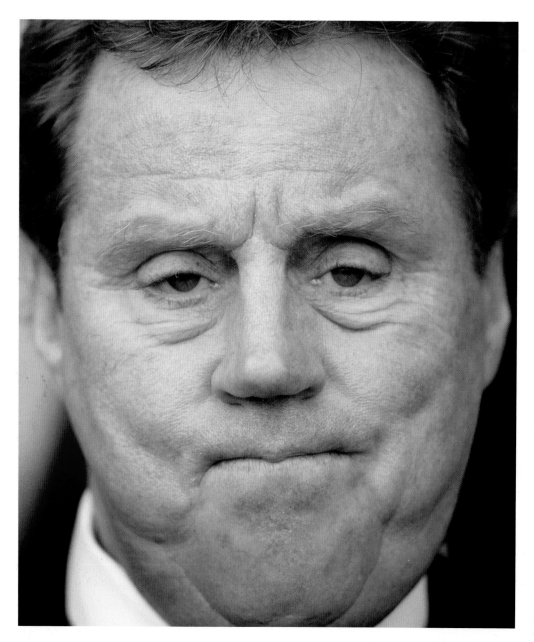

WORRIED 'ARRY

Always expressive, Harry Redknapp contemplates matters as his Portsmouth team beat Bolton Wanderers 1–0 in a closely fought Premiership encounter.

Date: **9th February, 2008**
Venue: **Reebok Stadium, Bolton**

FABIO SIGNS

England's Italian manager Fabio Capello – who actually scored against England as a player in 1973 – signs an autograph for a young England fan while watching a Fulham v Birmingham City Premiership match in London.

Date: **21st February, 2010**
Venue: **Craven Cottage, London**

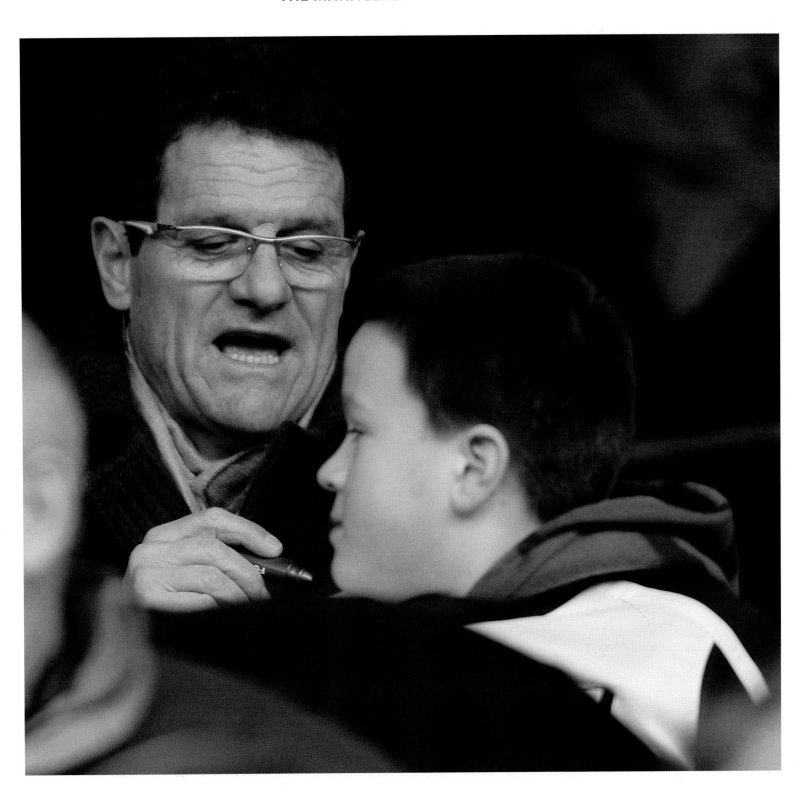

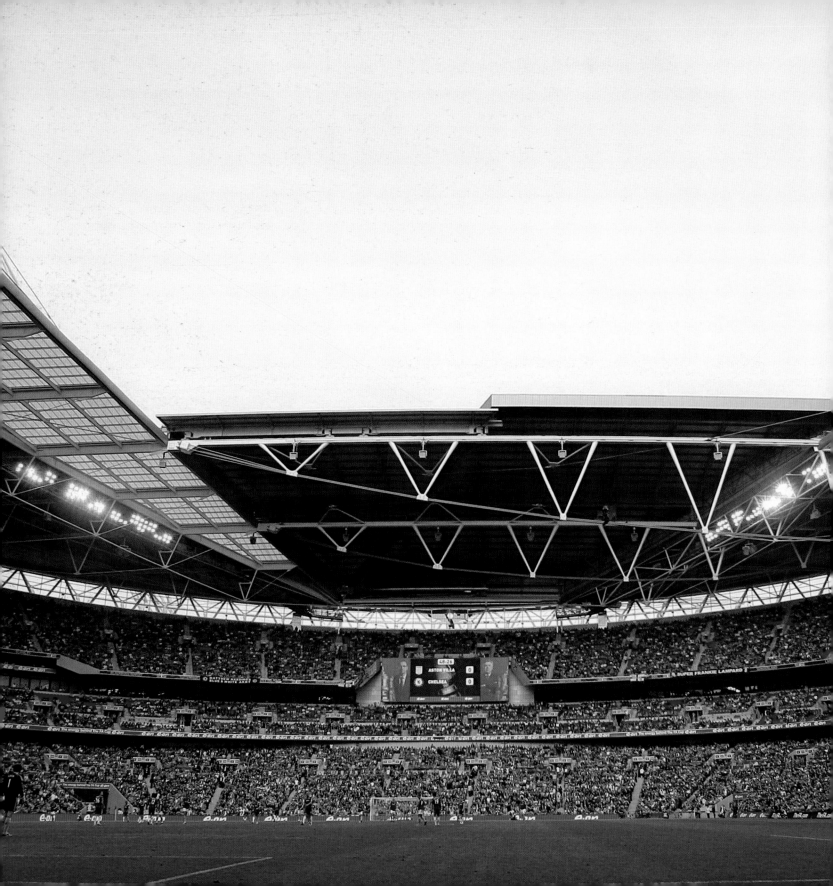

3 THE VENUES

As a fan you can't help but be impressed by the style and build of the football ground you're visiting.

Stadium architecture has come a long way since the game's early days, but every vast terrace, functional Archibald Leitch-designed criss-cross fronted stand or cantilever roof of yesteryear has its own unmistakeable charm.

This chapter acknowledges the classic British football stadium.

NEW WEMBLEY
Wembley Stadium is packed to the gunnels during the 2010 FA Cup semi-final between Chelsea and Aston Villa.

Date: **10th April, 2010**
Venue: **Wembley Stadium, London**

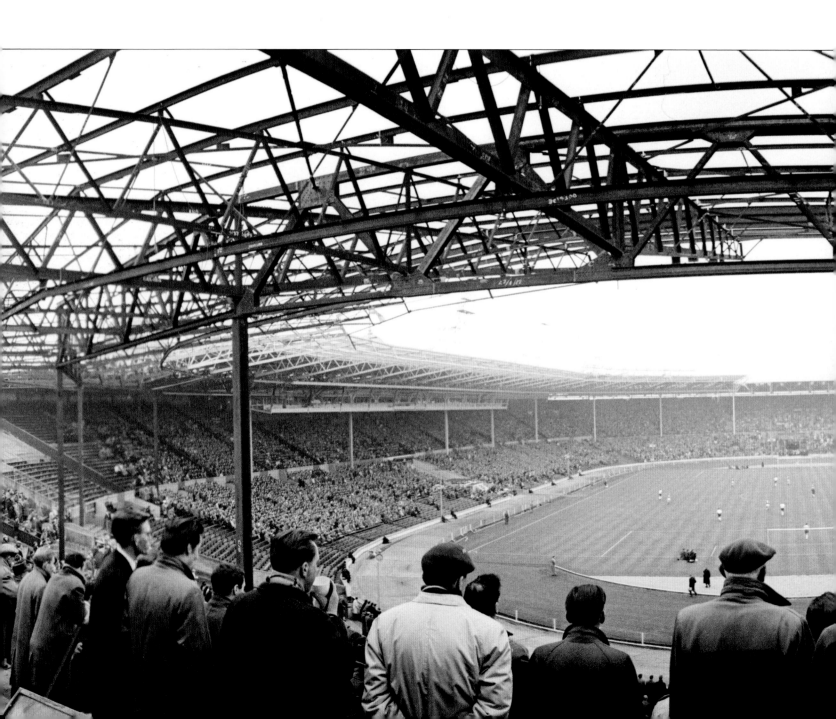

WEMBLEY WORK

Wembley Stadium during construction work. Although the original Empire Stadium opened in 1923, it wasn't until 1963 that aluminium and glass roofing was completed. This enhanced the atmosphere considerably, and remained in place until the stadium's demolition 40 years later.

Date: **21st October, 1962**
Venue: **Wembley Stadium, London**

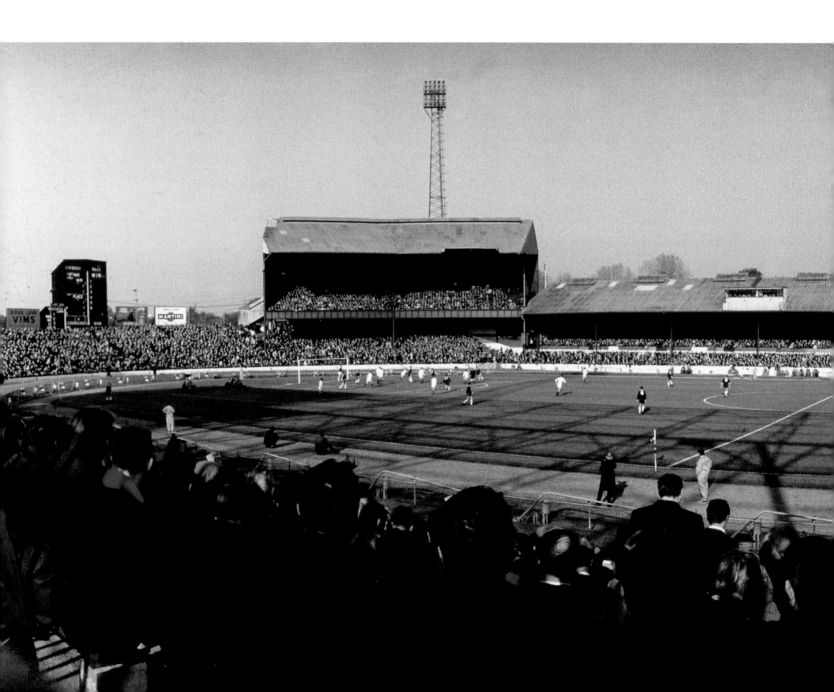

VIEW FROM THE BRIDGE

Stamford Bridge in west London, home to
Chelsea since 1905, is resplendent in the
hazy autumn sunshine as the hosts take on
Leicester City in the First Division.

Date: **23rd October, 1965**
Venue: **Stamford Bridge, London**

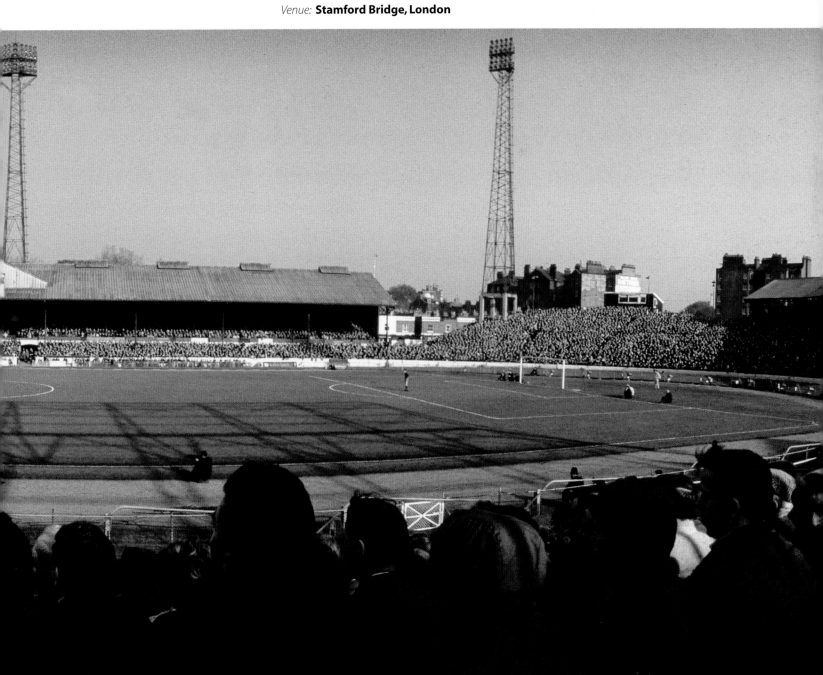

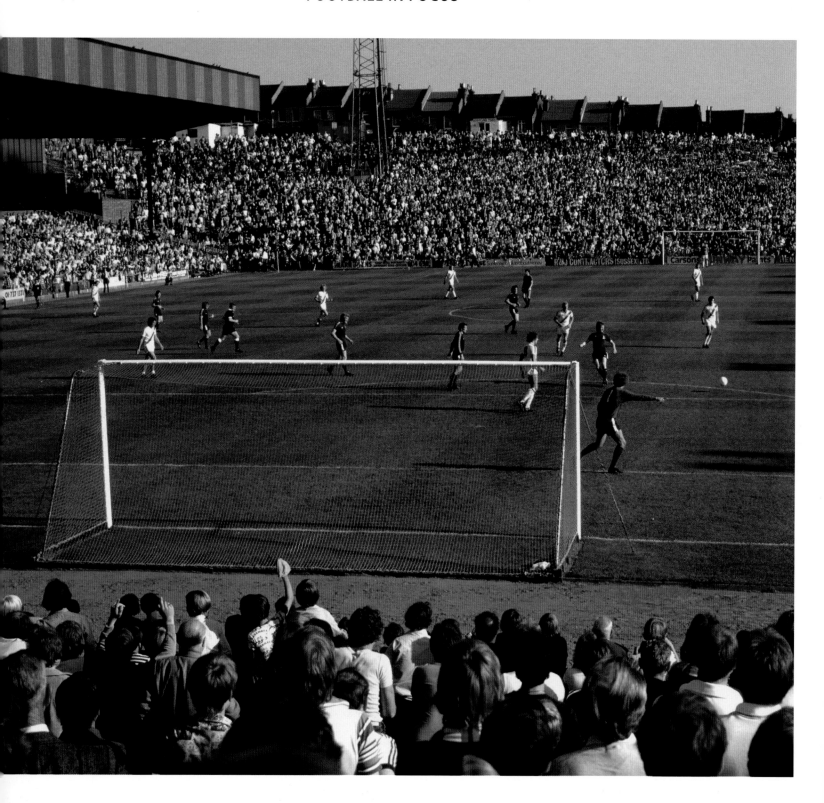

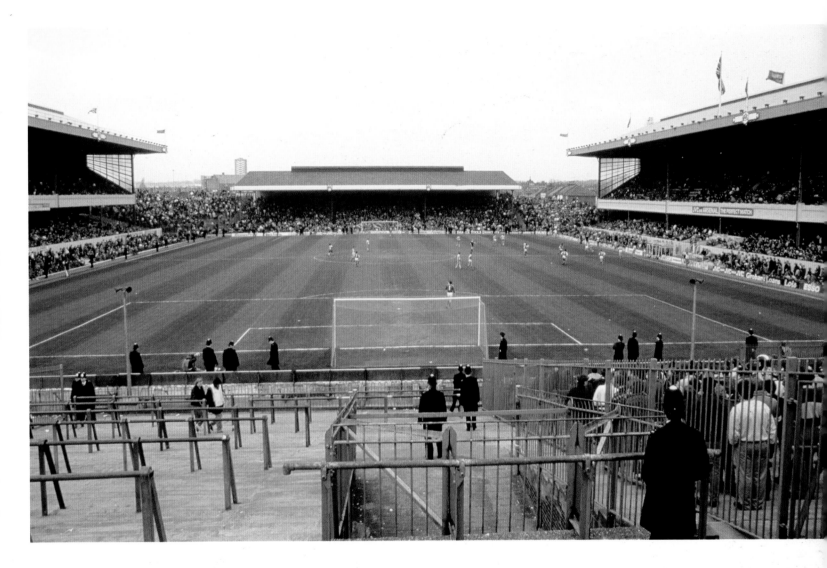

SELHURST SUNSHINE

Looking across to a packed Holmesdale Road end in autumn sunshine, Crystal Palace (in white) take on Oldham Athletic. Built in 1924, Selhurst Park has played host not only to Crystal Palace, but also to Charlton Athletic and Wimbledon during enforced exile from their own respective grounds.

Date: **23rd September, 1978**
Venue: **Selhurst Park, London**

EMPTY TERRACES

A general view of Highbury, showing a lack of fans in the visitors' terraces – reflecting much of the troubled times for English football in the late 1980s, when a variety of factors – including increased hooliganism, unsatisfactory stadium conditions, and indifferent football – kept supporters away. Home side Arsenal won this First Division fixture against Oxford United 2–0.

Date: **10th October, 1987**
Venue: **Highbury, London**

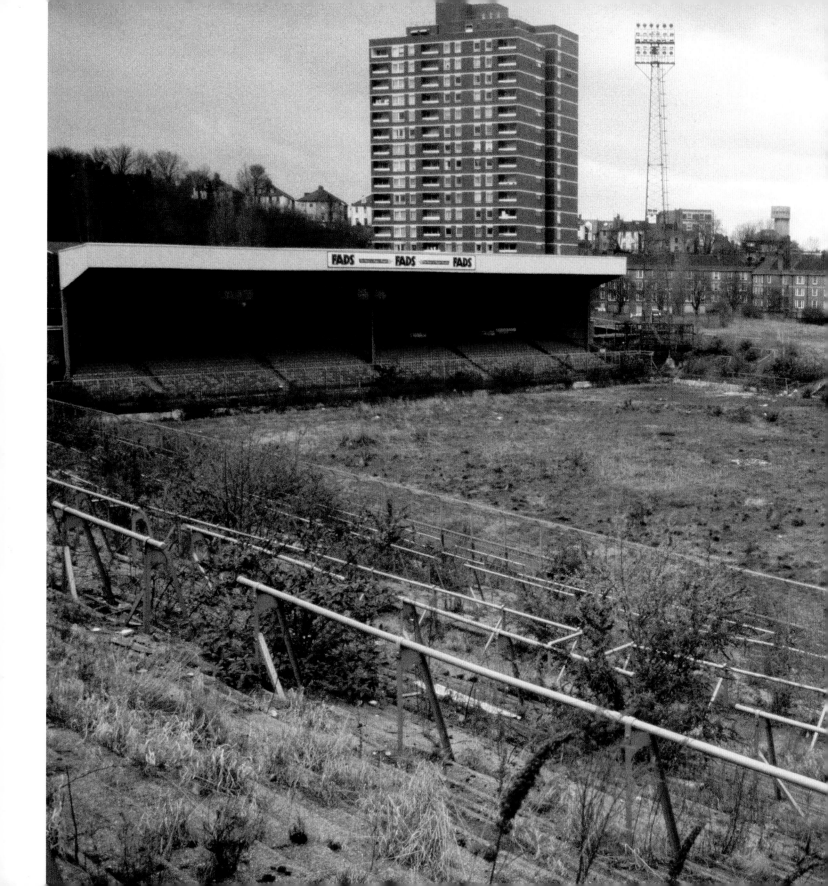

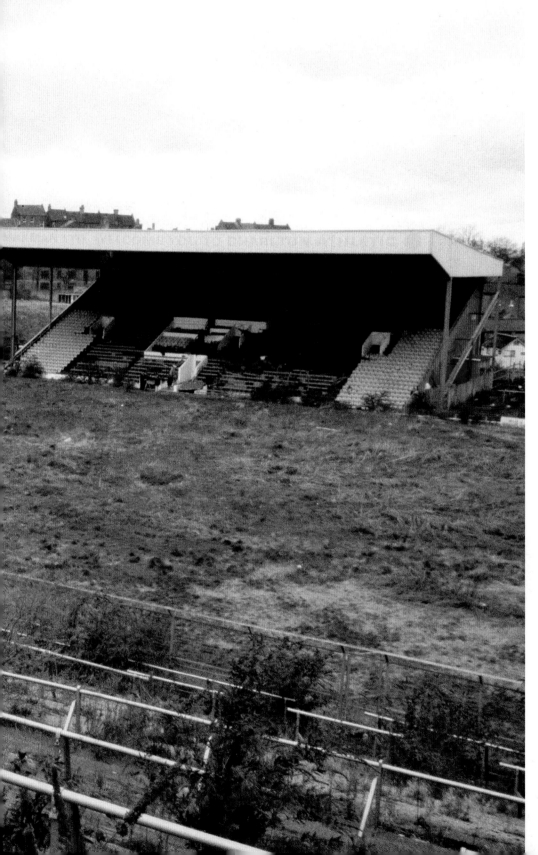

FORLORN VALLEY

The Valley lies derelict three years after Charlton Athletic had been forced to vacate it. Plans to rebuild the ground were at first rejected by the local council, but fans successfully set up their own political party to campaign against the decision. Charlton ultimately moved back to a revamped Valley late in 1992.

Date: **14th October, 1988**
Venue: **The Valley, London**

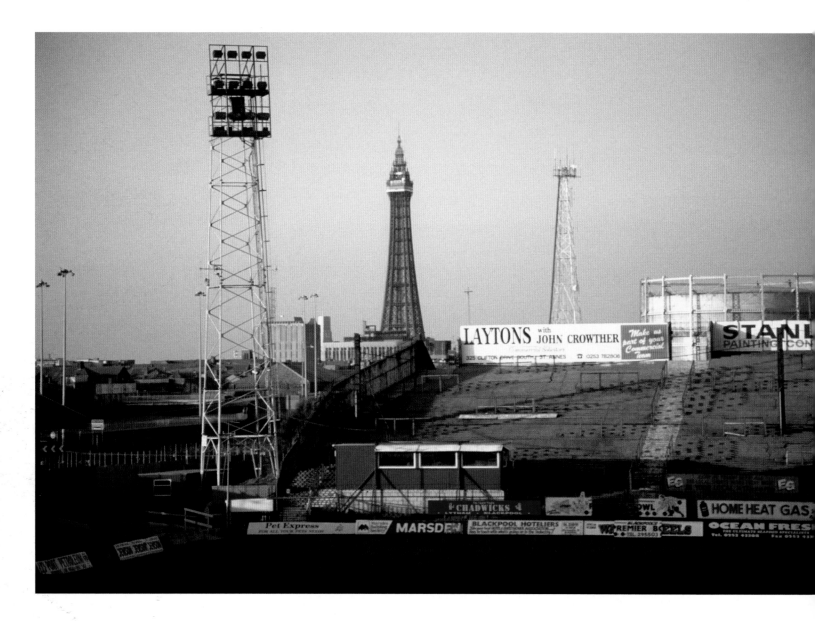

TOWERING ABOVE

The terraces at Bloomfield Road in Blackpool are overlooked (as is most of the rest of the town) by Blackpool Tower.

Date: **2nd February, 1994**
Venue: **Bloomfield Road, Blackpool**

TURF WARS

The artificial pitch at Deepdale, home to Preston North End, is rolled up and removed after the final day of the season. Artificial pitches, also installed by the likes of Queens Park Rangers, Luton Town and Oldham Athletic, were unpopular with many who preferred the traditional grass surface.

Date: **19th May, 1994**
Venue: **Deepdale, Preston**

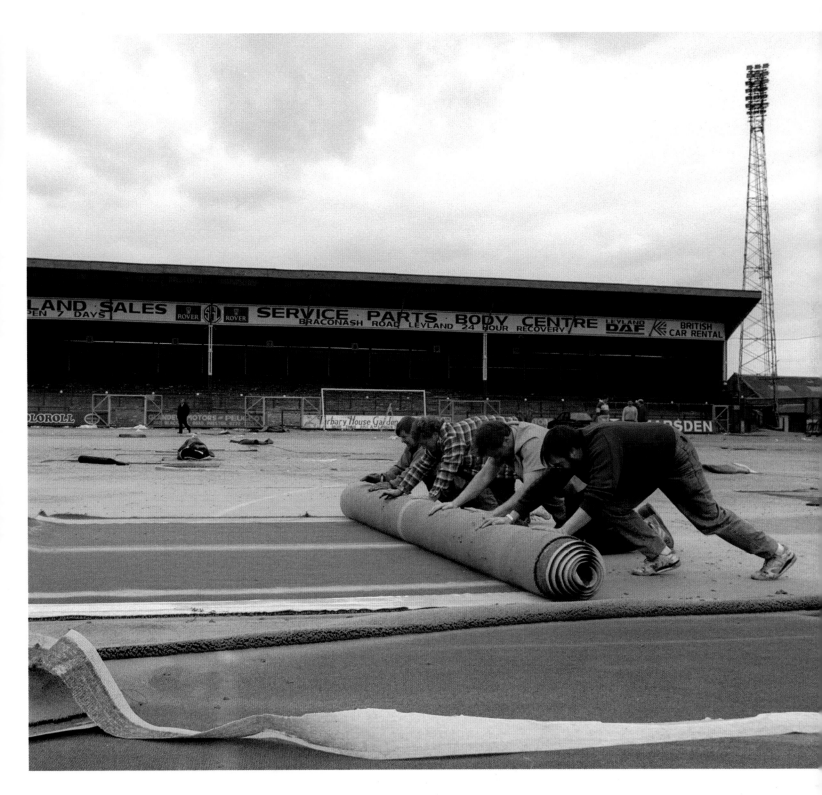

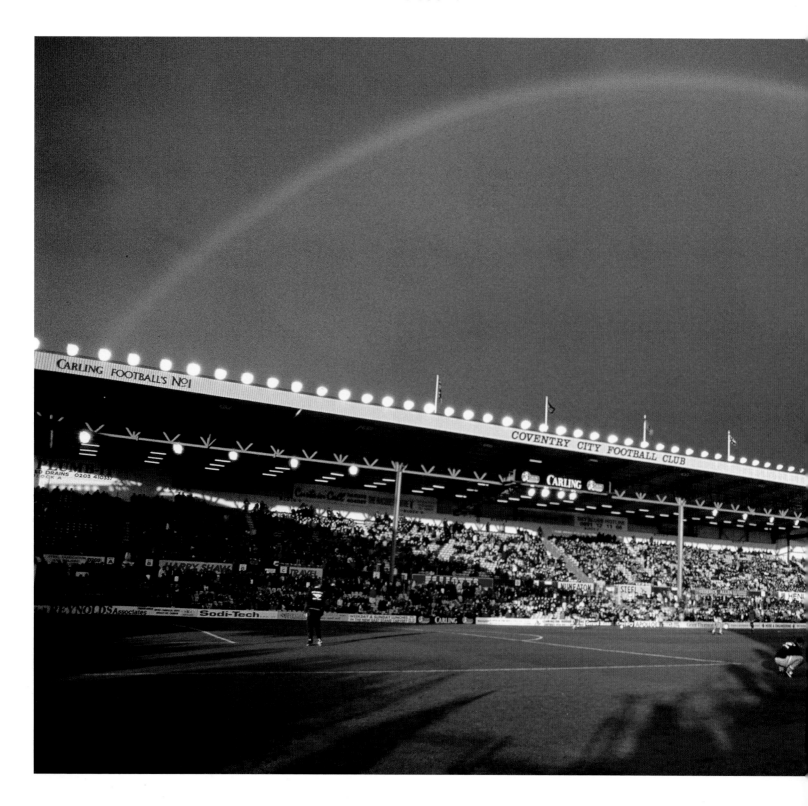

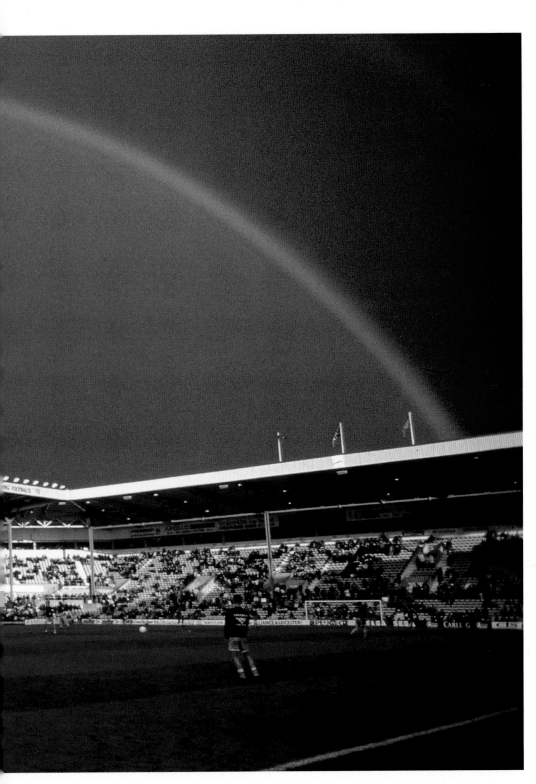

HIGH OVER HIGHFIELD

A rainbow frames a packed Highfield Road, Coventry, which became the first all-seater stadium in England in the early 1980s under the chairmanship of Jimmy Hill.

Date: **3rd December, 1994**
Venue: **Highfield Road, Coventry**

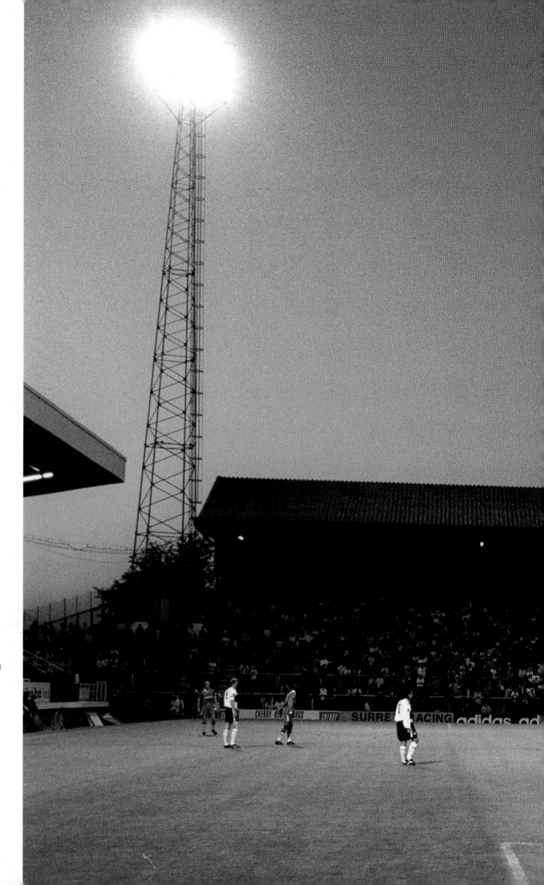

AUTUMN SUNSET

Stunning colours radiate over west London's Craven Cottage as Fulham take on Plymouth Argyle in the Second Division (then the third tier of English football). The pitch lies within what were once Anne Boleyn's hunting grounds, and the original 'cottage', built by the Sixth Baron Craven in 1780, was located where the centre circle is now.

Date: **9th September, 1997**
Venue: **Craven Cottage, London**

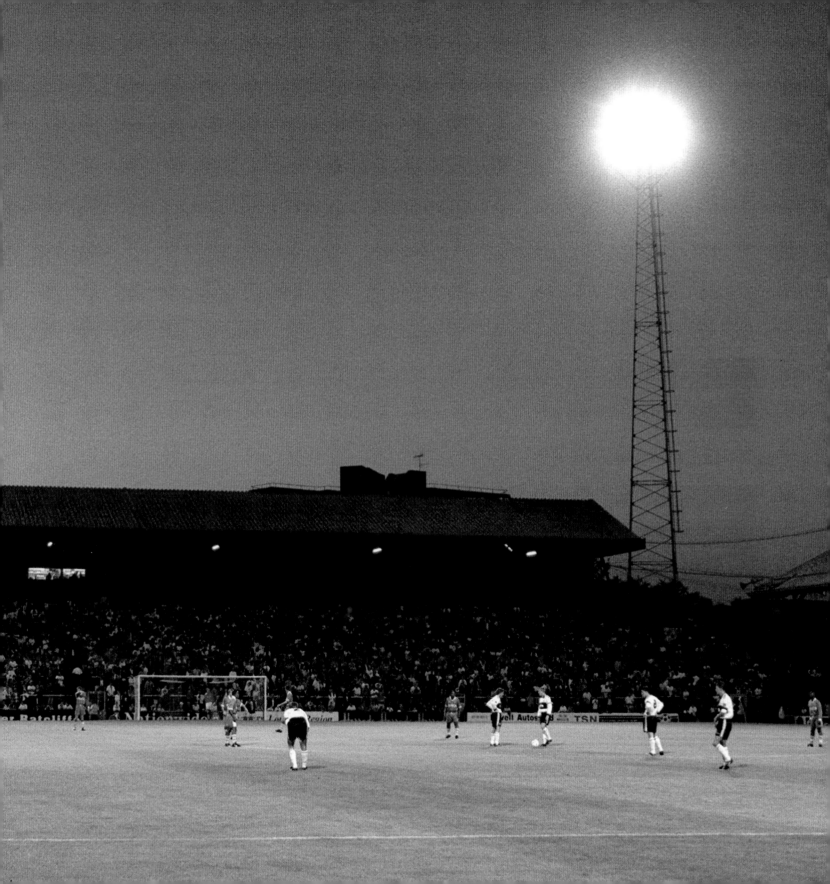

PARADE GROUND

Bradford City's sold-out Valley Parade
– now the Coral Windows Stadium. The
ground was rebuilt in stages after a fire on
the last day of the 1984–85 season.

Date: **12th September, 1999**
Venue: **Valley Parade, Bradford**

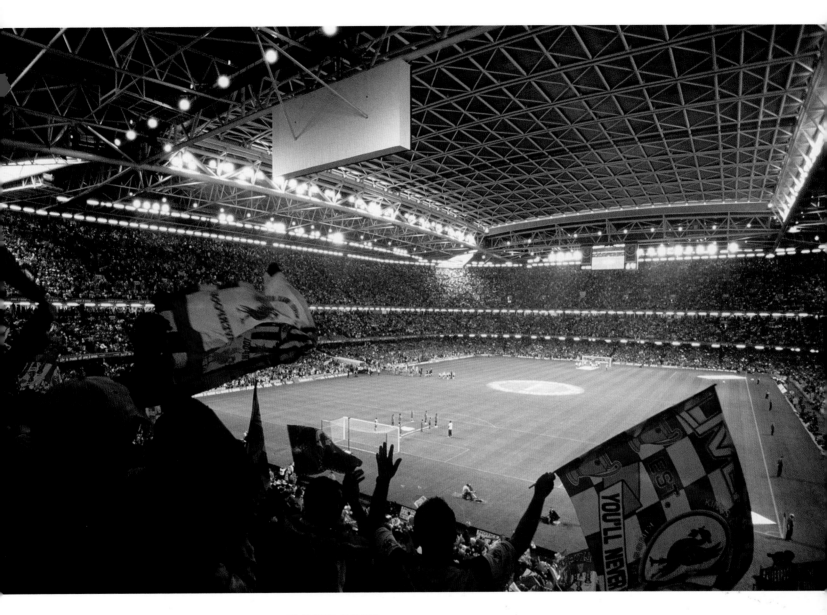

CLOSED ROOF

The stunning Millennium Stadium in Cardiff is the setting for the 2001 FA Charity Shield match between Liverpool and Manchester United. The roof is closed for this match due to inclement weather.

Date: **12th August, 2001**
Venue: **Millennium Stadium, Cardiff**

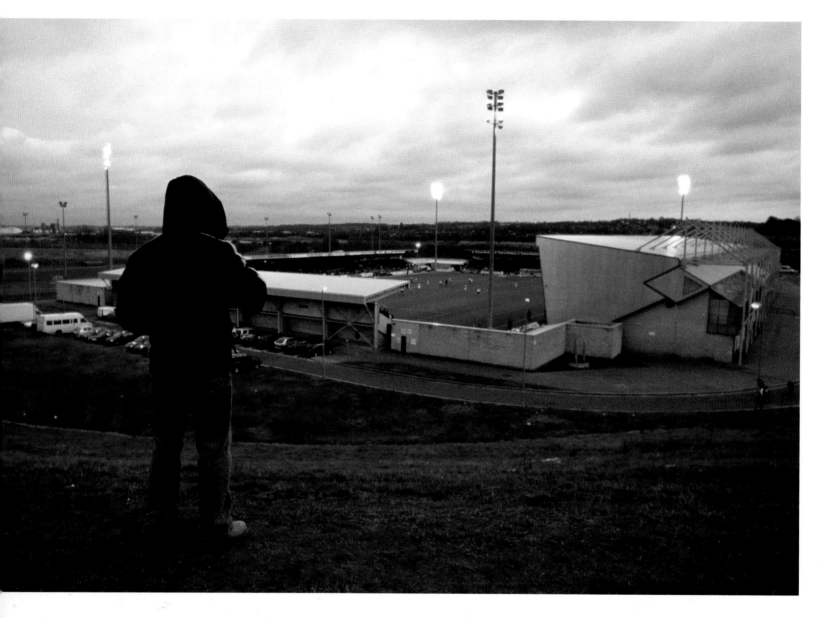

FREE VIEWING

The Sixfields Stadium was opened in 1994 as the new home of Northampton Town. The Cobblers had previously shared the County Ground with Northamptonshire Cricket Club. Here, a lone viewer watches Town beat York City 2–1 from outside the stadium.

Date: **17th January, 2004**
Venue: **Sixfields Stadium, Northampton**

THEATRE OF DREAMS

The magnificent 76,000-capacity Old Trafford, home of Manchester United since 1910. The record attendance at the venue was in fact set in 1939 during an FA Cup semi-final match between Wolverhampton Wanderers and Grimsby Town.

Date: **1st October, 2006**
Venue: **Old Trafford, Manchester**

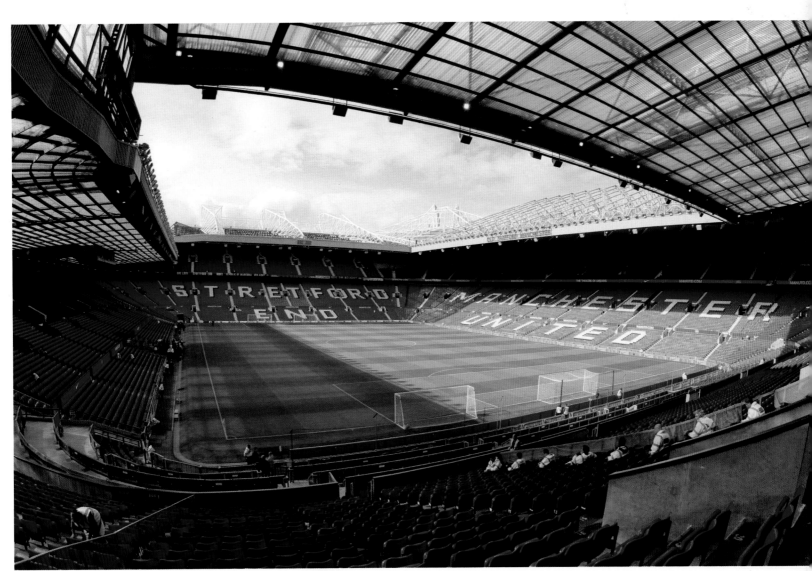

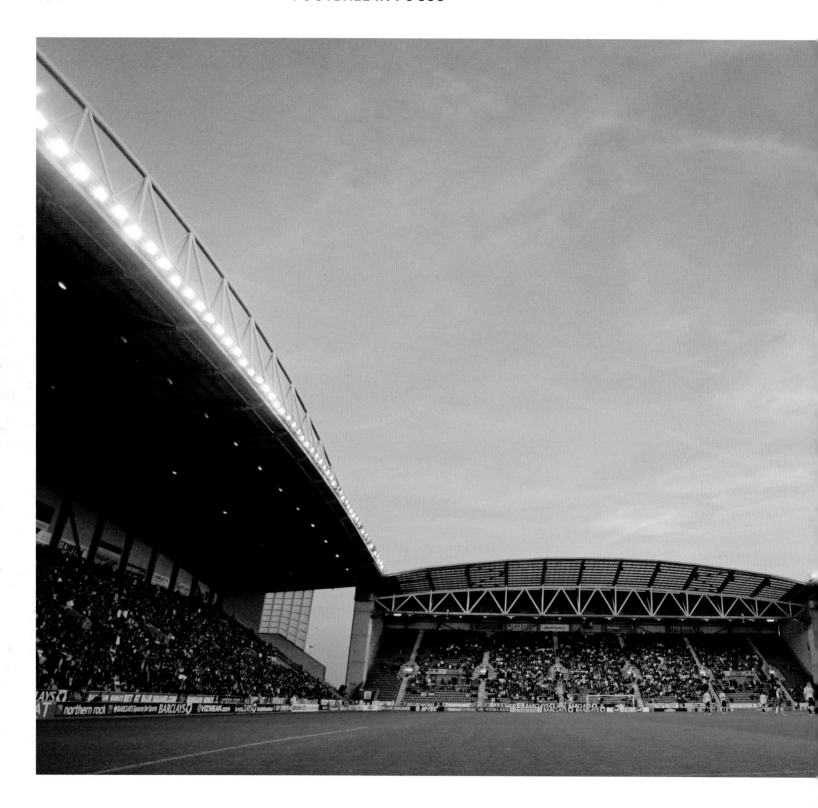

SHARED STADIUM

A general view of the JJB Stadium (L), home of both Wigan Athletic and Wigan Warriors Rugby League FC. The Latics were hosting Chelsea in the Premiership as the sunlight faded in the north west of England.

Date: **3rd November, 2007**
Venue: **JJB Stadium, Wigan**

RAZOR SMILE

Visiting fans are made to feel welcome outside Hereford United's Edgar Street ground. On this occasion, United were playing host to Cardiff City in an FA Cup fourth-round clash.

Date: **27th January, 2008**
Venue: **Edgar Street, Hereford**

VISITING SUPPORTERS

THE LONGEST-SERVING LIFERAFT

A Theatre of Trees rises behind the temporary seating at Withdean Stadium in Brighton. Originally intended to be used for just two seasons, vexatious protests and government slovenliness meant Brighton & Hove Albion's stay at the city's athletics stadium lasted for well over a decade.

Date: **30th January, 2009**
Venue: **Withdean Stadium, Brighton**

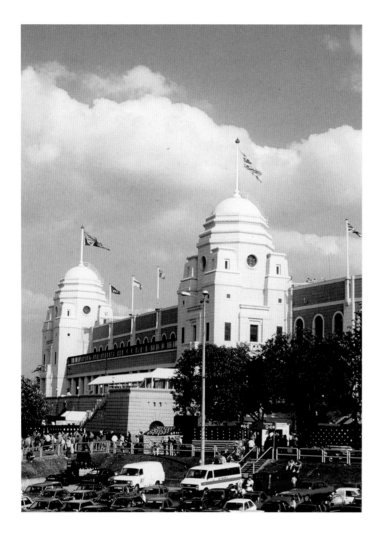

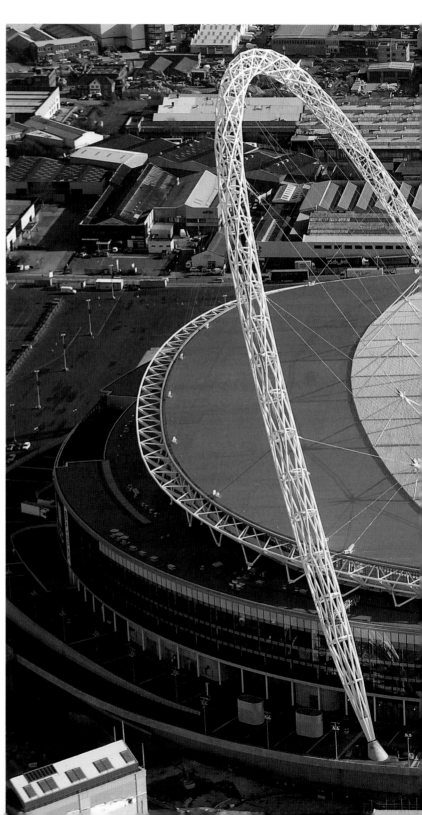

TWIN ICONS

Wembley's Empire Stadium, though the Venue of Legends, was by the turn of the century, nearly 80 years old and in desperate need of modernisation. The old stadium closed in December 2000 and was demolished three years later. Following delays, the new 90,000-capacity Wembley Stadium – the second-largest in Europe – opened in March 2007.

Date: **12th February, 2009**
Venue: **New Wembley Stadium, London**

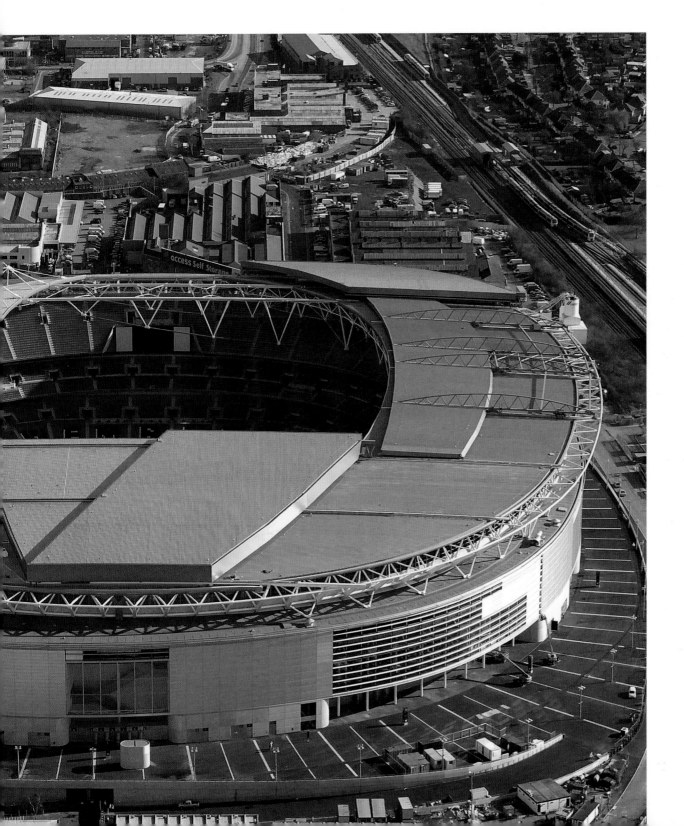

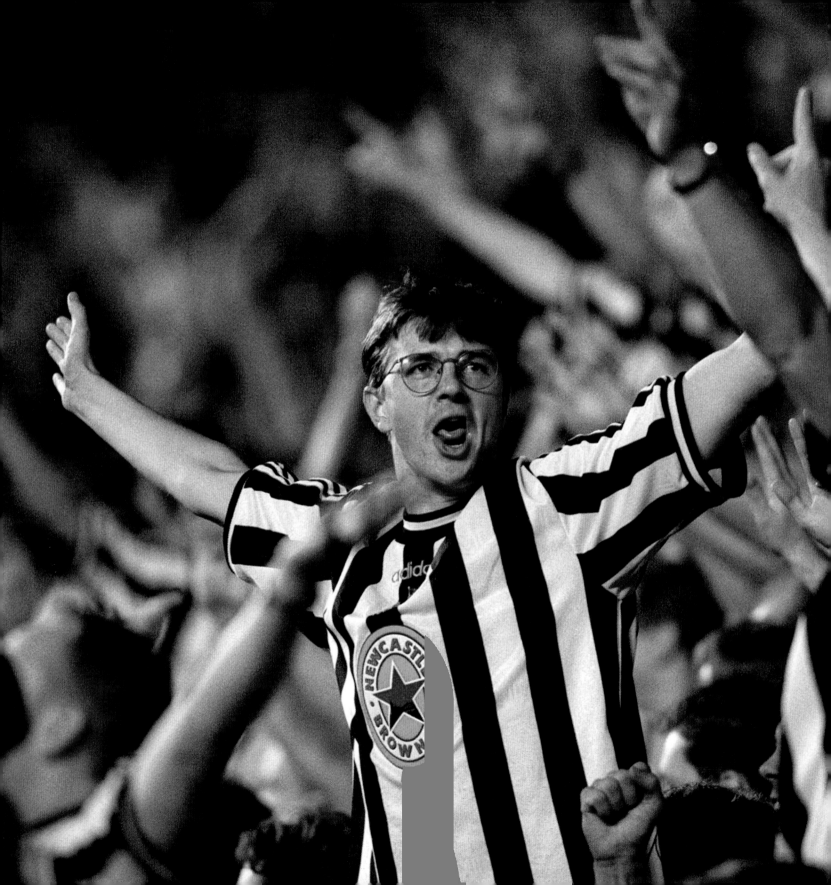

4 THE FANS

Fans are the lifeblood of the game. Without the supporters, football would be unable to function as a business and would lose its mass appeal.

Once allegiance is decided, the true fan stays with his or her club through thick and thin. Loyalty is everything, no matter how much it hurts.

"[Insert your own club] 'til I die..."

GANNIN' ALANG THE SCOTSWOOD ROAD...
Newcastle United fans, noted for their passionate support, are in full voice during their UEFA Champions League match against Barcelona.

Date: **17th September, 1997**
Venue: **St James' Park, Newcastle Upon Tyne**

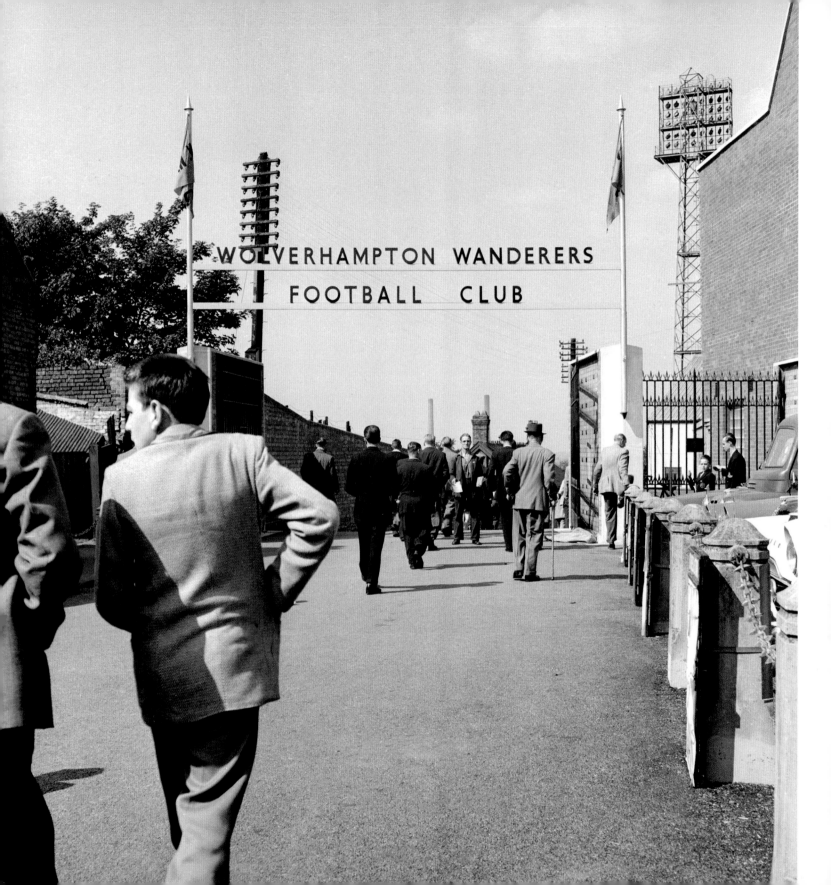

CURTAIN OPENER

Optimistic Wolverhampton Wanderers fans make their way in the August sunshine to watch their heroes in action against Arsenal at Molineux …

…where many thousands are already packed into the South Bank.

Date: **29th August, 1959**
Venue: **Molineux Ground, Wolverhampton**

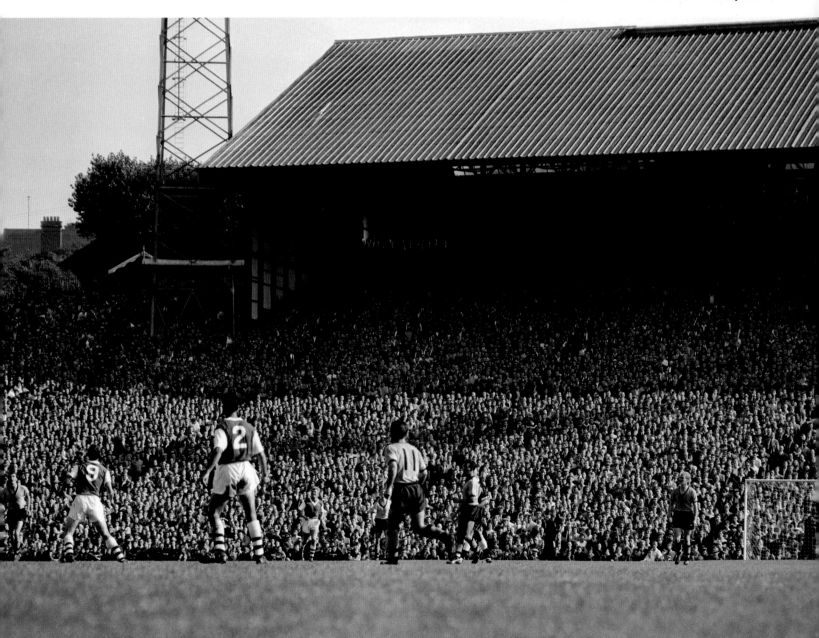

HERE'S TAE YE...

Rangers fans at Ibrox are in good voice –
one's even brought a light lunch of beer
and whisky before an Auld Firm clash with
Celtic on New Year's Day.

Date: **1st January, 1963**
Venue: **Ibrox, Glasgow**

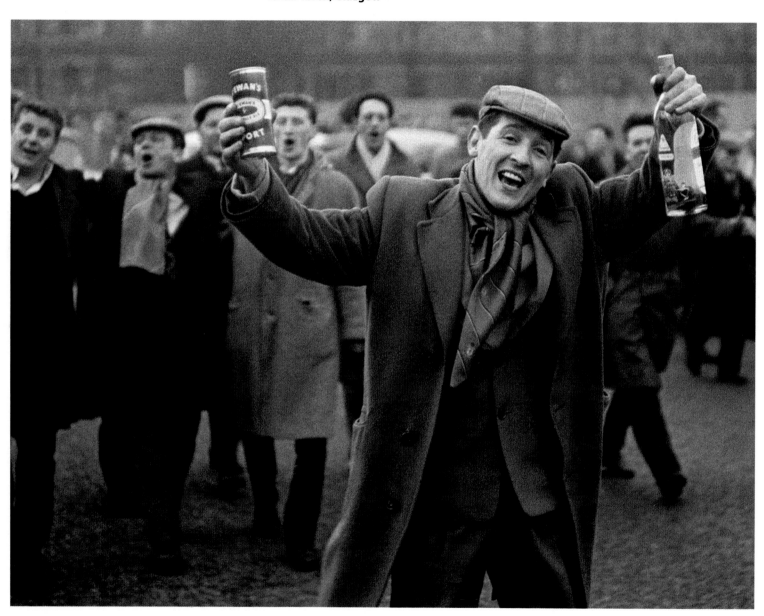

LUCKY BOOTS

A couple of young female Tottenham Hotspur fans bask in the late summer sunshine as their side take on Birmingham City. Not sure those boots will fit though.

Date: **5th September, 1964**
Venue: **White Hart Lane, London**

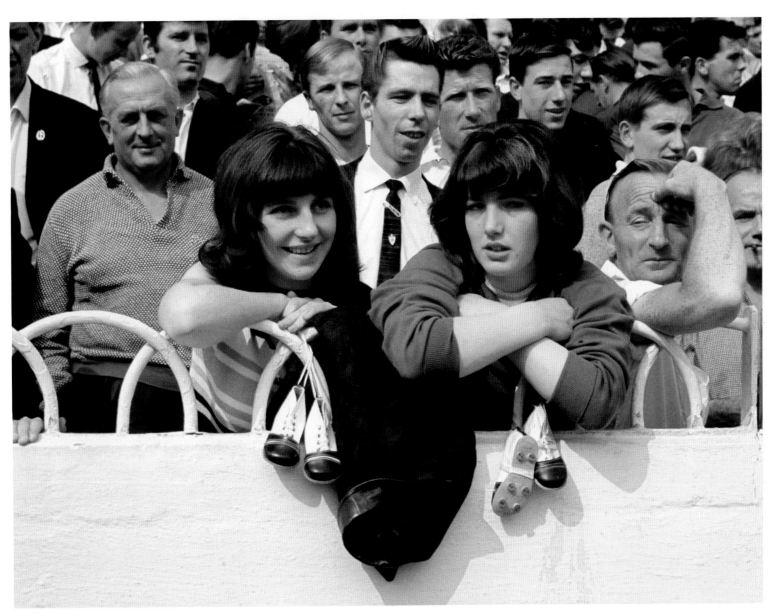

NO REFUNDS

Everton fans queue up at the Park End turnstiles at Goodison Park ahead of their club's First Division clash with Manchester United.

Date: **8th September, 1964**
Venue: **Goodison Park, Liverpool**

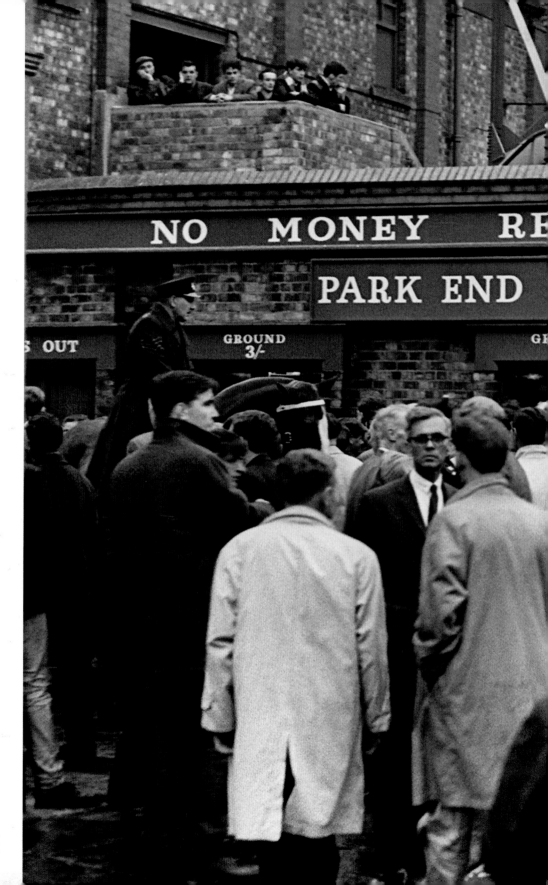

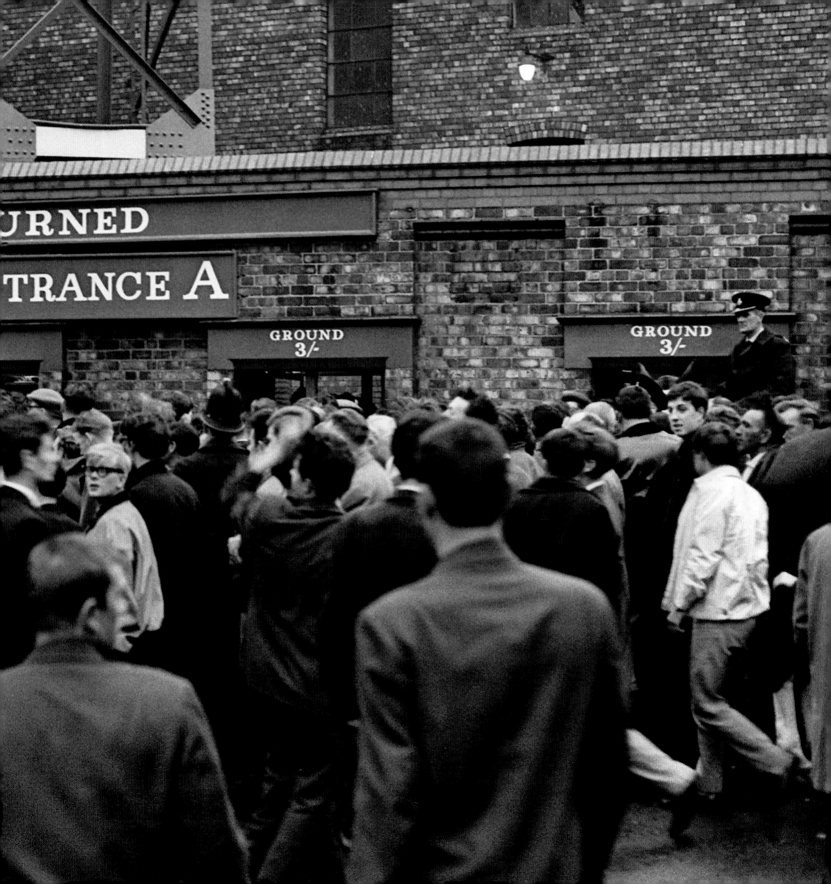

OH NO, THEY DROPPED...

A Burnley fan catches up with the latest news, views and team selections from his matchday programme before a home game against Manchester United...

Date: **4th February, 1967**
Venue: **Turf Moor, Burnley**

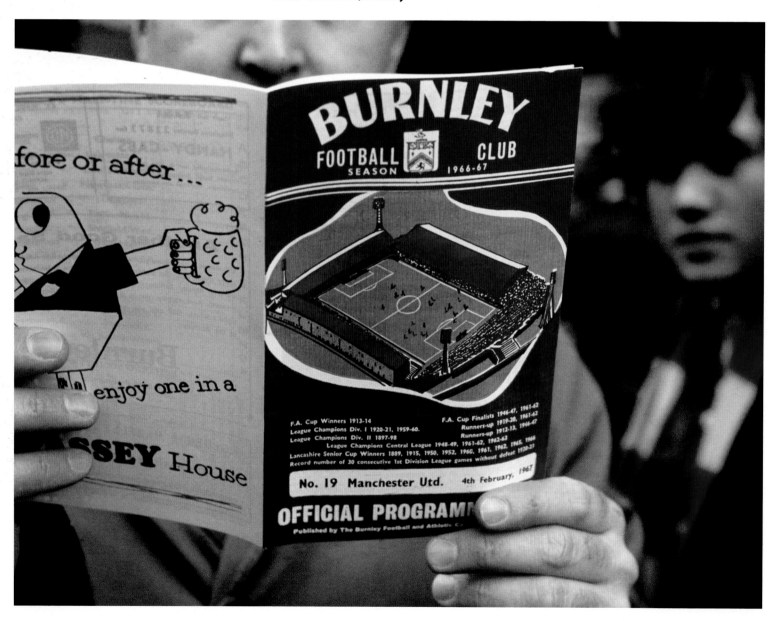

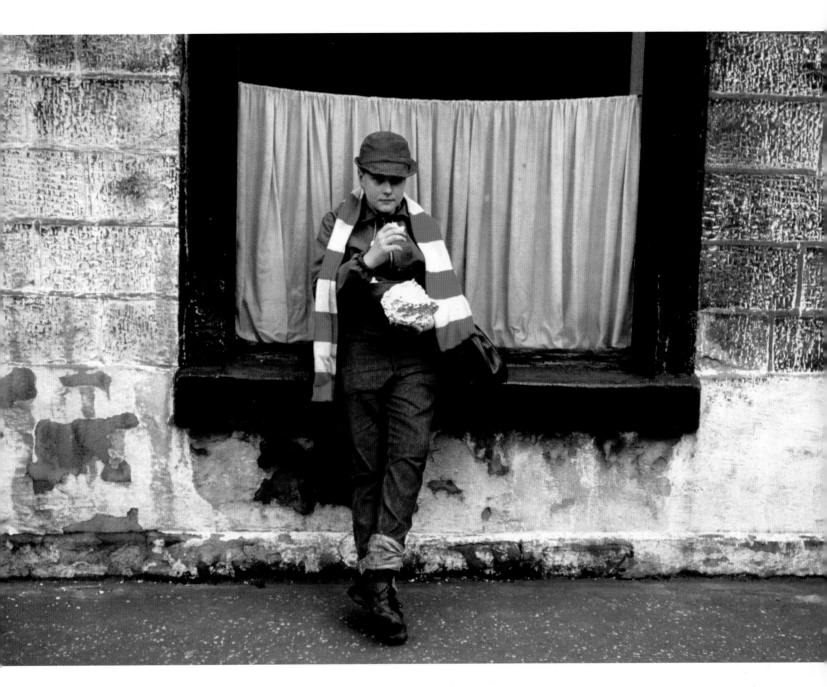

SILVER LINING
…while a young Manchester United fan
takes a moment to eat his packed lunch
before the Burnley game. The match
finished 1–1.

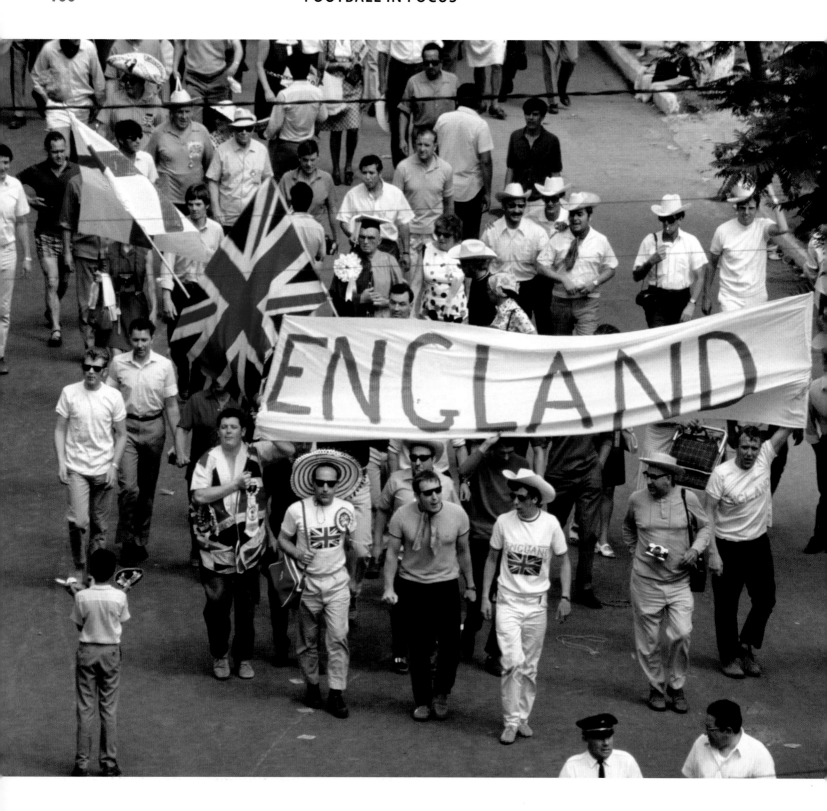

MAD DOGS AND ENGLISHMEN

England fans arrive at the stadium in Guadalajara for the 1970 World Cup group match with Brazil, dressed as coolly as possible (or as coolly as you can in a sombrero) for the midday kick-off.

Date: **7th June, 1970**
Venue: **Estadio Jalisco, Guadalajara, Mexico**

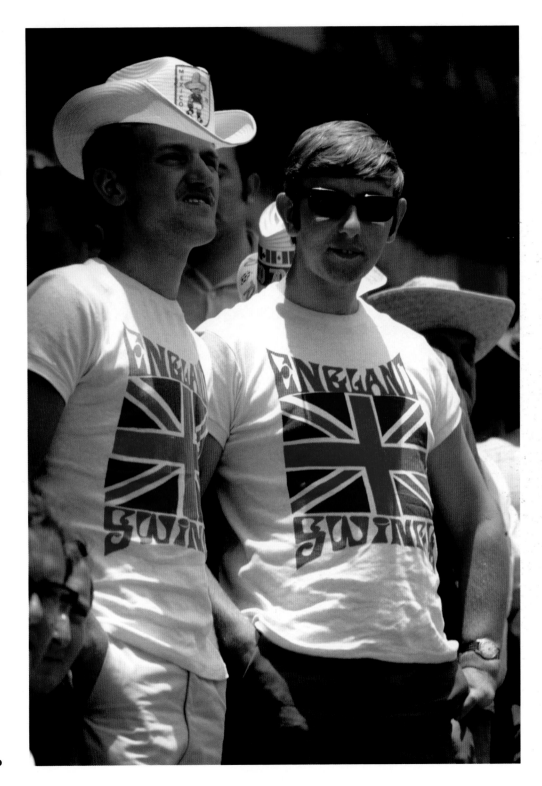

GROOVY BABY

Two England fans, wearing Union Flag T-shirts, watched the Brazil v England match from the stands at the 1970 World Cup in Mexico.

Date: **7th June, 1970**
Venue: **Estadio Jalisco, Guadalajara, Mexico**

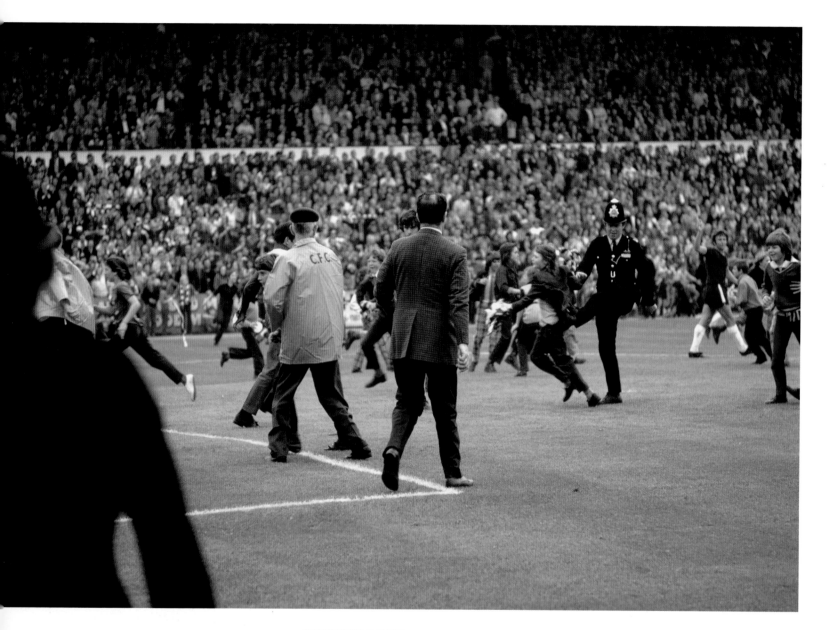

BOBBIE'S BOOT

A fan receives a boot up the backside from a policeman as supporters invade the pitch at Stamford Bridge, halting the Chelsea v Leeds United First Division match.

Date: **12th August, 1971**
Venue: **Stamford Bridge, London**

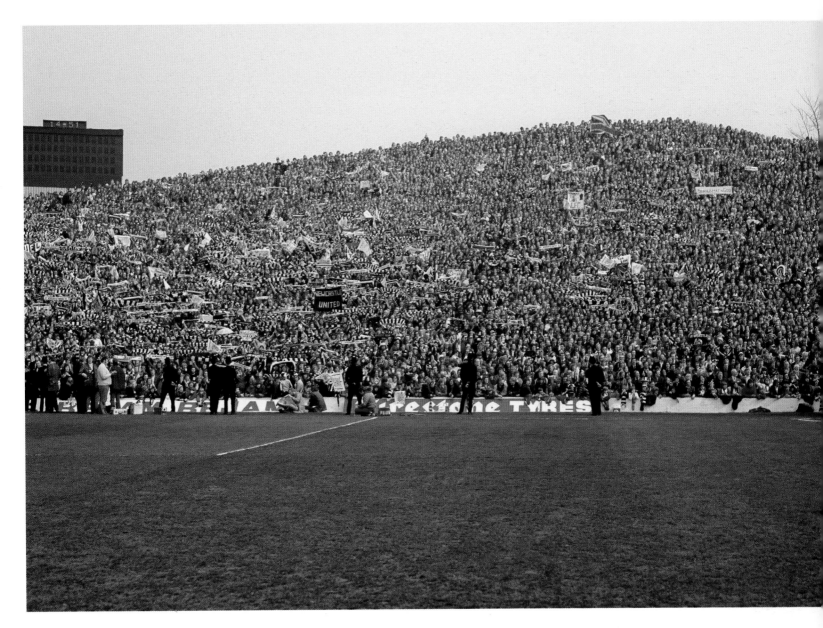

HILLSBOROUGH SUMMIT
The Kop at Sheffield Wednesday's
Hillsborough ground is a swaying sea
of black and white as nigh on 22,000
Newcastle United fans pack in for the 1974
FA Cup semi-final against Burnley.

Date: **30th March, 1974**
Venue: **Hillsborough, Sheffield**

BILLY THE BRAVE
Billy Bremner, described by Pelé as "outstanding" during the 1974 World Cup Finals, poses with admiring fans behind a Scotland flag after a training session in West Germany.

Date: **17th June, 1974**
Venue: **West Germany**

'ELLO, 'ELLO, 'ELLO
The North Bank at Highbury wildly applauds Brian Kidd (No 10) as he tries on a policeman's helmet during goal celebrations against Manchester City.

Date: **24th August, 1974**
Venue: **Highbury, London**

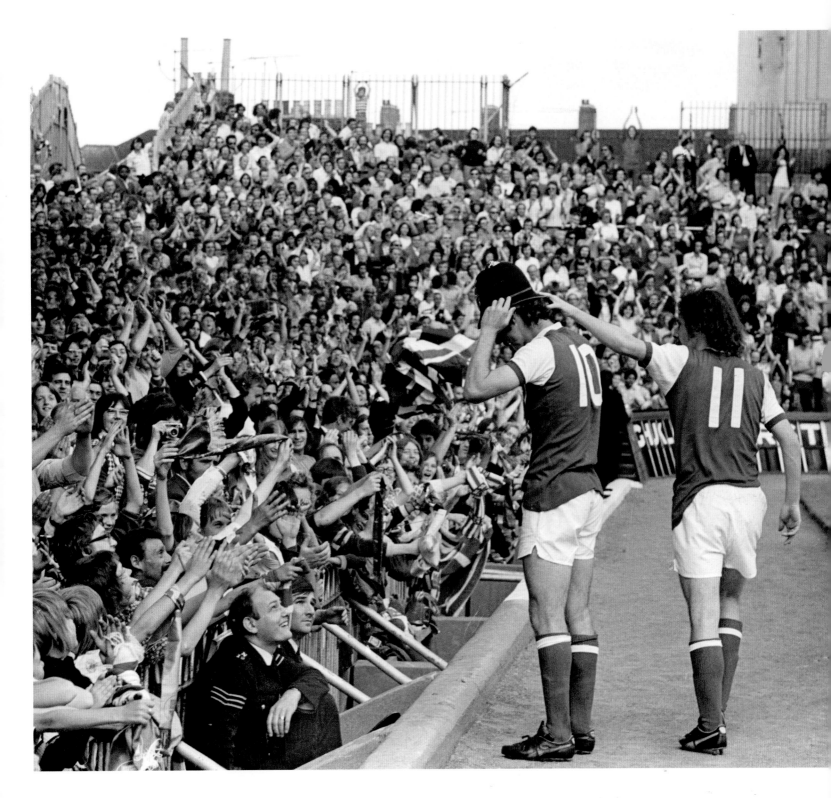

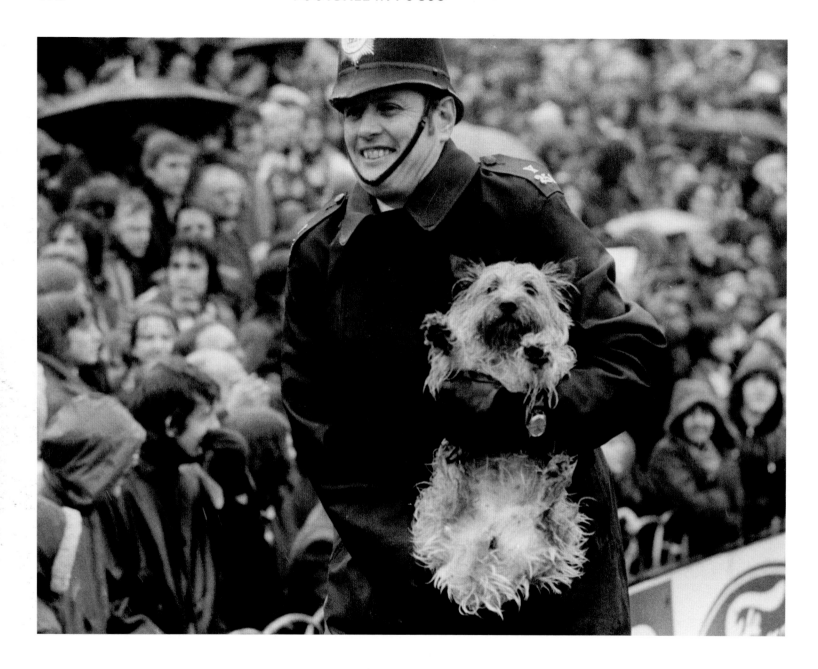

A BARKING FAN

Dogs on pitches have sadly become a thing of the past. A startled hound is carted away by a pitchside policeman during a rain-soaked FA Cup match between Arsenal and West Ham United.

Date: **8th March, 1975**
Venue: **Highbury, London**

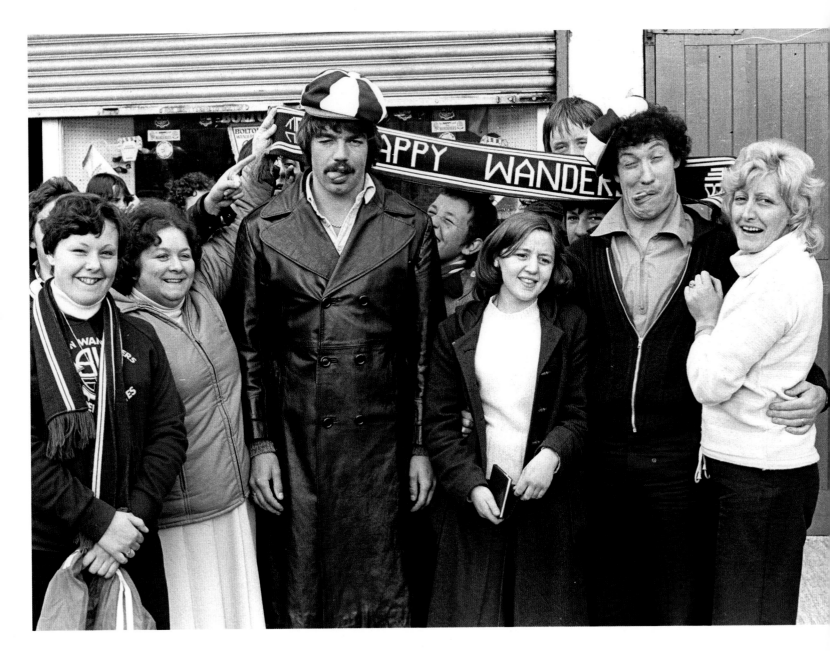

HAPPY WANDERERS
Sam Allardyce (L) and Roy McDonough of Bolton Wanderers happily gurn for the cameras with a gaggle of fans after winning the Second Division title.

Date: **29th April, 1978**
Venue: **Burnden Park, Bolton**

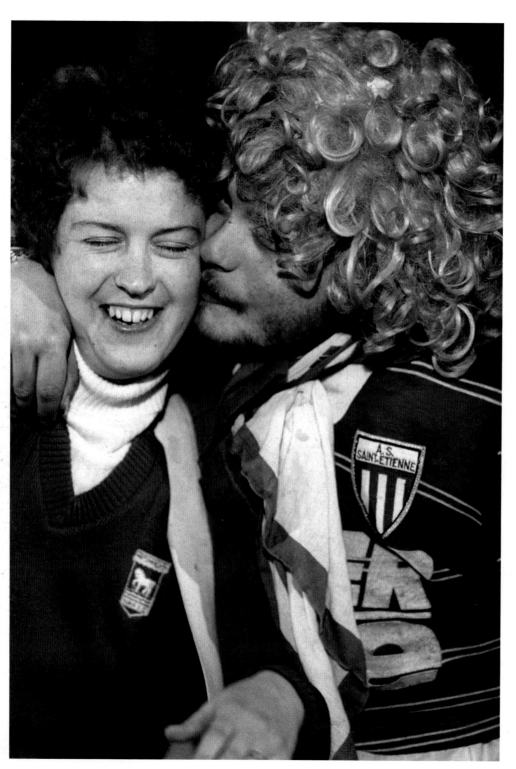

ALLEZ LES TRACTEURS

An Ipswich Town supporter and Saint Etienne fan get acquainted ahead of a UEFA Cup quarter-final match. Ipswich progressed comfortably, beating 'Les Verts' (who featured the awesome French midfielder, Michel Platini) 7–2 on aggregate. The Blues went on to defeat AZ67 Alkmaar in the final.

Date: **18th Match, 1981**
Venue: **Portman Road, Ipswich**

DEFIANT FANS

Scotland fans hold aloft a banner taunting Ted Croker, the FA Secretary. The FA withheld the normal Scottish ticket allocation for the match against England at Wembley in the Home Internationals, hoping to avoid the violent incidents of previous years. The visitors return home happy – a John Robertson penalty sinks England 1–0.

Date: **23rd May, 1981**
Venue: **Wembley Stadium, London**

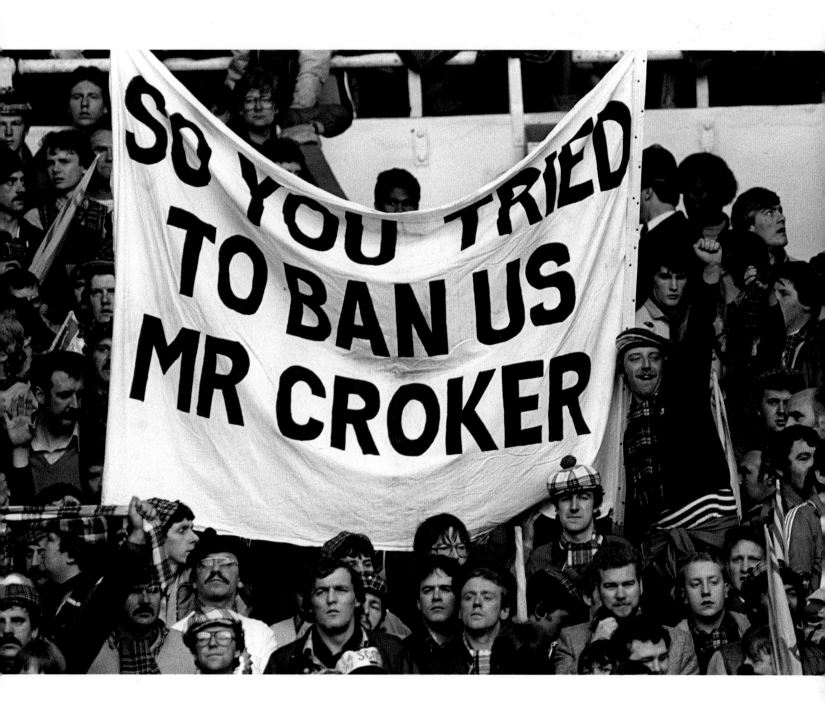

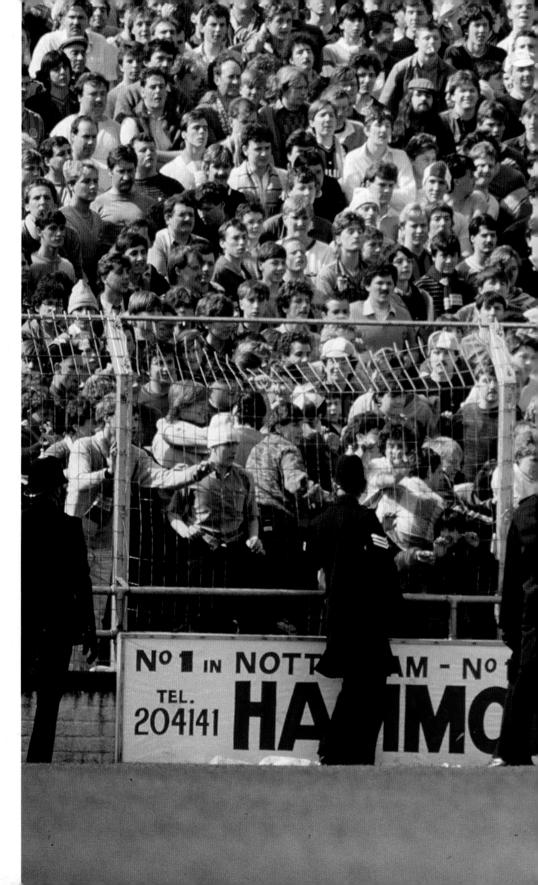

OFFENSIVE BEHAVIOUR

Police move in as Manchester City fans pull down pitchside fencing surrounding the terraced enclosure at Notts County. Sadly, this sort of behaviour was becoming more and more prevalent during the 1980s and fans and authorities often clashed. The Nottingham club won this First Division encounter 3–2.

Date: **6h May, 1985**
Venue: **Meadow Lane, Nottingham**

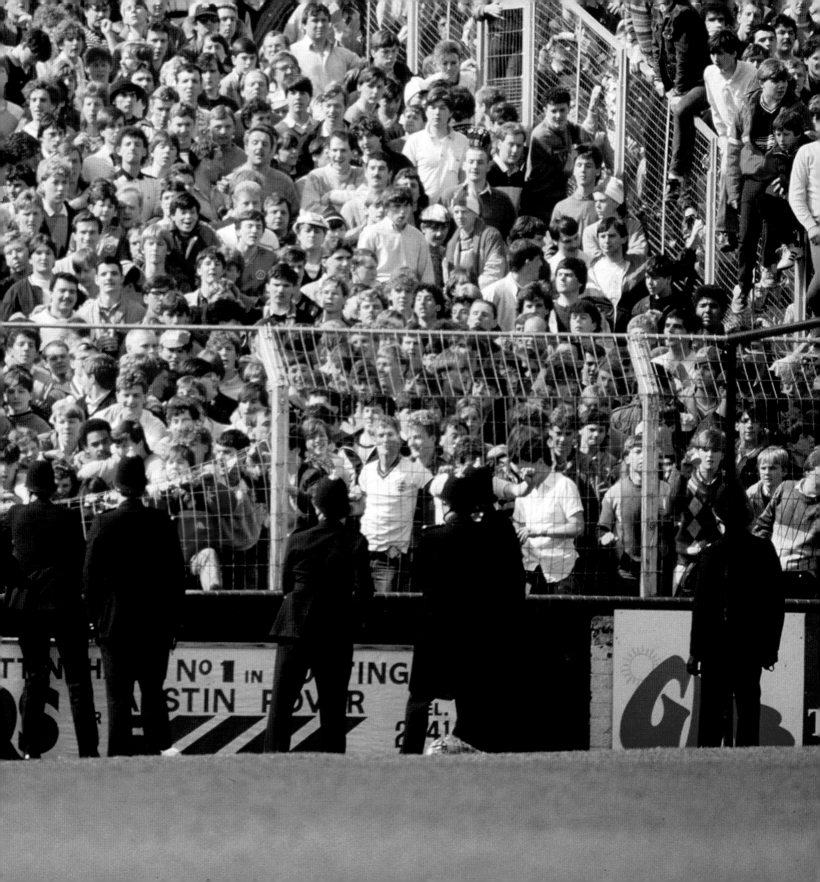

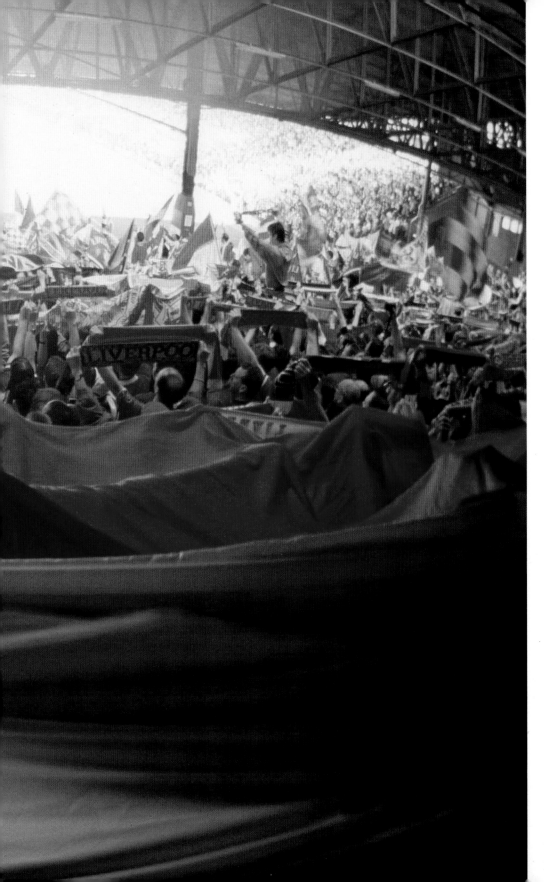

THE KOPITES
Liverpool supporters gathered on The
Kop behind the north goal at Anfield are
reputed to be worth an extra goal
for their club with their passionate
support, especially on key European nights.

Date: **17th July, 1986**
Venue: **Anfield, Liverpool**

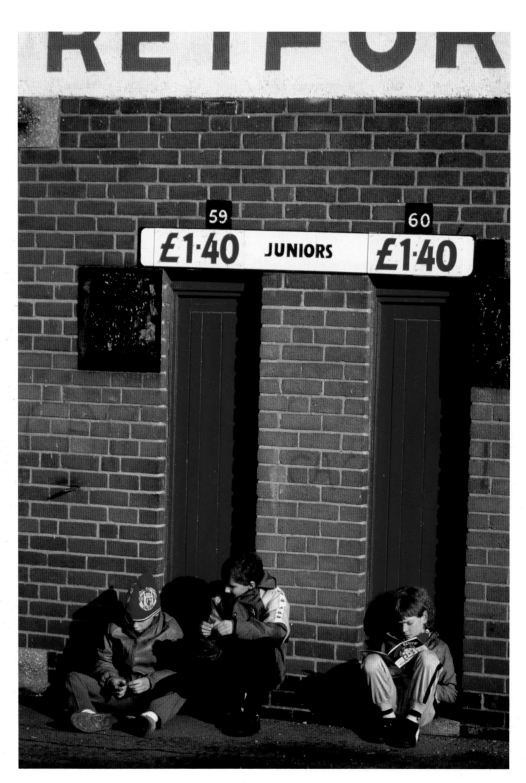

STILL WAITING

Young Manchester United fans sit and read the matchday programme, waiting patiently – £1.40 at the ready – for the turnstiles to open at the Stretford End of Old Trafford. Their heroes are taking on Arsenal in Division One.

Date: **24th January, 1987**
Venue: **Old Trafford, Manchester**

NO MERGER

When well-organised football fans become a force to be reckoned with, Fulham supporters make their feelings known regarding the notion of a merger with west London rivals Queens Park Rangers. Fortunately for both sets of fans, nothing came of it.

Date: **28th February, 1987**
Venue: **Craven Cottage, London**

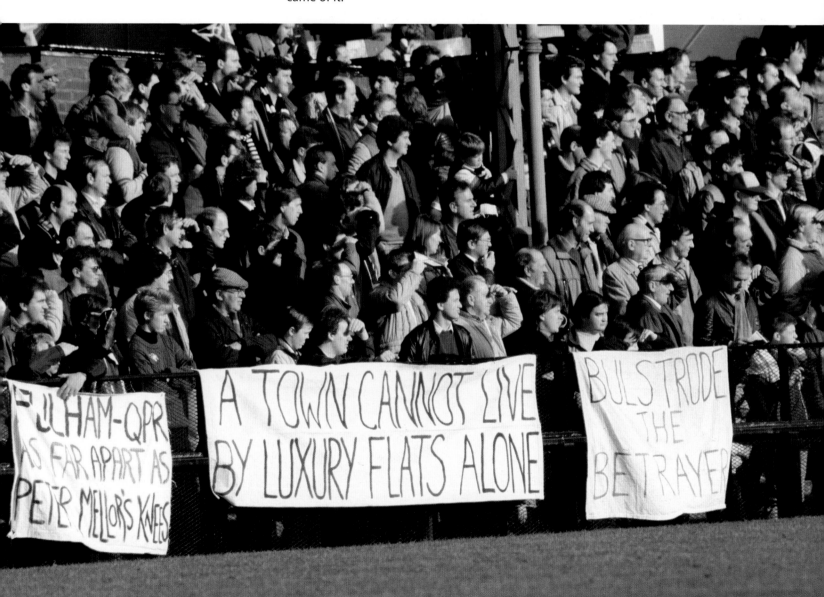

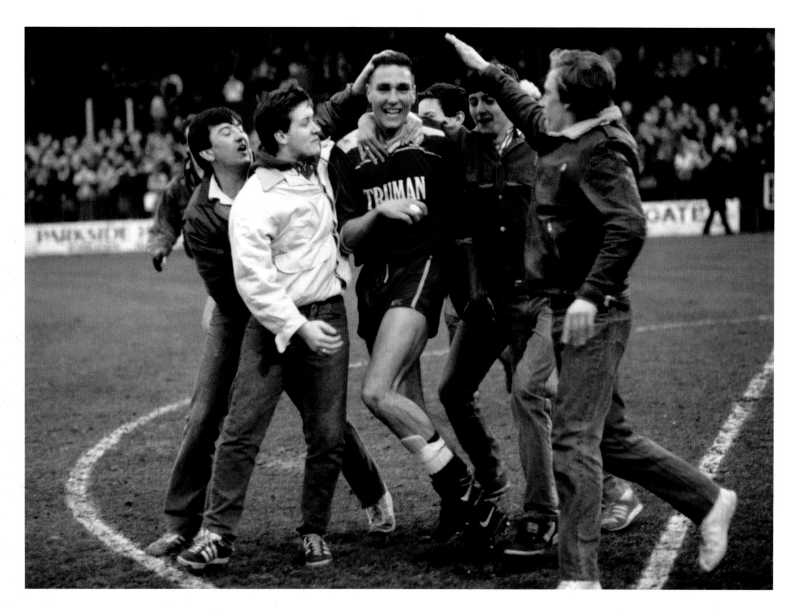

WOMBLING FREE

Jubilant Wimbledon fans rush onto the pitch to celebrate with Vinnie Jones. The Dons have just beaten Watford to progress to the semi-finals of the FA Cup for the first time in their history.

Date: **12th March, 1988**
Venue: **Plough Lane, London**

MARCHING ON TOGETHER

A happy Leeds United fan, bedecked in his team's gold and blue colours, celebrates Lee Chapman's goal against Arsenal as United gain a point and move one step closer to winning the league title.

Date: **22nd March, 1992**
Venue: **Highbury, London**

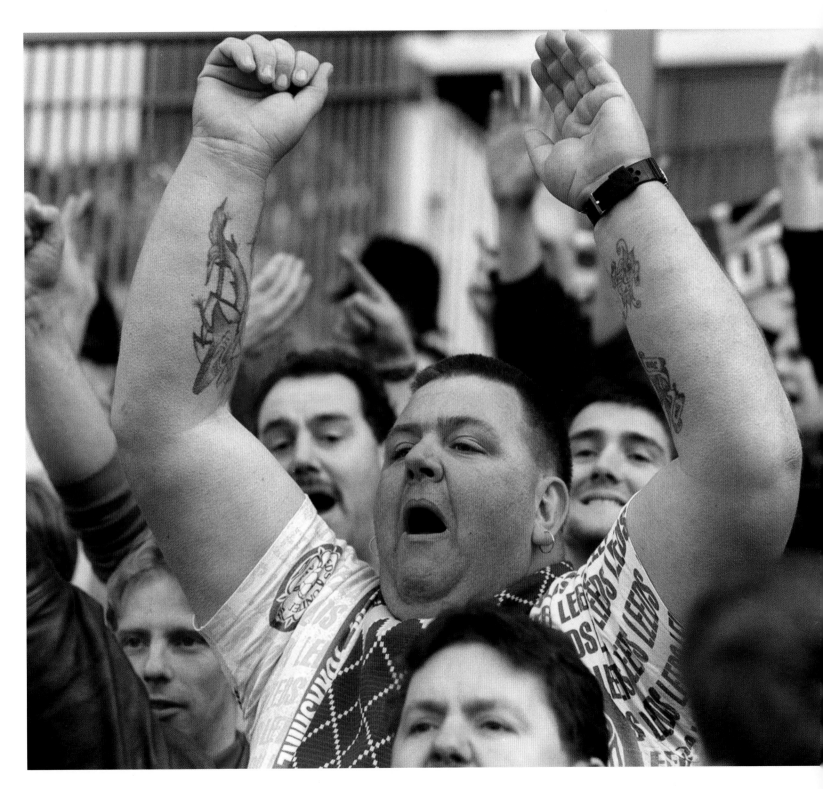

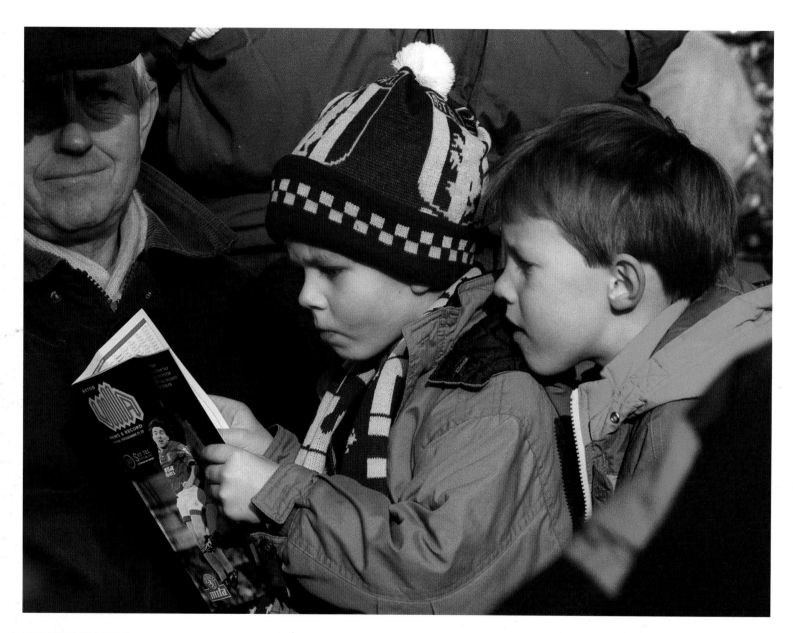

YOUNG VILLANS

Two junior Aston Villa fans intently take in all the news about their heroes from the matchday programme before their team's First Division match with Wimbledon.

Date: **27th March, 1993**
Venue: **Villa Park, Birmingham**

YOUNG OWL

A Sheffield Wednesday fan uses his matchday programme as a telescope to watch his team take on Manchester United in the League Cup semi-final. This youngster would go home disappointed, as the Owls lost 1–0.

Date: **13th February, 1994**
Venue: **Old Trafford, Manchester**

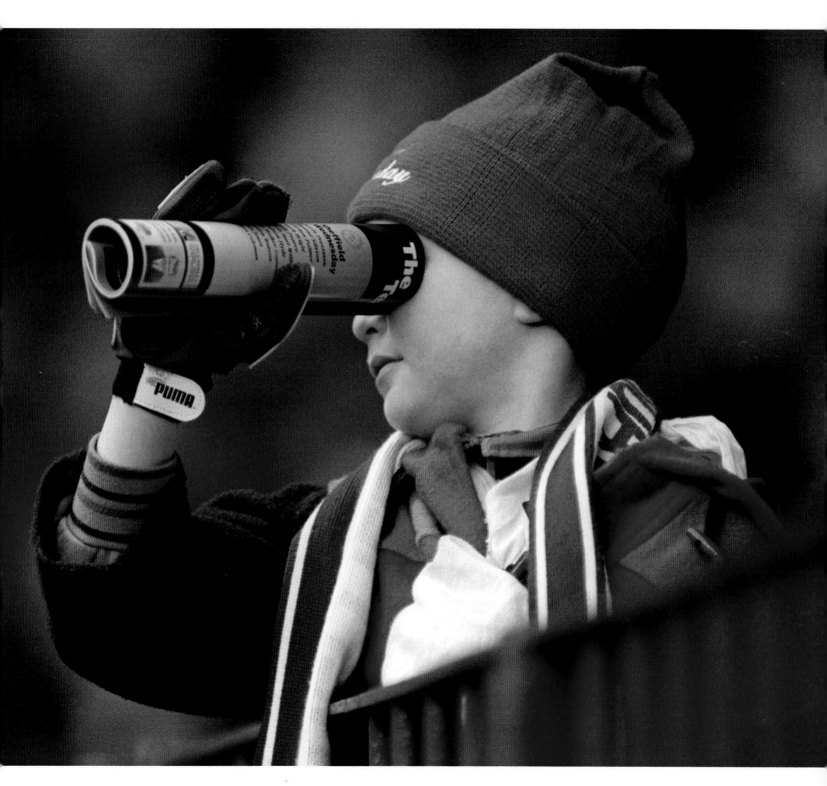

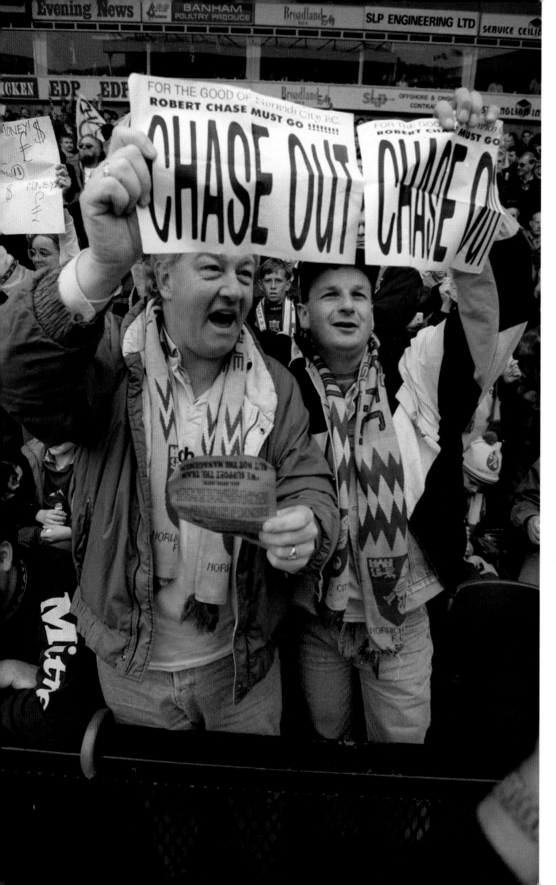

CHASE OUT

A chairman, though often the main bankroller of a football club, is also considered a transitory guardian by the fans. Norwich City supporters make their feelings known about the way chairman Robert Chase is running the club.

Date: **29th April, 1995**
Venue: **Carrow Road, Norwich**

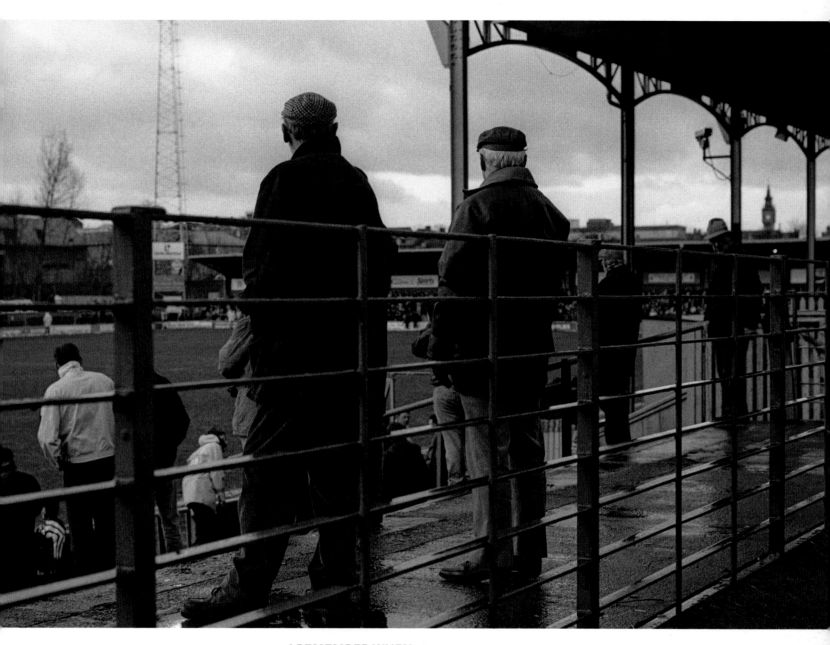

I REMEMBER WHEN...
A sparse crowd watches Darlington beat
Leyton Orient 2-0 on a freezing cold wet
February afternoon.

Date: **3rd February, 1996**
Venue: **Feethams, Darlington**

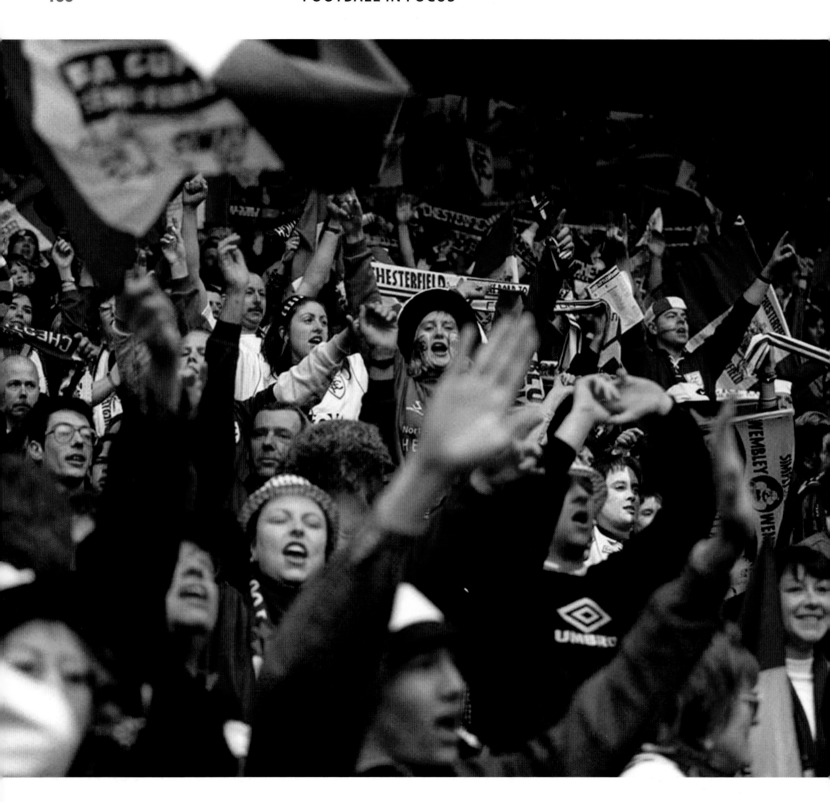

A-SPIRE-ING TO GREATNESS

Chesterfield fans are in good voice during the Spireites' FA Cup semi-final against Middlesbrough at Old Trafford. The third-tier side took a 2–0 lead but the match finished 3–3 after extra time. There was to be no dream final for the underdogs as Middlesbrough won the replay 3–0.

Date: **13th April, 1997**
Venue: **Old Trafford, Manchester**

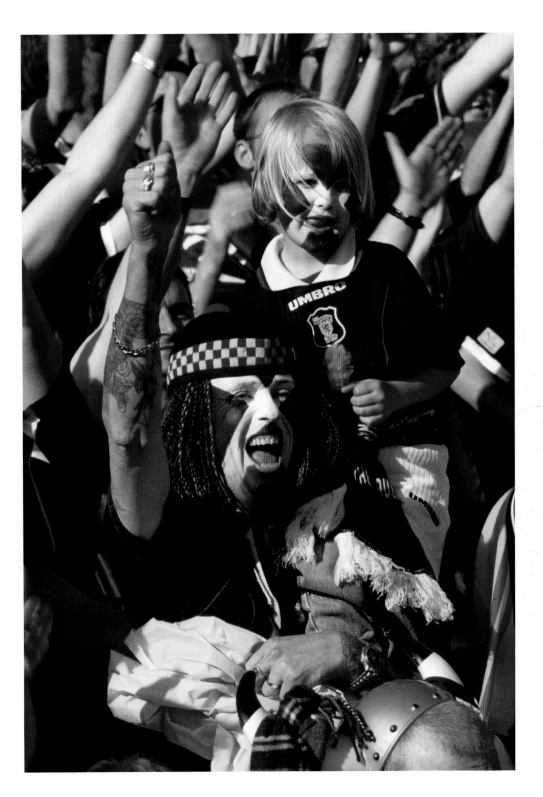

SCOTLAND THE BRAVE

A young face-painted Scotland fan joins in the cheers of the Tartan Army as her team takes on Norway at the 1998 World Cup in France.

Date: **16th June, 1998**
Venue: **Parc Lescure, Bordeaux**

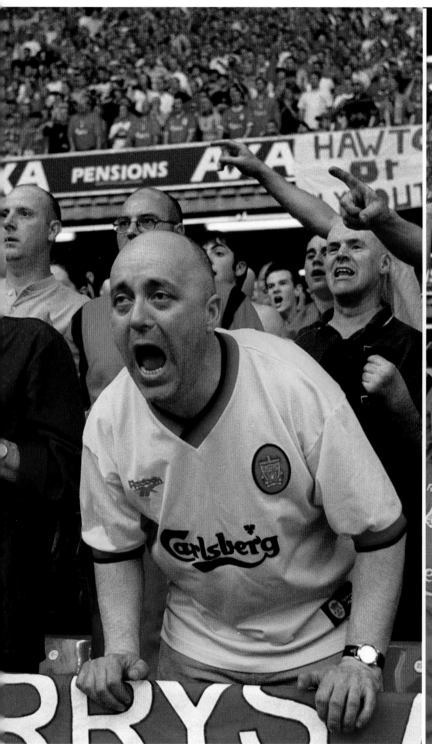
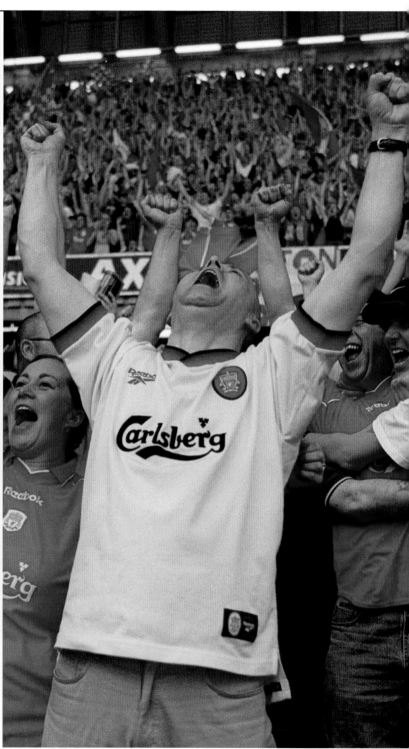

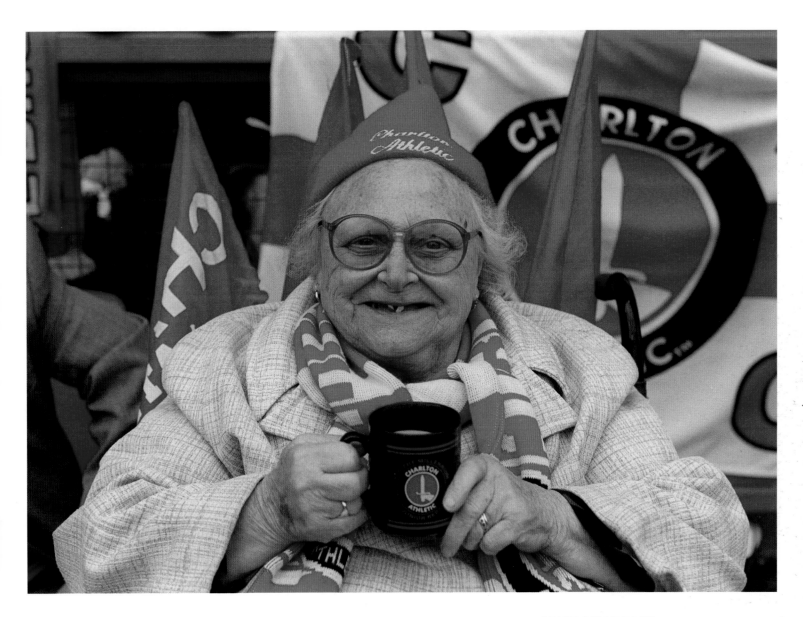

COME ON REF!

Tense Liverpool fans scream at the referee to blow the final whistle… and then erupt with joy at the 2001 FA Cup Final. Their side has come from 1–0 down to beat Arsenal 2–1 at the Millennium Stadium in Wales.

Date: **12th May, 2001**
Venue: **Millennium Stadium, Cardiff**

ONCE AN ADDICK…

An elderly Charlton Athletic fan, mug of tea in hand, enjoys a game at The Valley, even though her team loses 4–0 to Liverpool.

Date: **19th May, 2001**
Venue: **The Valley, London**

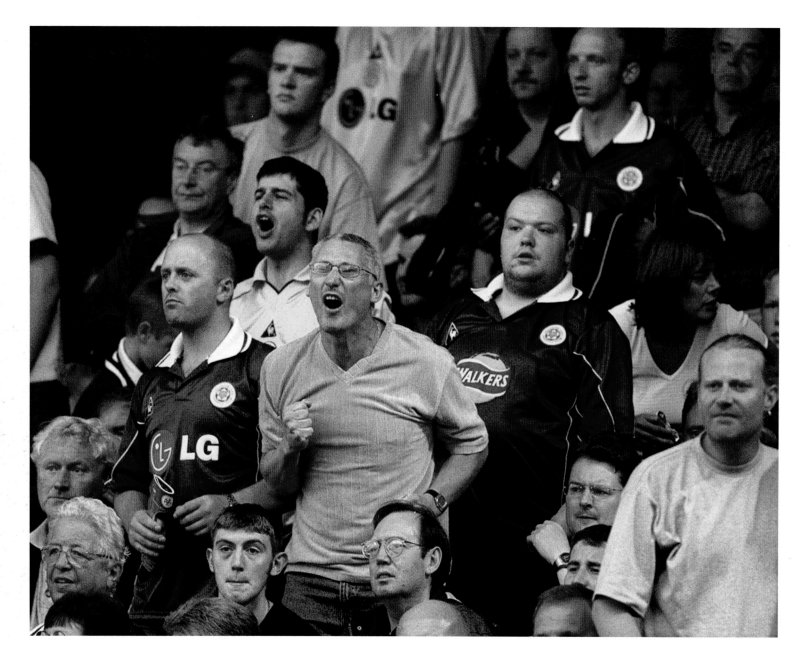

CITY'S LIMITS

Unhappy fans voice their disapproval as Leicester City head for the changing rooms 4–0 down at half-time. It doesn't get any better in the second half as Bolton Wanderers score again to win 5–0.

Date: **18th August, 2001**
Venue: **Filbert Street, Leicester**

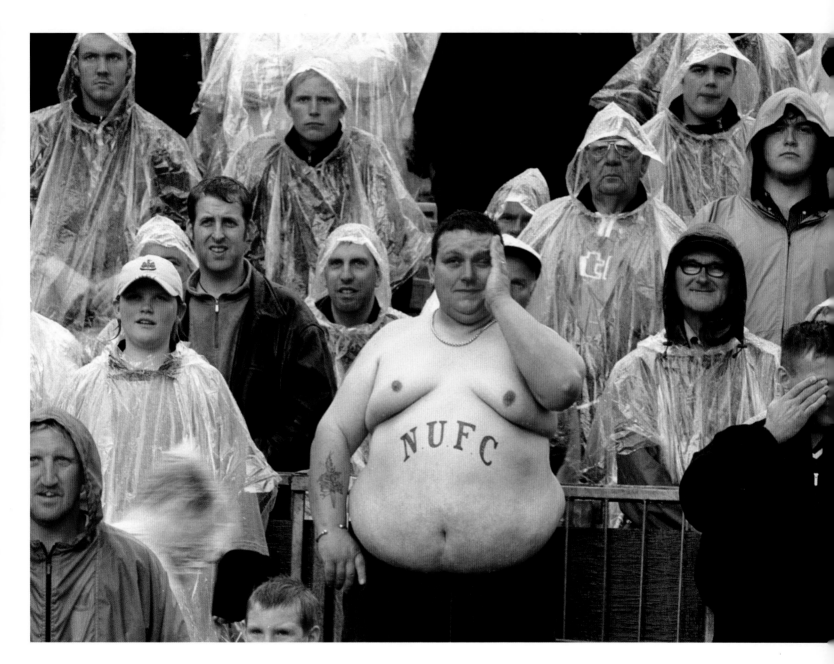

WHAT RAIN?

A Newcastle United fan ignores the English summer elements – and the raingear of his fellow fans – while watching his beloved Magpies lose 1–0 to Manchester City in the Premiership.

Date: **24th August, 2002**
Venue: **Maine Road, Manchester**

MIND THE GAPS *(Previous page)*
Cheeky spectators try and get a glimpse of
Manchester United's FA Cup fourth-round
visit to Northampton Town.

Date: **25th January, 2004**
Venue: **Sixfields, Northampton**

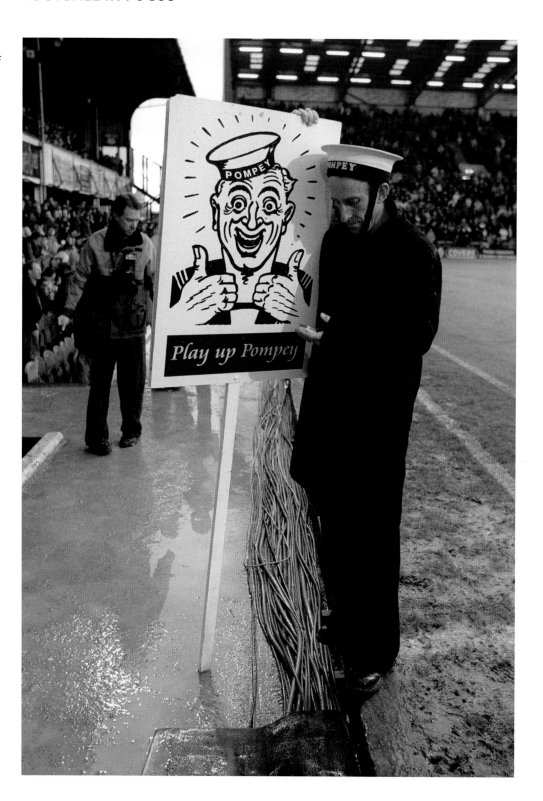

PLAY UP POMPEY
A soaked Portsmouth fan looks less than
enthusiastic as he carts round a board
reminding his fellow supporters of their
signature chant. It doesn't work out that
badly, as his side draws 1–1 with Arsenal.

Date: **4th May, 2004**
Venue: **Fratton Park, Portsmouth**

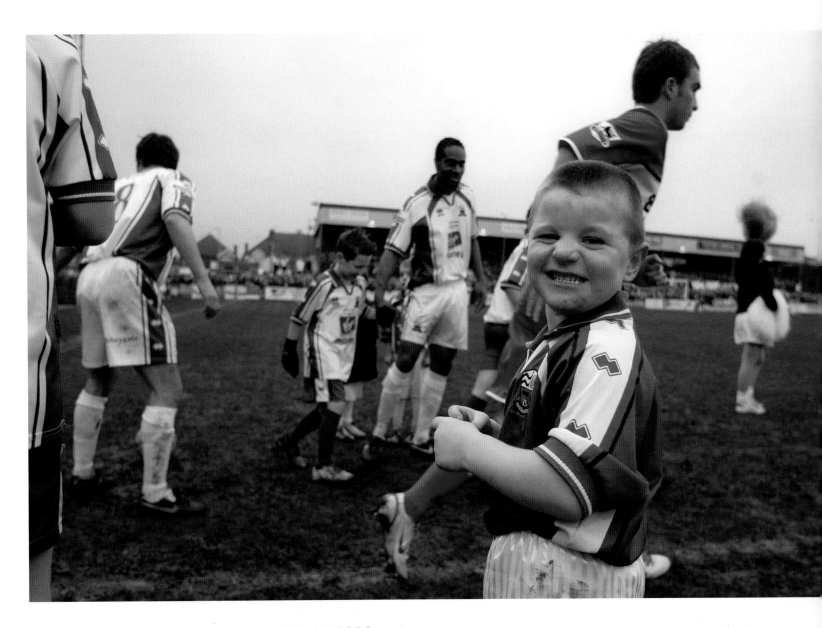

BORO V BORO

The young Nuneaton Borough mascot snarls cheekily at the camera before an FA Cup third-round tie against Premiership Middlesbrough. The non-league side earns a highly commendable 1–1 draw before succumbing 5–2 in the replay at The Riverside.

Date: **7th January, 2006**
Venue: **Manor Park, Nuneaton**

HAPPY MILLERS

The final day of the season brings untold drama, tears, relief and joy. Rotherham United fans jubilantly spill onto the pitch as their team's 0–0 draw with MK Dons means they avoid relegation to the fourth tier of English football.

Date: **6th May, 2006**
Venue: **Millmoor, Rotherham**

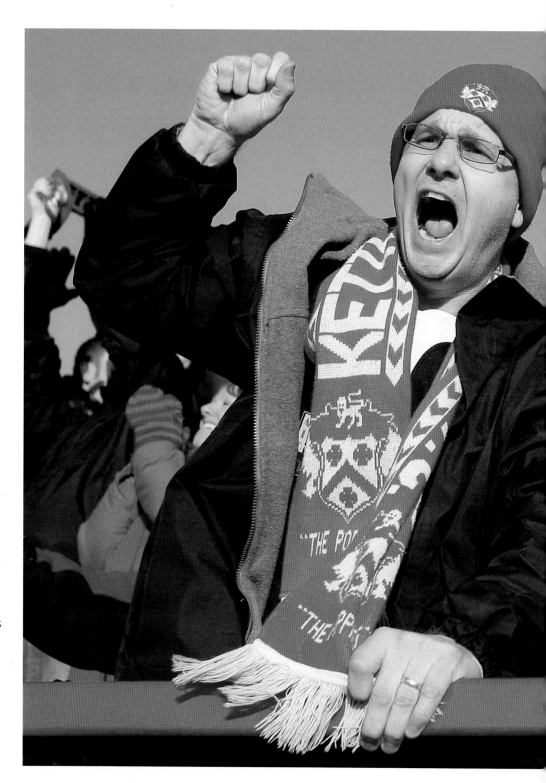

POPPY LOVE

The FA Cup often throws up enticing draws, allowing supporters of smaller sides a chance to see big clubs come to their ground. Kettering Town supporters cheer their team's first-half goal against Fulham – four divisions above them – in a fourth-round tie.

Date: **24th January, 2009**
Venue: **Rockingham Road, Kettering**

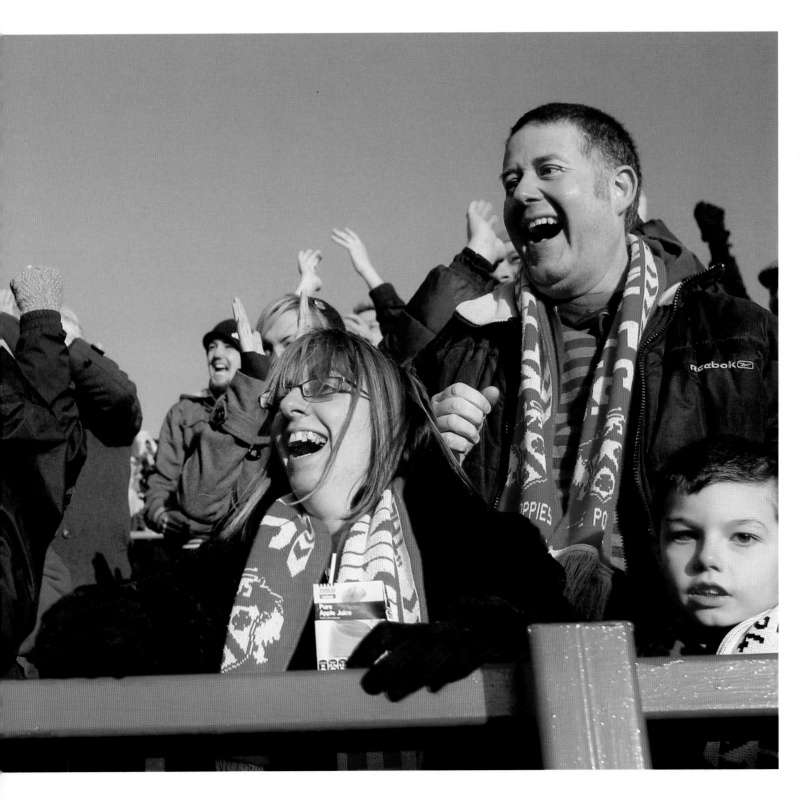

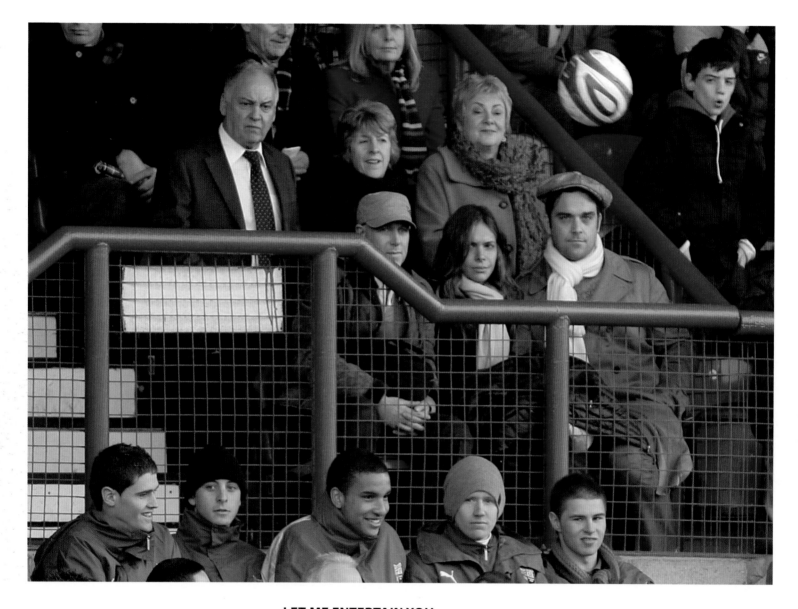

LET ME ENTERTAIN YOU
Don't let anyone fool you into thinking that with celebrity status comes celebrity fandom. Mad keen Port Vale fan Robbie Williams watches his beloved side lose 2–0 to Brentford.

Date: **14th February, 2009**
Venue: **Griffin Park, London**

WIMBLEDON SHIFT

The original Wimbledon Football Club moved to Milton Keynes in 2003, becoming MK Dons for the 2004–5 season. Meanwhile, many fans regrouped and formed AFC Wimbledon, who now play just outside the Football League. Here, AFC Wimbledon fans take cover against the rain in a Blue Square South match against Basingstoke Town.

Date: **10th April, 2009**
Venue: **Kingsmeadow, Kingston upon Thames**

SANTA RANT

A fan dressed as Santa Claus, watching Stoke City against Wigan Athletic, momentarily loses his Christmas spirit and lets his feelings be known to the opposition supporters…

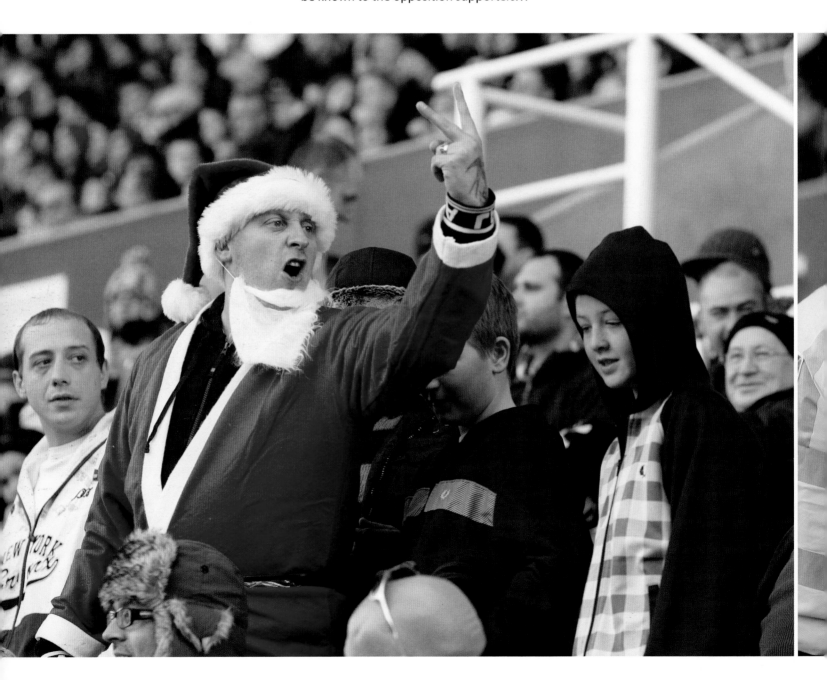

…until a kindly bobby steps in and
reminds him of his seasonal obligations.

Date: **12th December, 2009**
Venue: **Britannia Stadium, Stoke-on-Trent**

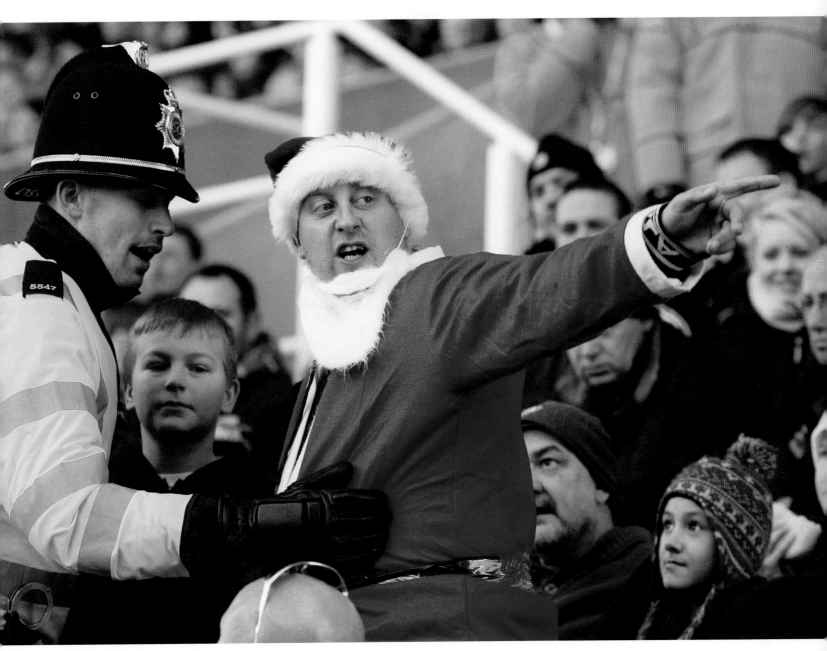

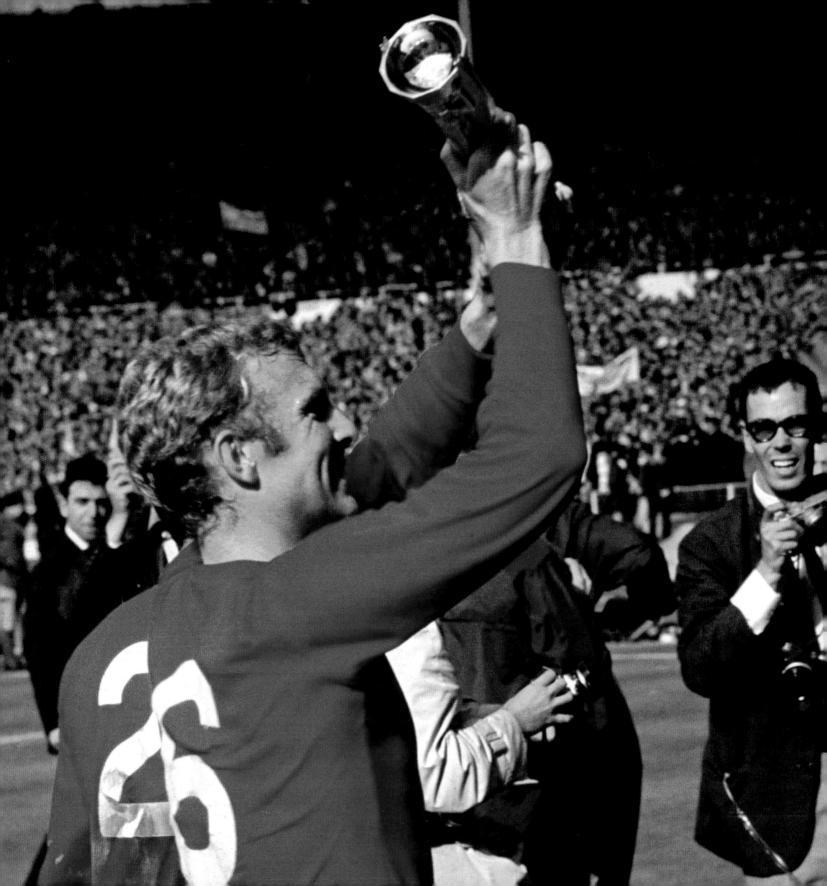

5 THE MATCHES

Great matches are defined by individual acts of brilliance, excellent passing and teamwork, non-stop, end-to-end action – or sometimes all the above, with multiple sendings-off and a dog on the pitch thrown in for good measure.

Other matches are 'great' if they mean something to you personally; maybe your team were up for promotion or desperately fighting to avoid relegation. Or maybe it was great just because you were there.

This chapter highlights action from some classic matches, some famous matches, and the odd forgettable one too.

ON TOP OF THE WORLD
Surrounded by photographers, England captain Bobby Moore holds aloft the Jules Rimet Trophy, after the host team had beaten West Germany 4–2 in the World Cup Final, giving them their first (and to date, only) World Cup win.

Date: **30th July, 1966**
Venue: **Wembley Stadium, London**

TOWERING SAVE

Blackpool goalkeeper Tony Walters successfully dives to make a save in a First Division match against Fulham. The visitors won 1–0.

Date: **18th November, 1961**
Venue: **Craven Cottage, London**

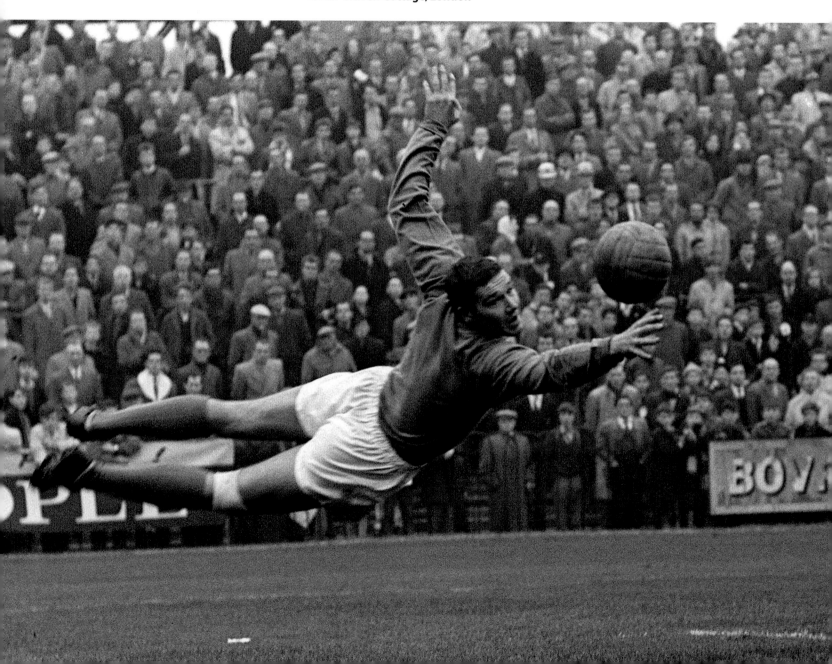

CHARITABLE IPSWICH

Tottenham Hotspur goalkeeper Bill Brown gets his fingertips to the ball, surrounded by (in white, L–R) Dave Mackay, Maurice Norman, John White and Danny Blanchflower during the 1962 FA Charity Shield match against league champions Ipswich Town. FA Cup winners Spurs went on to win the Shield 5–1.

Date: **11th August, 1962**
Venue: **Portman Road, Ipswich**

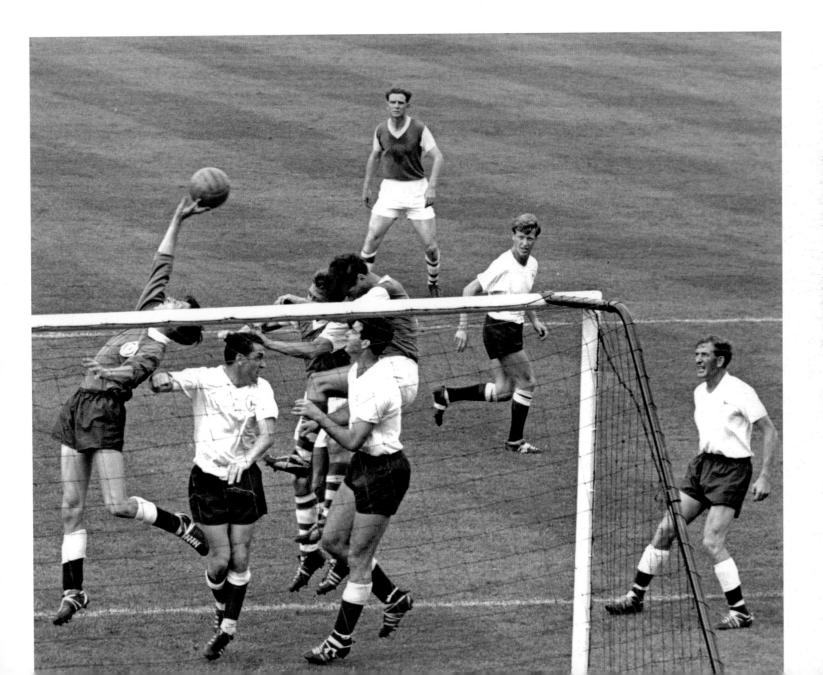

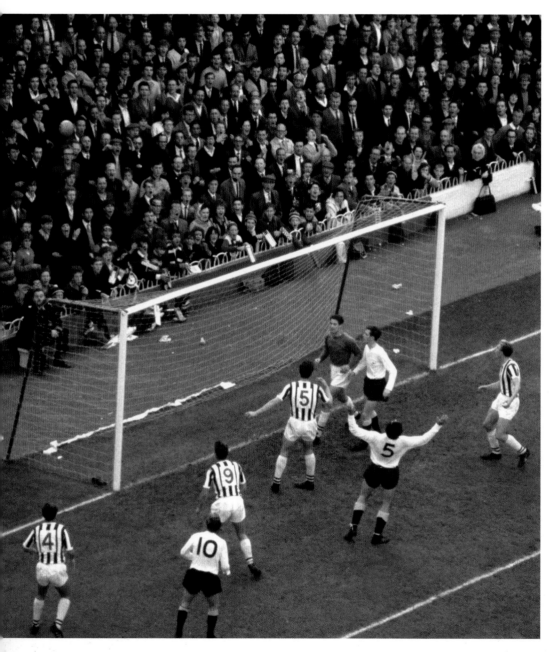

COME ON YOU SPURS

A Tottenham Hotspur player throws his hands up in exasperation as a chance goes flying over the bar against West Bromwich Albion. Spurs did run out 1–0 winners however.

Date: **19th September, 1964**
Venue: **White Hart Lane, London**

SHANKLY'S RED ARMY

The victorious Liverpool team celebrate with the FA Cup, having beaten Leeds United 2–1.
Back row: (L–R) Ron Yeats, Gordon Milne, Willie Stevenson, Ian St John, Chris Lawler, Gerry Byrne.
Front row: (L–R) Tommy Lawrence, Peter Thompson, Geoff Strong, Tommy Smith, Roger Hunt and Ian Callaghan.

Date: **1st May, 1965**
Venue: **Wembley Stadium, London**

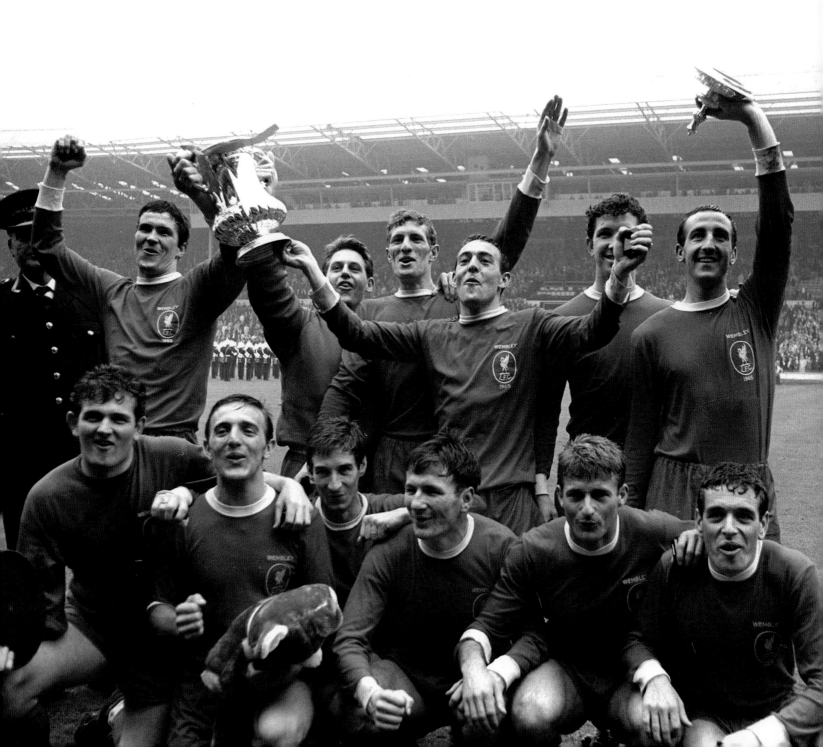

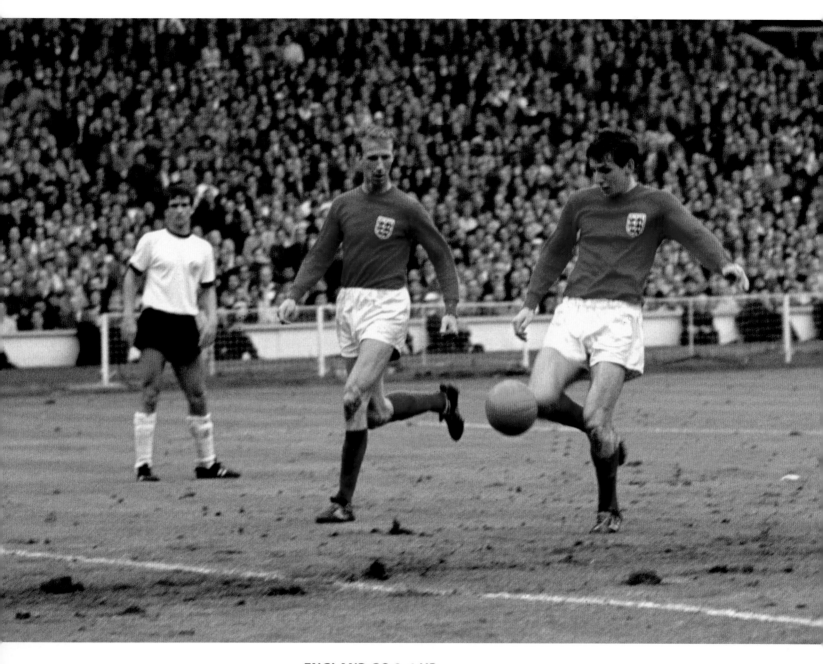

ENGLAND GO 2–1 UP
Martin Peters (R), flanked by Jack Charlton,
puts England 2–1 ahead in the 1966 World
Cup Final against West Germany…

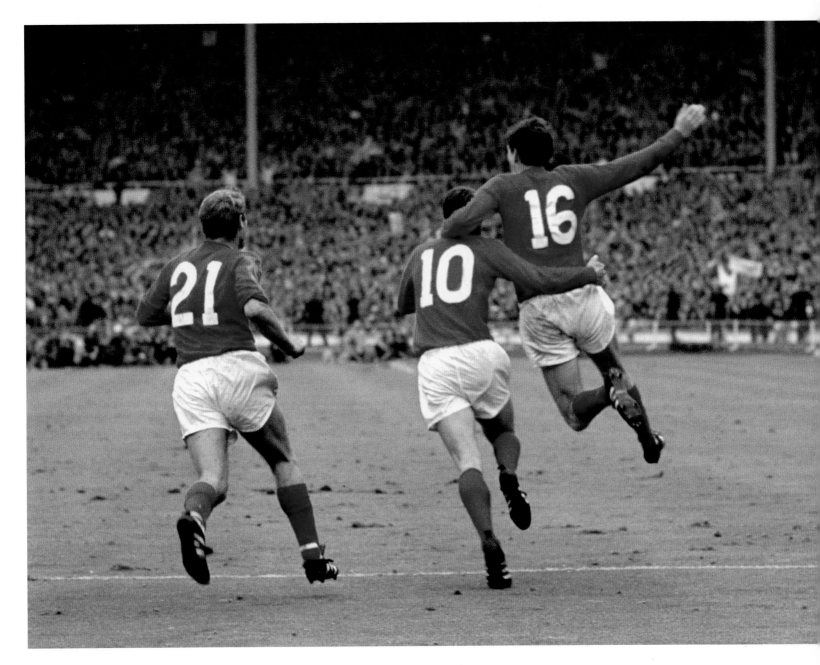

... and is joined in celebration with Roger
Hunt (21) and Geoff Hurst (10).

Date: **30th July, 1966**
Venue: **Wembley Stadium, London**

"OUR KID"

Bobby Charlton rises above the Benfica defence to score Manchester United's fourth goal in the 1968 European Cup Final. United were to become the first English side to win the competition.

Date: **29th May, 1968**
Venue: **Wembley Stadium, London**

CHAMPAGNE CHARLIE

A packed Stamford Bridge watches Chelsea's Charlie Cooke attempt a drag back while taking on West Ham United defender Bobby Moore. This First Division match finished 1–1.

Date: **21st September, 1968**
Venue: **Stamford Bridge, London**

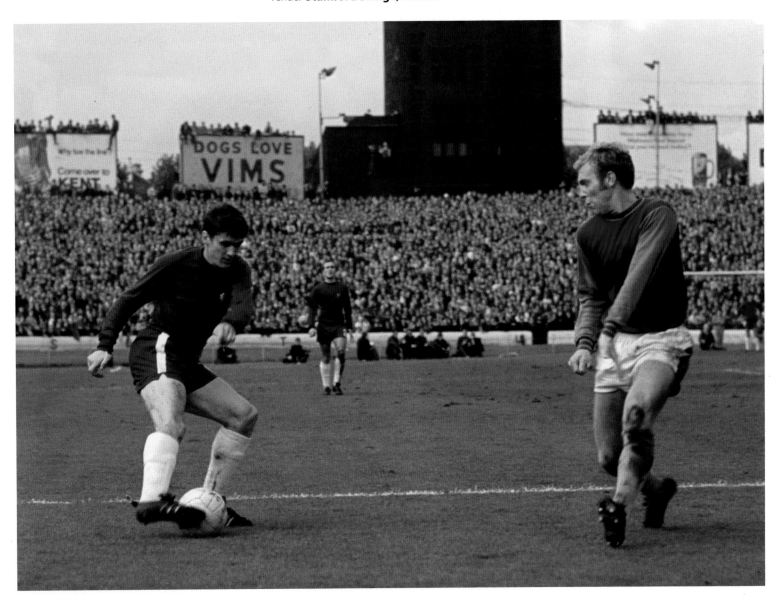

THE CAT

Chelsea goalkeeper Peter Bonetti claims the ball from on-rushing Sunderland forward Charlie Hurley (in red). Bonetti has a good day as Chelsea run out 5–1 winners.

Date: **22nd February, 1969**
Venue: **Stamford Bridge, London**

IT WAS GOING SO WELL ...

Alan Mullery (No 4) raises both hands aloft as England scores against West Germany in the 1970 World Cup quarter-final. Francis Lee wheels away with his own celebration.

Date: **14th June, 1970**
Venue: **Estadio Nou Camp, Leon, Mexico**

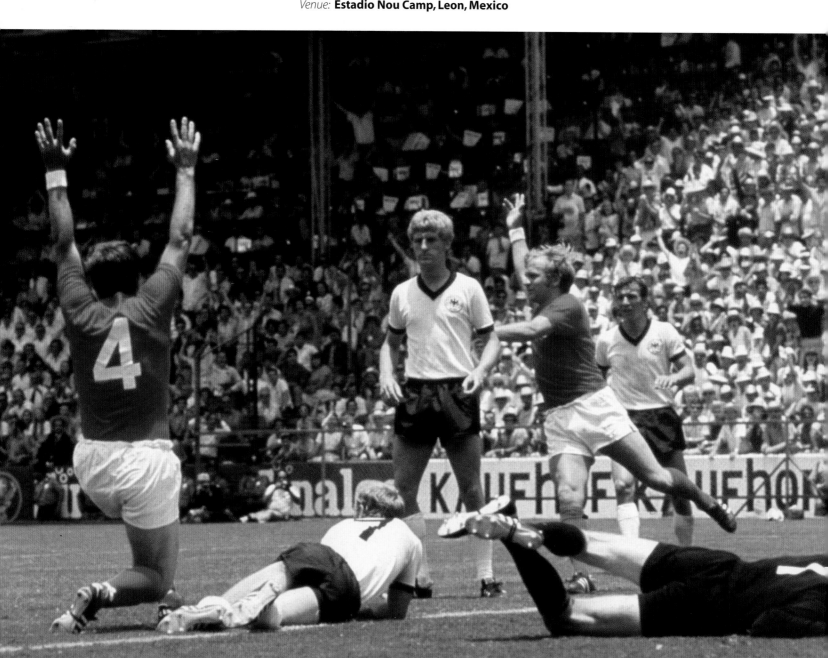

...FOR 60 MINUTES

England's Bobby Charlton takes a dramatic tumble after clashing with West Germany's Horst-Dieter Höttges in the 1970 World Cup quarter-final in Mexico. With England 2–0 up and only 30 minutes remaining, manager Alf Ramsey takes Charlton off, with the intention of preserving him for the upcoming semi-final against Italy. However, Franz Beckenbauer, previously kept busy by Charlton, is now free to orchestrate proceedings. By 90 minutes, West Germany were level, and they went on to win 3–2 in extra-time, knocking out the holders.

Date: **14th June, 1970**
Venue: **Estadio Nou Camp, Leon, Mexico**

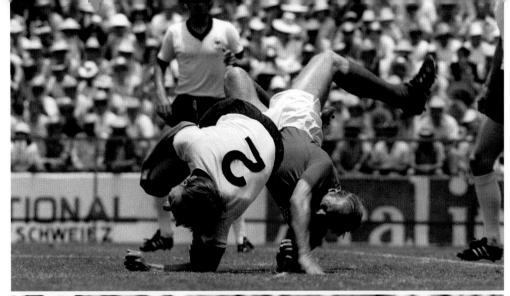

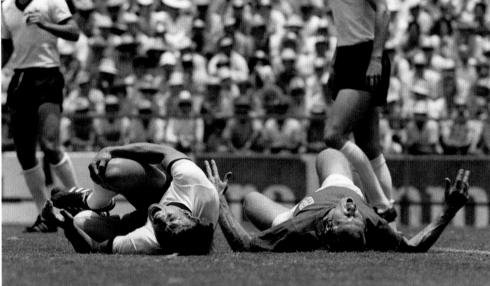

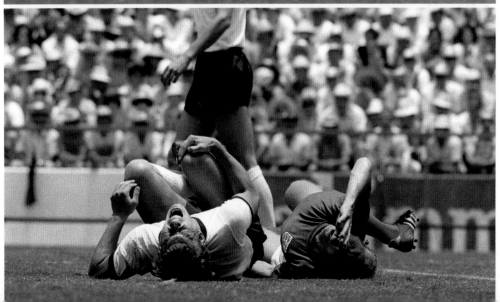

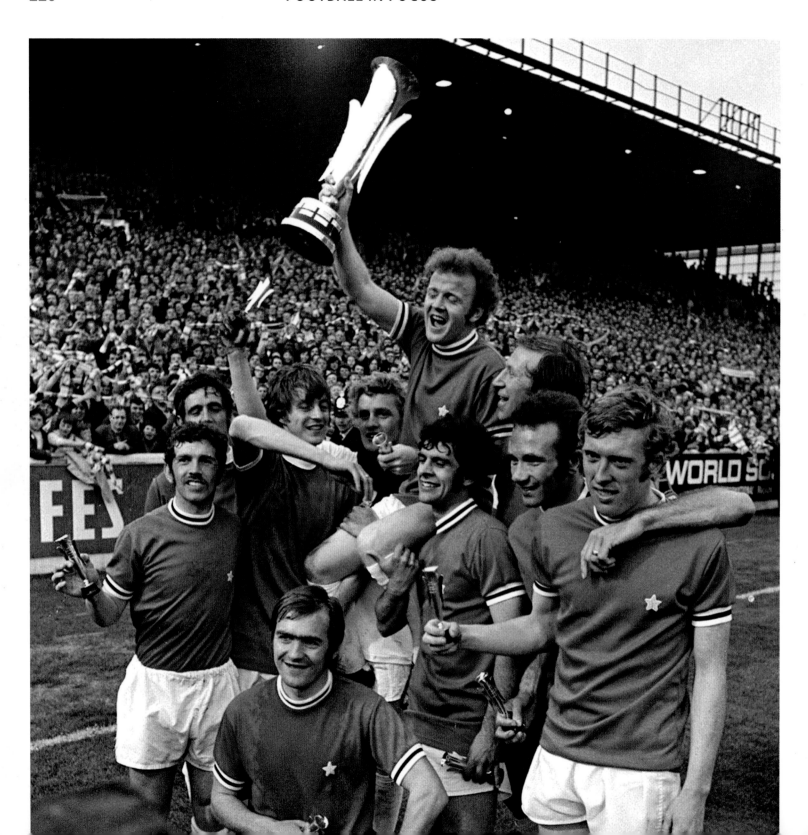

FAIR PLAY

Leeds United's Billy Bremner celebrates with his team-mates, all of whom are now wearing swapped Juventus shirts, as he holds aloft the European Fairs Cup (later UEFA Cup). Leeds beat the Italian giants on away goals.

Date: **3rd June, 1971**
Venue: **Elland Road, Leeds**

ELEGANT OSGOOD

Chelsea striker Peter Osgood makes a determined run towards the Arsenal defence, marshalled by Gunners captain Frank McLintock.

Date: **14th August, 1971**
Venue: **Stamford Bridge, London**

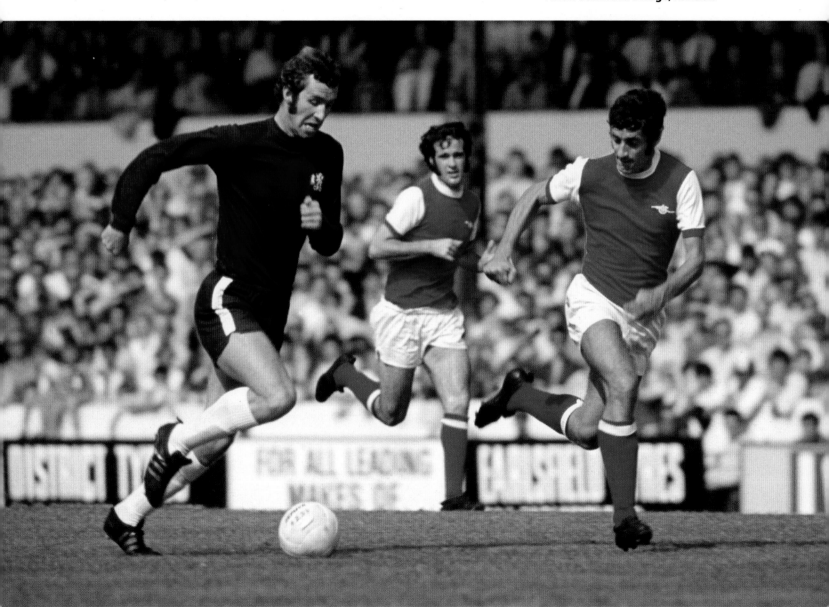

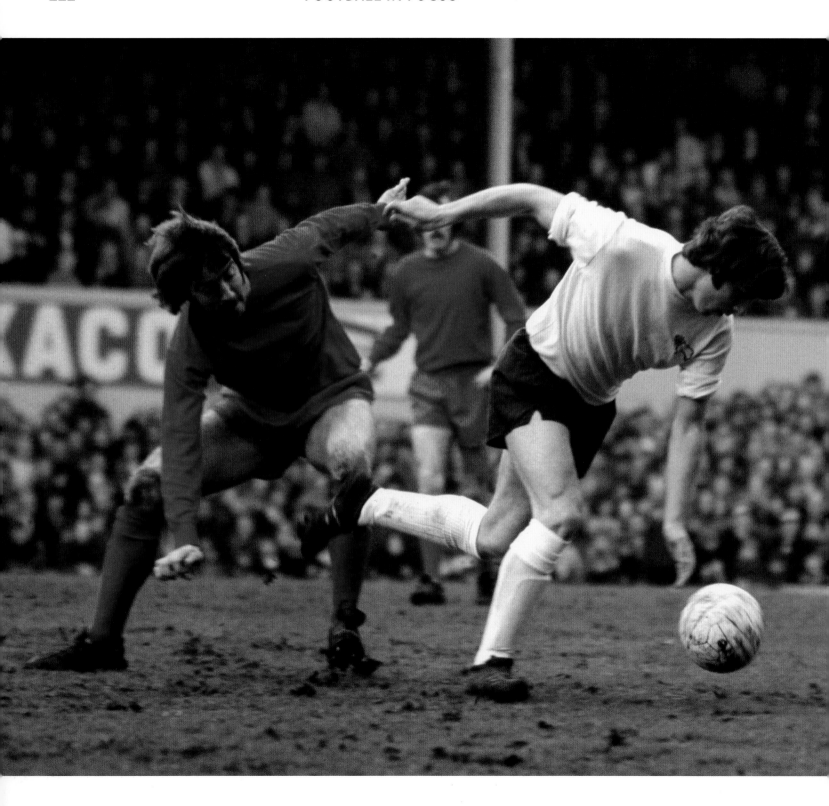

ON THEIR WAY
Derby County's Kevin Hector breaks free
from Newcastle United's Frank Clark. Later
this month, County, under the management
of Brian Clough and Peter Taylor, go on to
lift their first ever top-tier title.

Date: **3rd April, 1972**
Venue: **Baseball Ground, Derby**

HALFWAY THERE
Alan Gowling leads Huddersfield Town
off the pitch at half-time during their
Second Division match against Blackpool.
The home side finish this season-opening
match 1–0 winners.

Date: **12th August, 1972**
Venue: **Leeds Road, Huddersfield**

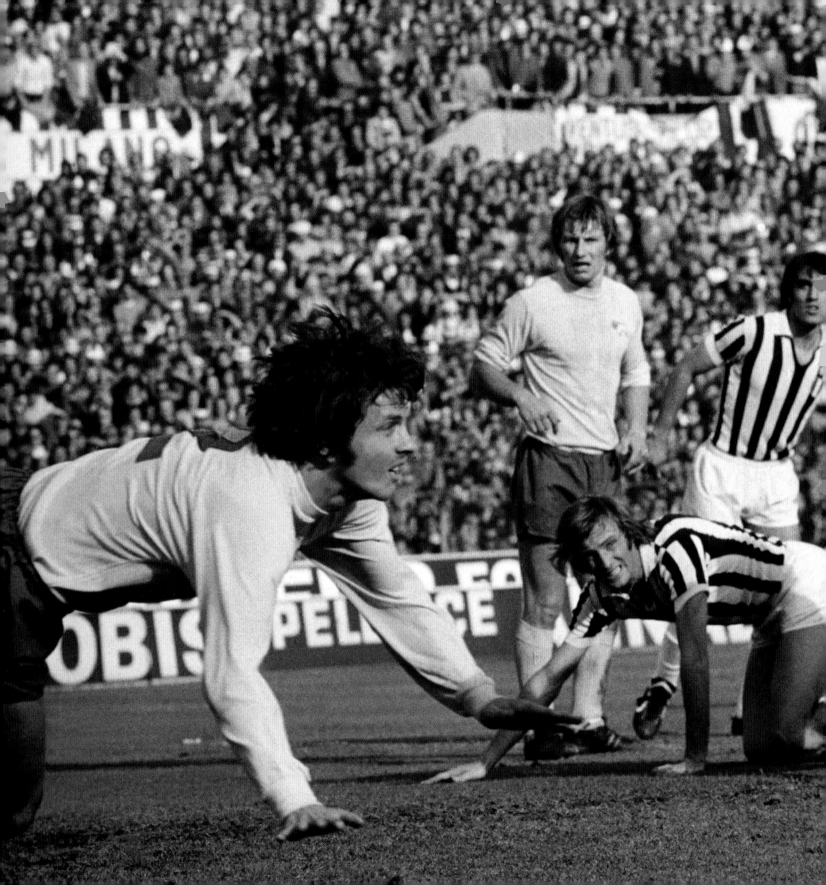

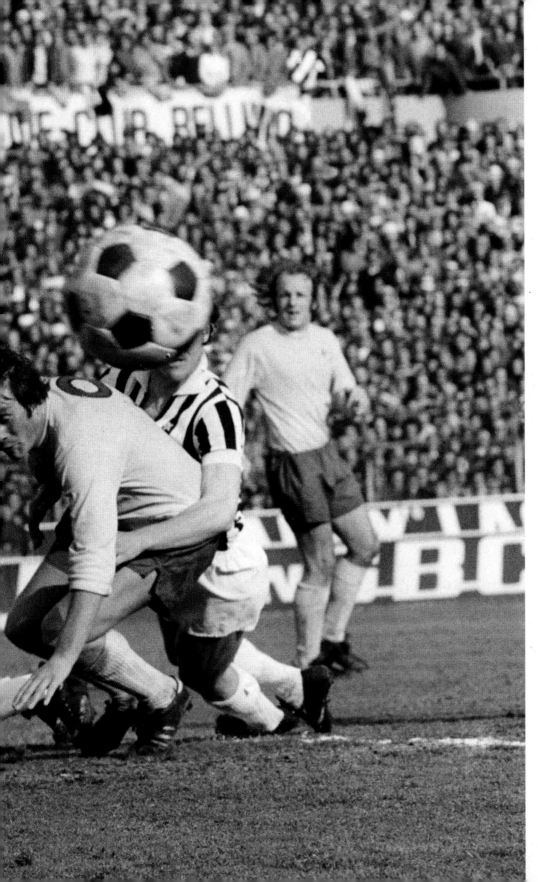

THE EYES HAVE IT

It's all fall down in the penalty area as Ron Webster (L) keeps a close eye on the ball, and (L–R) team-mates Colin Todd, John O'Hare and Archie Gemmill look on from a distance in the European Cup semi-final first-leg match between Juventus and Derby County. Juve went on to win 3–1, holding Derby to a goalless stalemate in England, before losing 1–0 to the Johann Cruyff-led Ajax Amsterdam in the final.

Date: **11th April, 1973**
Venue: **Stadio Communale Vittorio Pozzo, Turin, Italy**

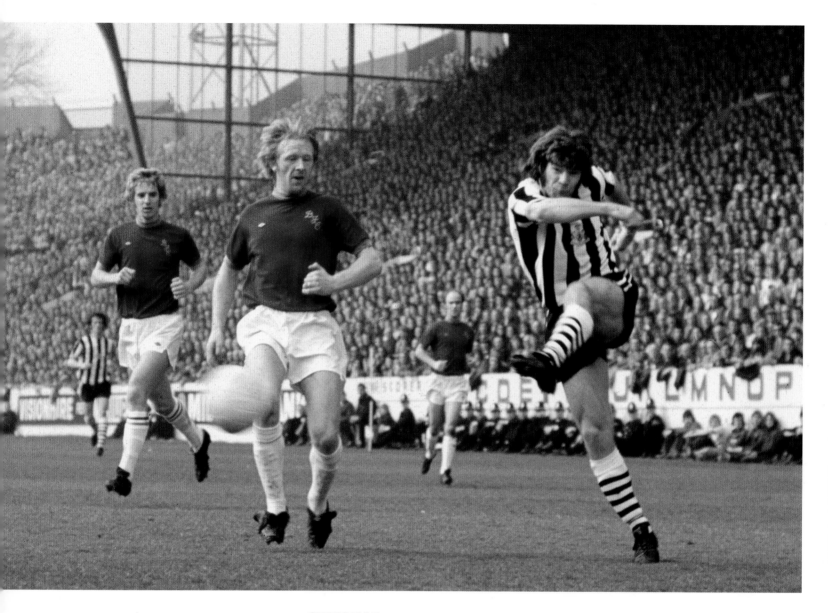

SUPERMAC

Newcastle United's Malcolm Macdonald shoots wide of the Burnley goal, watched by Geoff Nulty (L) and Doug Collins (C), during the 1974 FA Cup semi-final. Macdonald scored twice in the match, taking his side onto the final, where they lost to Liverpool.

Date: **30th March, 1974**
Venue: **Hillsborough, Sheffield**

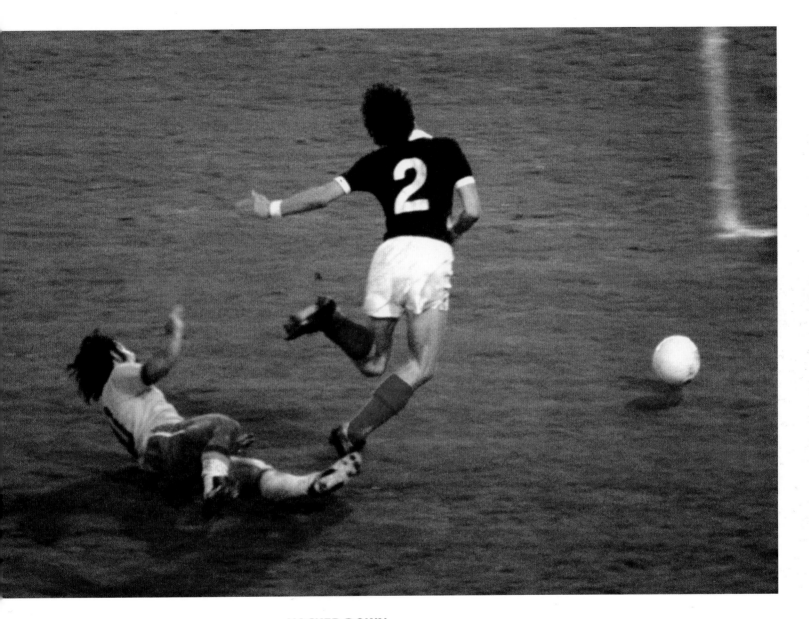

HACKED DOWN

Scotland No 2 Sandy Jardine is clobbered by Brazilian midfielder Roberto Rivelino in a goalless draw during the 1974 World Cup in West Germany. Brazil, a shadow of the team from four years previously, are shown up by new kids on the block, the Netherlands, who put on a display of 'Total Football' to defeat the holders in the second group stage. Scotland go home after the first round on goal difference, despite being undefeated.

Date: **18th June 1974**
Venue: **Waldstadion, Frankfurt, Germany**

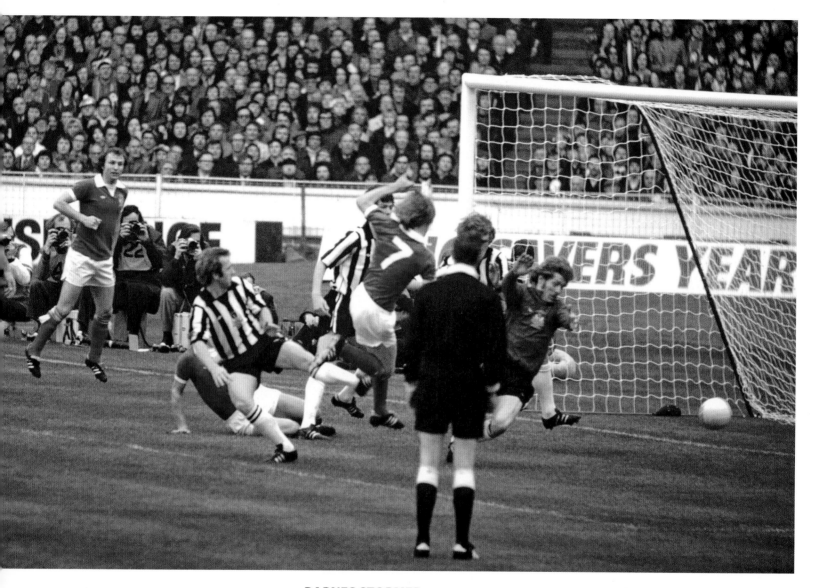

BARNES STORMER

Peter Barnes (No 7) scores Manchester City's first goal in the 1976 League Cup Final against Newcastle United. Newcastle equalised through Alan Gowling, before Dennis Tueart sealed it for City with a spectacular overhead kick.

Date: **28th February, 1976**
Venue: **Wembley Stadium, London**

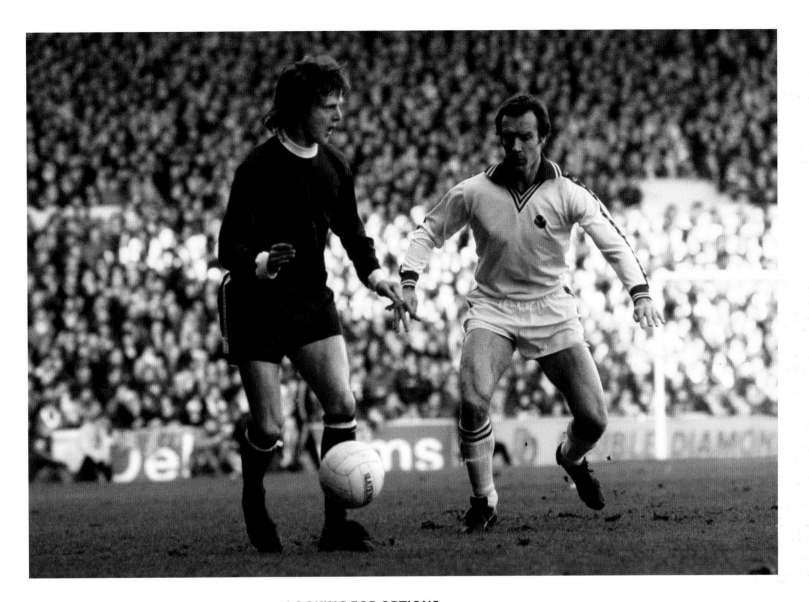

LOOKING FOR OPTIONS

Tottenham Hotspur's Neil McNab (L) looks for team-mates while Leeds United's Paul Madeley moves in for a challenge. This season proved a disaster for Tottenham as they were relegated to Division Two.

Date: **19th February, 1977**
Venue: **Elland Road, Leeds**

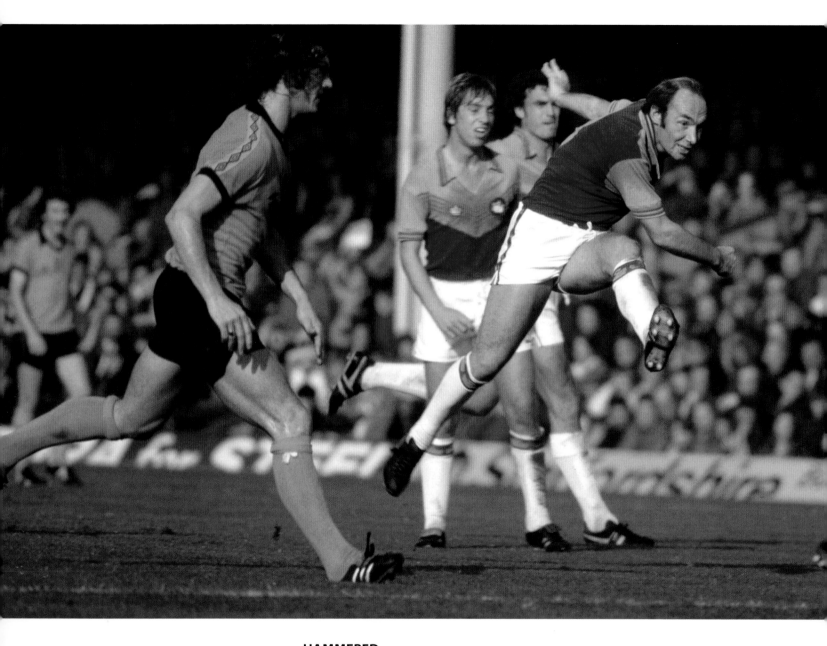

HAMMERED

West Ham United's Bryan 'Pop' Robson unleashes a left-foot thunderbolt against Wolverhampton Wanderers, watched closely by team-mates (L–R) Geoff Pike and Trevor Brooking, during an encounter that finishes 2–2.

Date: **15th October, 1977**
Venue: **Molineux Ground, Wolverhampton**

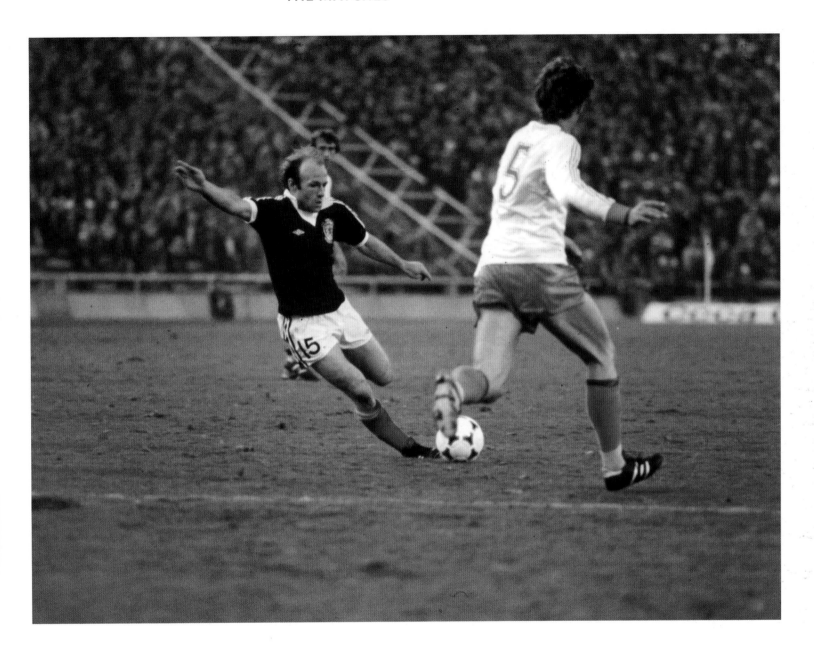

WONDER GOAL

Archie Gemmill ghosts past legendary Dutch defender Ruud Krol on his way to scoring Scotland's scintillating third goal in their defeat of the Netherlands in the 1978 World Cup.

Date: **11th June, 1978**
Venue: **Estadio Ciudad de Mendoza, Argentina**

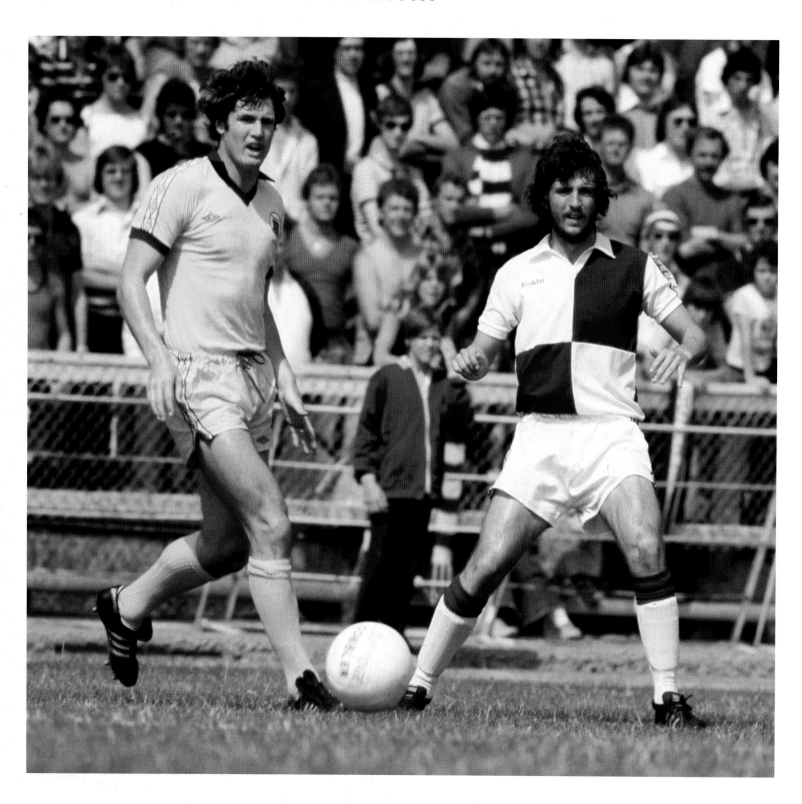

HOT WORK
Mick Lyons of Everton (L) watches Bristol Rovers' free-scoring Paul Randall's pass during a pre-season friendly on a scorching day at Eastville.

Date: **29th July, 1978**
Venue: **Eastville, Bristol**

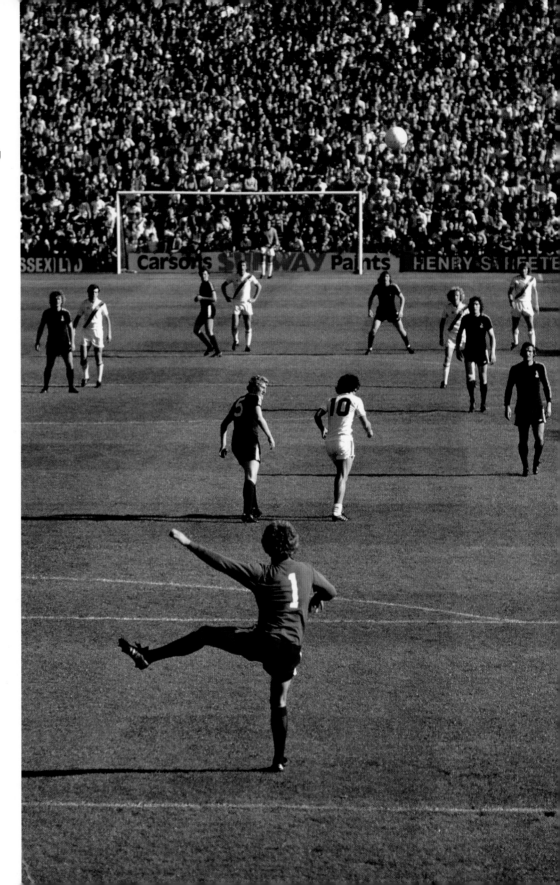

KEEPER CLEARANCE
The Oldham Athletic goalkeeper Peter McDonnell clears long in this sunshine-drenched Second Division encounter with Crystal Palace. The hosts won 1–0, and went on to win the Second Division title.

Date: **23rd September, 1978**
Venue: **Selhurst Park, London**

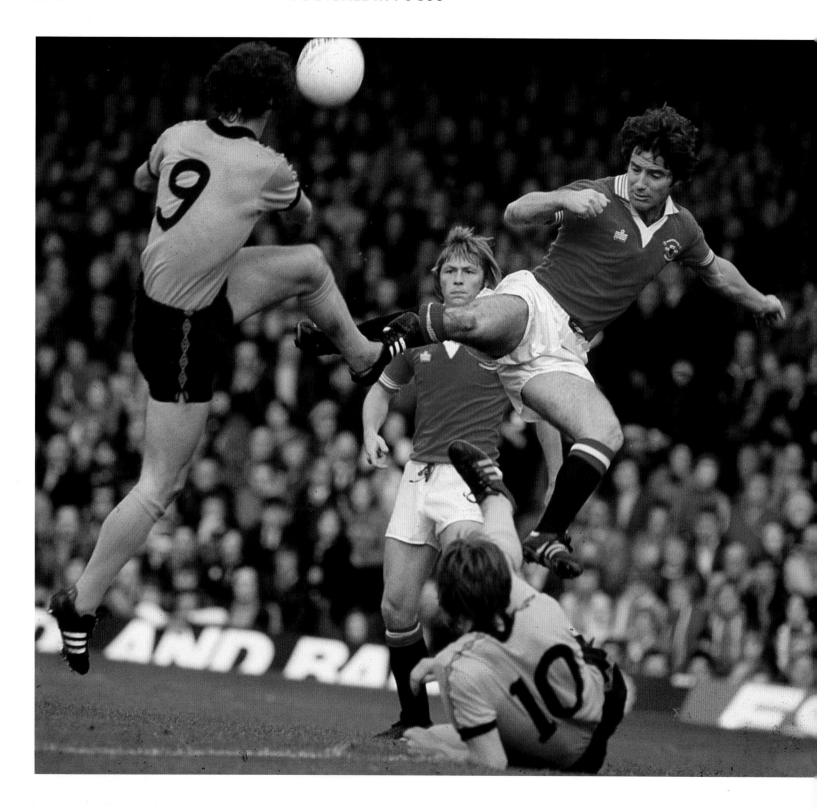

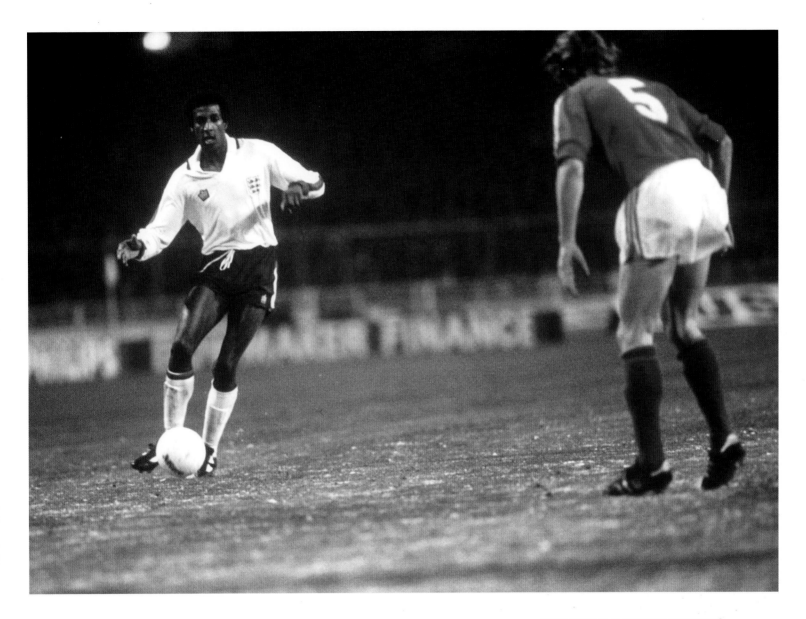

HIGH FEET

Wolverhampton Wanderers' Billy Rafferty (No 9) takes on Manchester United captain Martin Buchan in an aerial encounter. Brian Greenhoff in the background looks on. United won this First Division match 4–2.

Date: **28th October, 1978**
Venue: **Molineux Ground, Wolverhampton**

BREAKING DOWN BARRIERS

Nottingham Forest's Viv Anderson becomes the first black player to represent England. Here he is looking to take on Czechoslovakian defender Koloman Gogh.

Date: **29th November, 1978**
Venue: **Wembley Stadium, London**

RED FOR TED

Captain Brian Horton (R) and Andy Rollings of Brighton & Hove Albion protest with referee Mr Bombroff, who has given Teddy Maybank (hidden) a red card during a Second Division game against Sheffield United. The home side still go on to secure a 2–0 victory.

Date: **17th March, 1979**
Venue: **Goldstone Ground, Hove**

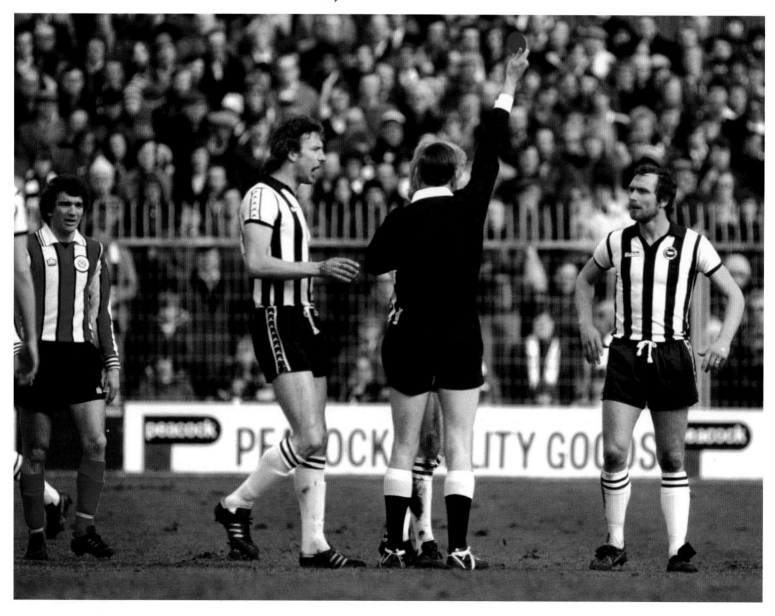

LOCAL PRIDE

The infamous glue-pot of the Baseball Ground pitch plays host to Derby County – whose star was definitely falling by the end of the 1970s – versus the team of the era, Nottingham Forest. Forest were the current First Division champions and shortly to head off to Munich to claim the European Cup. Here, Kenny Burns of Nottingham Forest (in red) has a nibble at Derby County's Andy Crawford.

Date: **14th April, 1979**
Venue: **Baseball Ground, Derby**

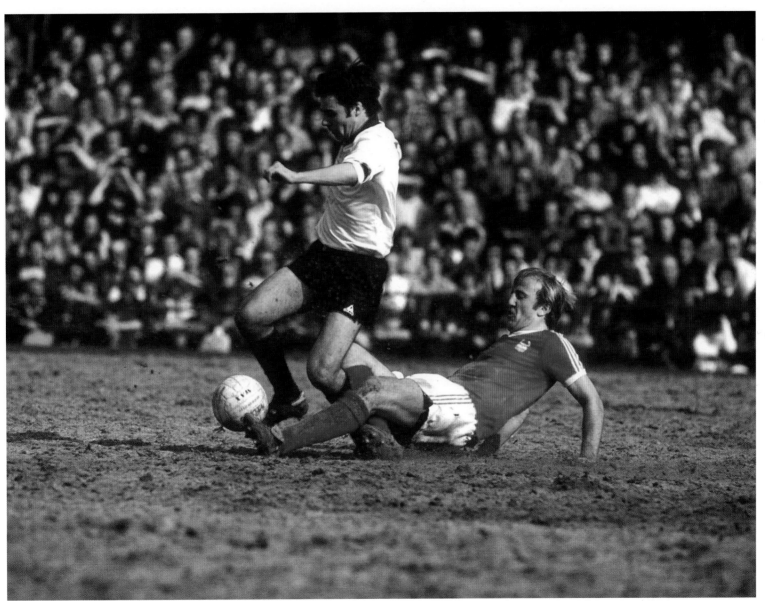

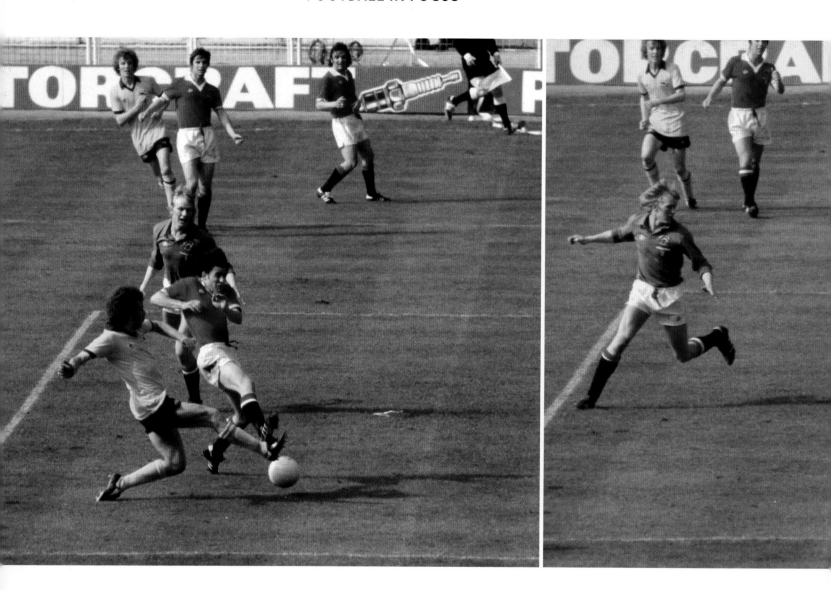

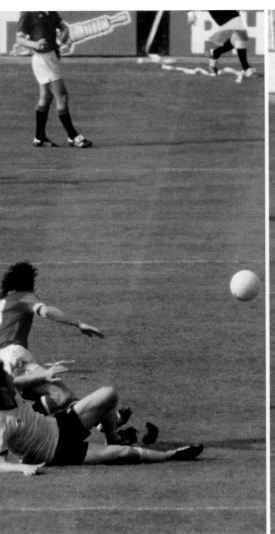

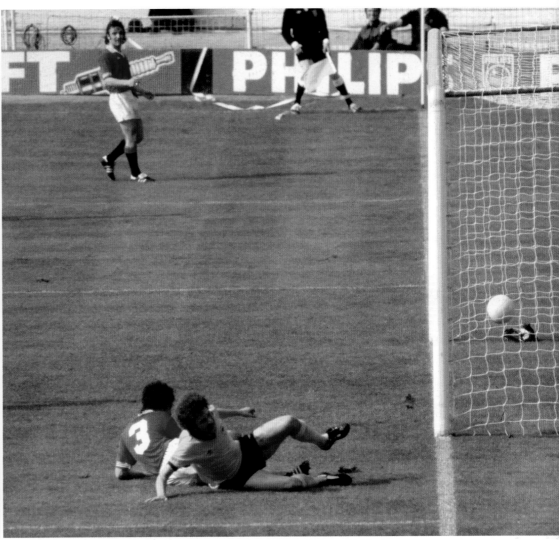

LAST-MINUTE WINNER

In the 1979 FA Cup Final, Arsenal were cruising to a fairly drab, comfortable 2–0 win over Manchester United with five minutes to play. However, it turned out to be one of the most dramatic finishes in the competition's history as Gordon McQueen (86 mins) and Sammy McIlroy (88 mins) pulled United level. In the dying seconds of the game, Graham Rix (in yellow, far L, top) sent over a far-post cross, which evaded United goalkeeper Gary Bailey (in green), for Alan Sunderland (foreground) to slide in the winner.

Date: **12th May, 1979**
Venue: **Wembley Stadium, London**

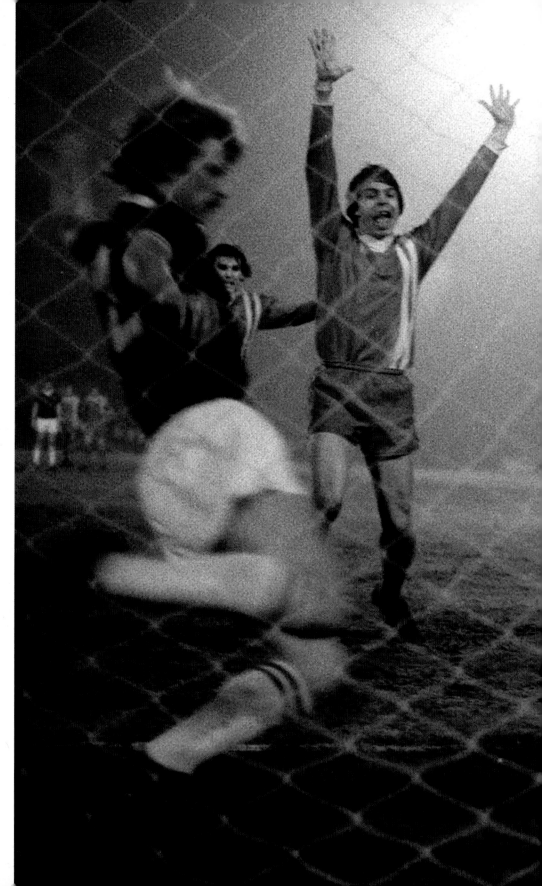

LOCAL HERO

John McKenzie scores the winning goal for Isthmian Premier League side Harlow Town against Second Division Leicester City in one of the biggest giant-killings in FA Cup history. Harlow went on to the fourth round, where they eventually lost 4–3 to Watford.

Date: **8th January, 1980**
Venue: **Sportscentre, Harlow**

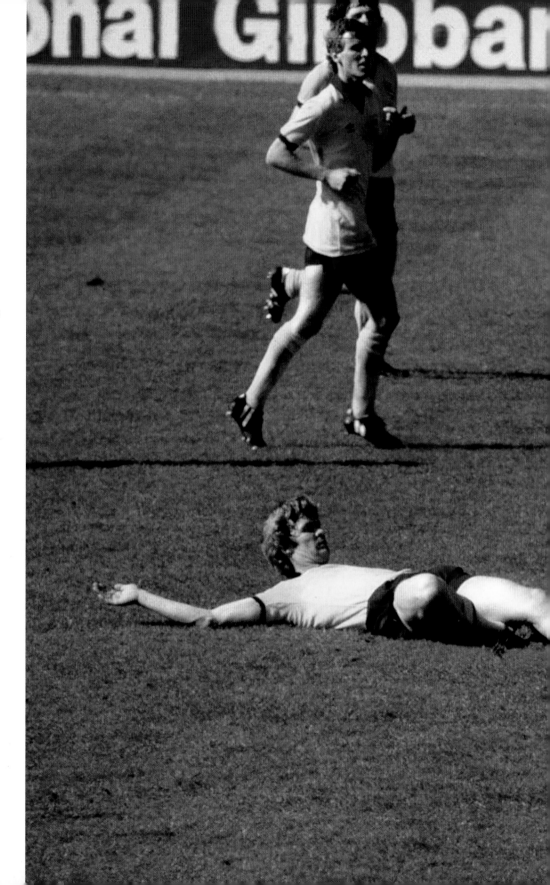

YOUNG TRIPS THE YOUNGEST

The stuff shattered dreams are made of. Seventeen-year-old Paul Allen (in white), at the time the youngest-ever player in a Wembley FA Cup Final, has been put through and only has the goalkeeper to beat, only to be tripped by Willie Young of Arsenal (in yellow, on his back). West Ham United fluff the subsequent free-kick but Trevor Brooking's early goal is enough to secure the trophy for the Hammers.

Date: **10th May, 1980**
Venue: **Wembley Stadium, London**

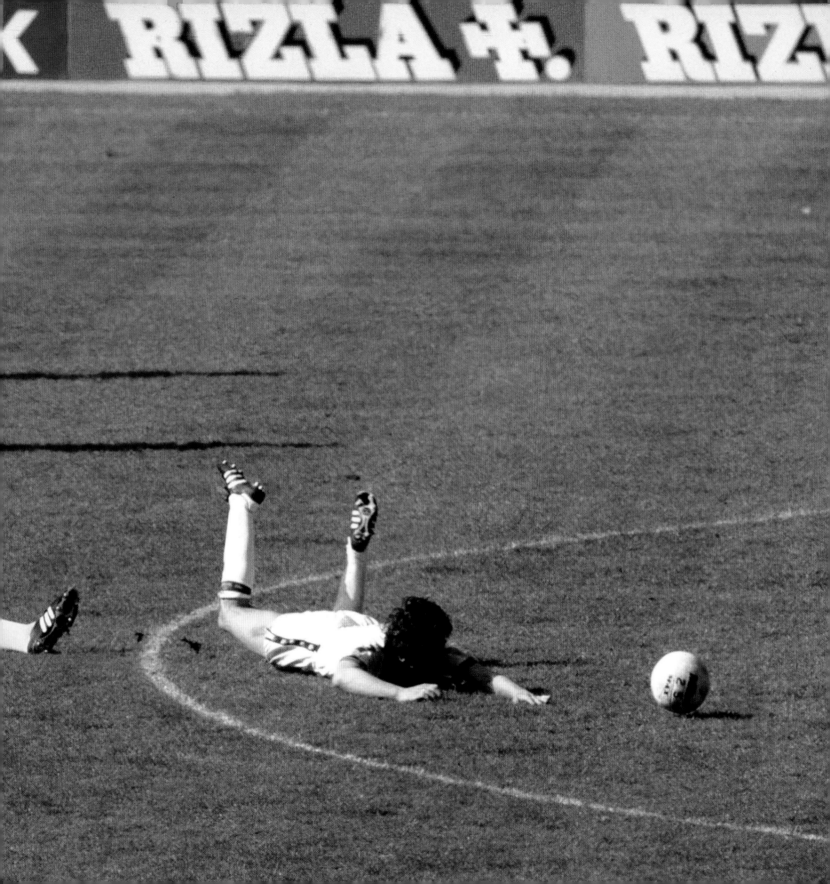

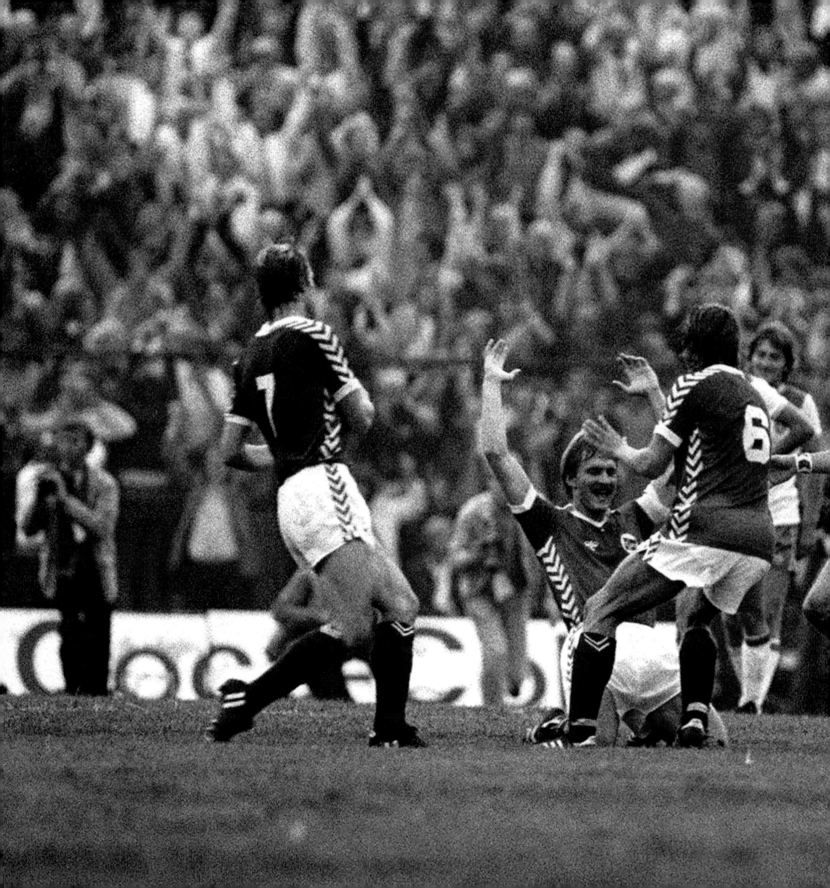

"YOUR BOYS TOOK A HELL OF A BEATING"

Roger Albertsen drops to his knees after scoring Norway's equaliser in a World Cup qualifying match in Oslo against England. Amazingly, considering Norway's footballing status at the time, the hosts score again before half-time, and hold on in the second half to secure a memorable win. Norwegian radio commentator Bjørge Lillelien got a little bit excited: *"Lord Nelson, Lord Beaverbrook, Sir Winston Churchill, Sir Anthony Eden, Clement Attlee, Henry Cooper, Lady Diana – we have beaten them all. Maggie Thatcher can you hear me? Maggie Thatcher – Your boys took a hell of a beating! Your boys took a hell of a beating!"*

Date: **9th September, 1981**
Venue: **Ullevaal Stadion, Oslo, Norway**

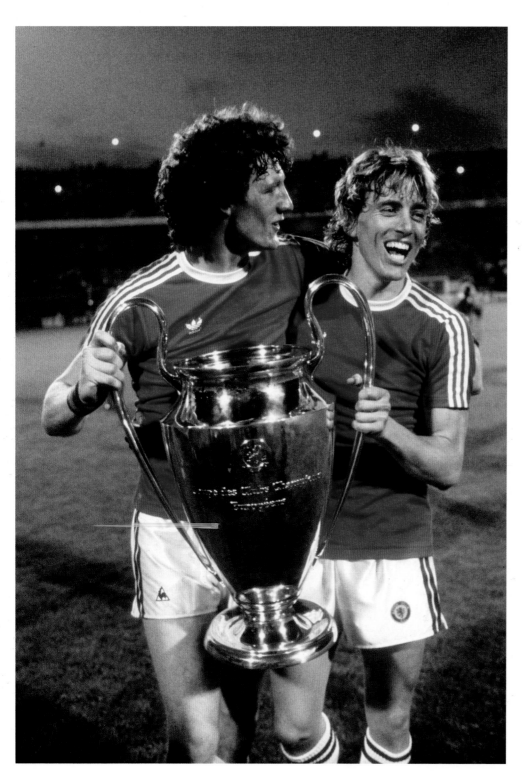

VILLA GLORY

Aston Villa's Allan Evans (L) and Tony Morley, wearing Bayern Munich shirts, hold the European Cup, having beaten the West German champions 1–0 in Holland. Peter Withe scored the game's only goal, smashing the ball home from a Morley cross.

Date: **26th May, 1982**
Venue: **Feijenoord Stadion, Rotterdam, The Netherlands**

ESPANA '82

England's Phil Thompson tussles with France captain Michel Platini during their opening World Cup match in Spain in 1982. England won 3–1, with Bryan Robson scoring after 27 seconds. However, England ran out of steam as the tournament wore on, while France went from strength to strength, losing in a semi-final shoot-out against West Germany.

Date: **16th June, 1982**
Venue: **Estadio San Mamés, Bilbao, Spain**

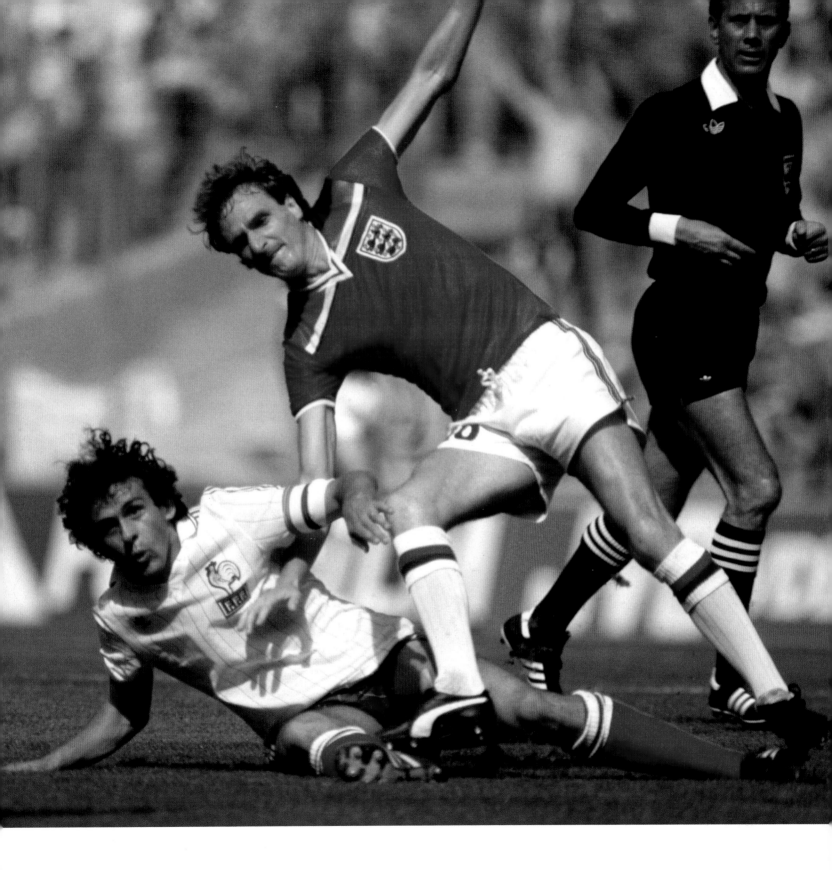

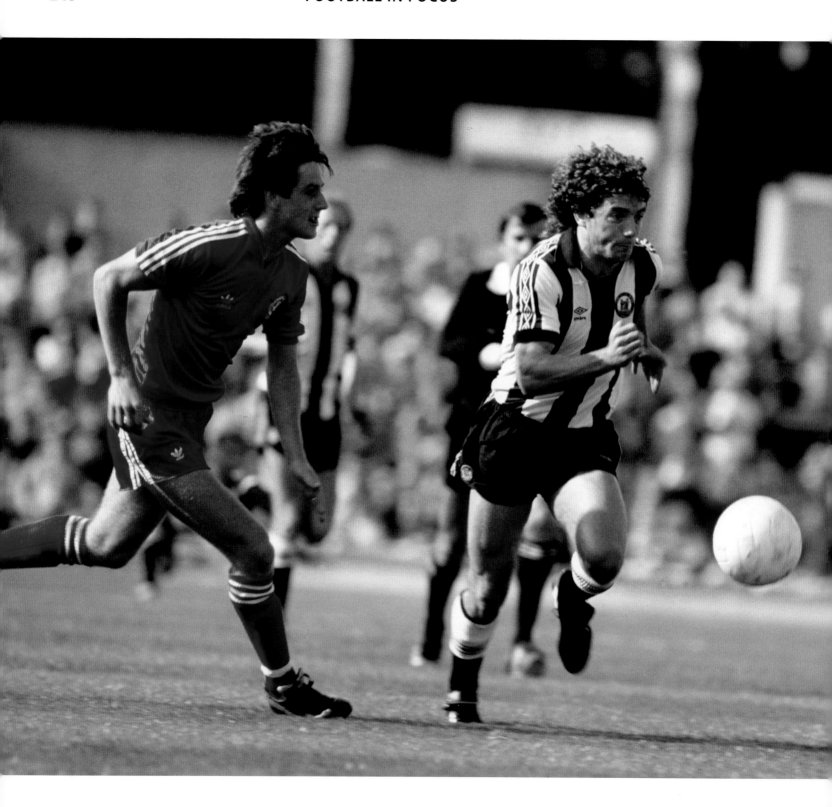

MAGPIE ON THE BALL

Kevin Keegan, in Newcastle United's black and white stripes, sprints away from Queens Park Rangers' defender Terry Fenwick in this Second Division season-opener, won 1–0 by the hosts.

Date: **28th August, 1982**
Venue: **St James' Park, Newcastle**

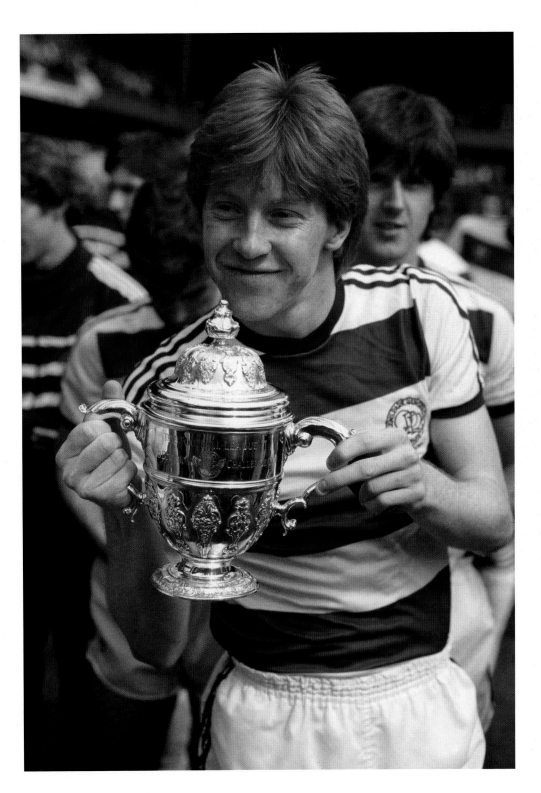

COME ON YOU R's

Gary Waddock of Queens Park Rangers, having just beaten Wolverhampton Wanderers 2–1, offloads the cheesiest grin as he holds the Second Division Championship trophy. Terry Fenwick looks on approvingly.

Date: **7th May, 1983**
Venue: **Loftus Road, London**

FERGUSON'S DONS

The victorious Aberdeen team are presented with the European Cup Winners' Cup in Gothenburg. Alex Ferguson's side beat the mighty Real Madrid 2–1 with goals from Eric Black and an extra time winner from John Hewitt.

Date: **11th May, 1983**
Venue: **Nya Ullevi, Gothenburg, Sweden**

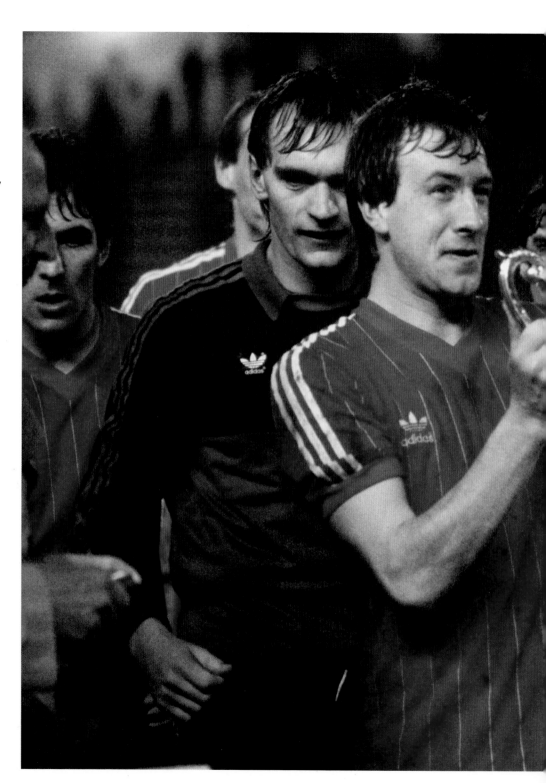

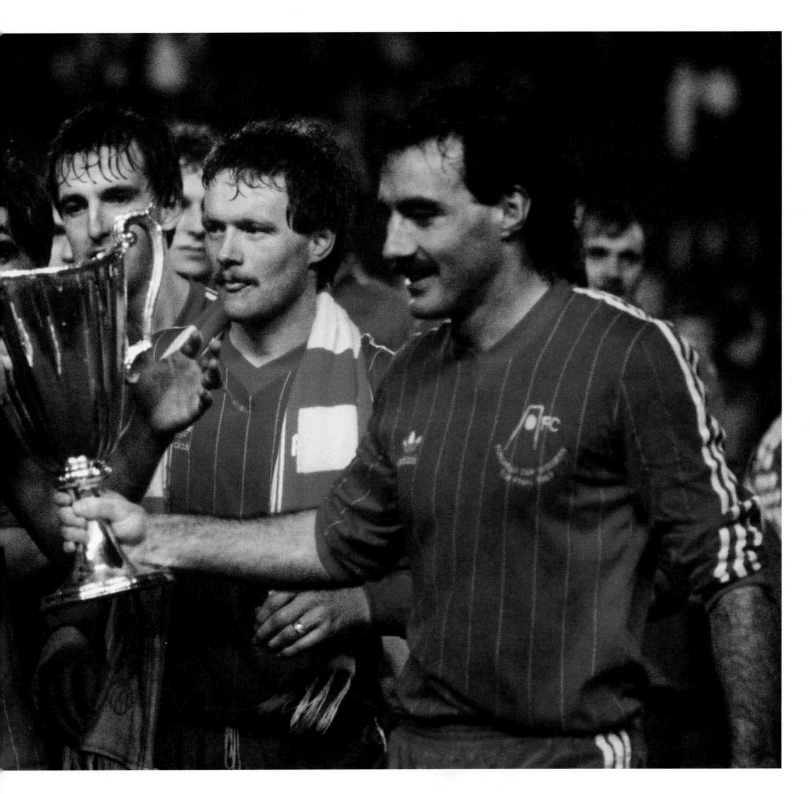

ROMAN ADVENTURE

The AS Roma players and fans go up as one as Roberto Pruzzo (partially hidden) scores against Dundee United. The Terrors would have fancied their chances of reaching the final after their 2–0 win in the first leg at Tannadice Park. Sadly for them, Roma won the return fixture 3–0.

Date: **25th April, 1984**
Venue: **Stadio Olimpico, Rome, Italy**

ROUND ONE

Notts County's John Chiedozie (L) squares up to Nottingham Forest's Chris Fairclough in this goalless Nottingham derby. County were relegated at the end of the season.

Date: **30th April, 1984**
Venue: **Meadow Lane, Nottingham**

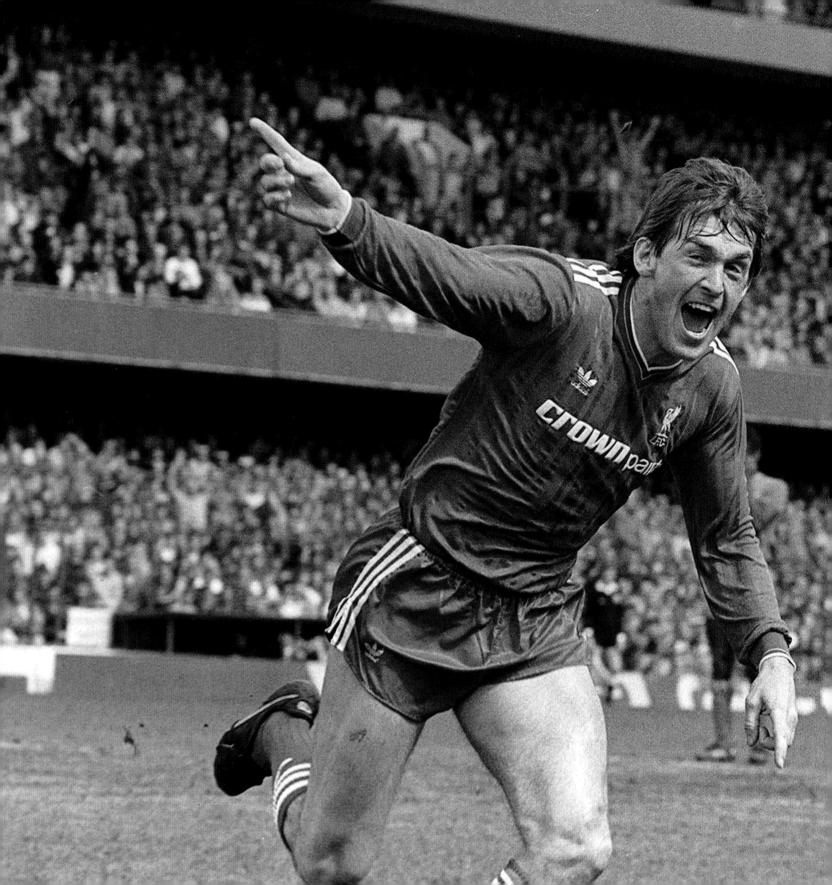

KING KENNY

Liverpool player-manager Kenny Dalglish scores the goal that secures the 16th league title in the Reds' history, and the first part of their league and cup double – a double that would be completed in the FA Cup final win over Everton the following week.

Date: **3rd May, 1986**
Venue: **Stamford Bridge, London**

HARD SHOULDER

Bryan Robson, noted for having a troublesome shoulder, sees his injury return in the second match of England's 1986 World Cup campaign. The first two games were a disaster as England lost to Portugal and drew with Morocco. However, Bobby Robson's side went through the group, destroying Poland 3–0 courtesy of a Gary Lineker hat-trick.

Date: **6th June, 1986**
Venue: **Estadio Technológico, Monterrey, Mexico**

TAKE OFF

Tottenham Hotspur's Clive Allen takes a flying leap over Coventry City's Trevor Peake in the 1987 FA Cup Final. Coventry upset the odds by beating Spurs to claim their first ever Cup trophy. Strikes from Dave Bennett and Keith Houchen, followed by an extra-time own goal from Gary Mabutt saw them home 3–2.

Date: **16th May, 1987**
Venue: **Wembley Stadium, London**

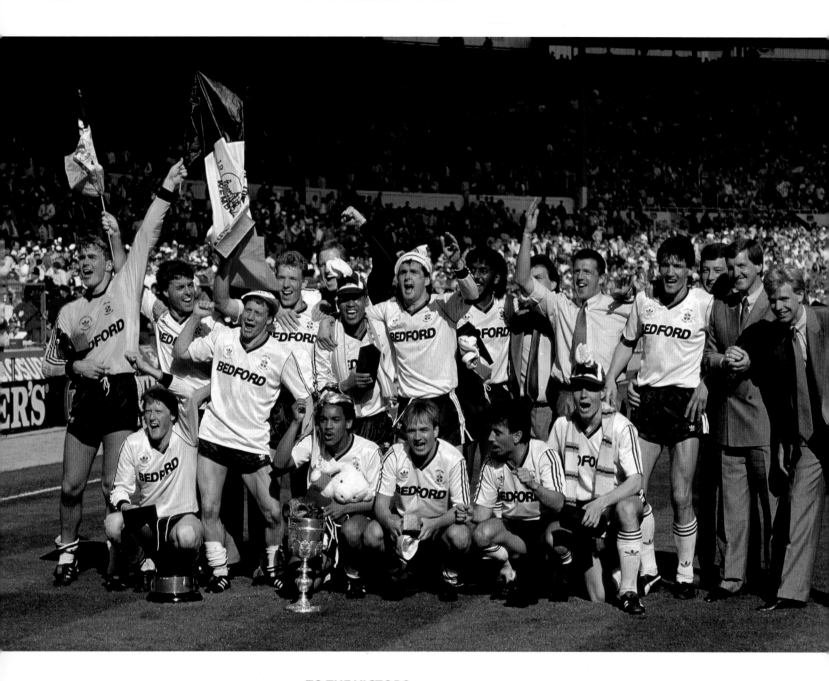

TO THE VICTORS . . .
The highs and lows of a Wembley
cup final. The Luton Town players and
management celebrate winning the
League Cup 3–2 in 1988. . .

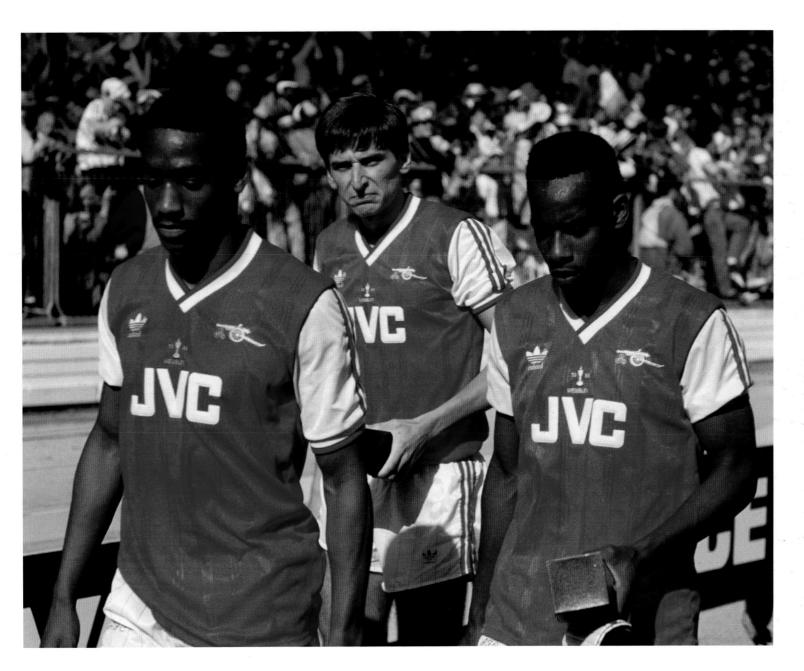

...while (L–R) Arsenal's Gus Caesar, Alan Smith and Michael Thomas trudge off having collected their runners-up medals.

Date: **24th April, 1988**
Venue: **Wembley Stadium, London**

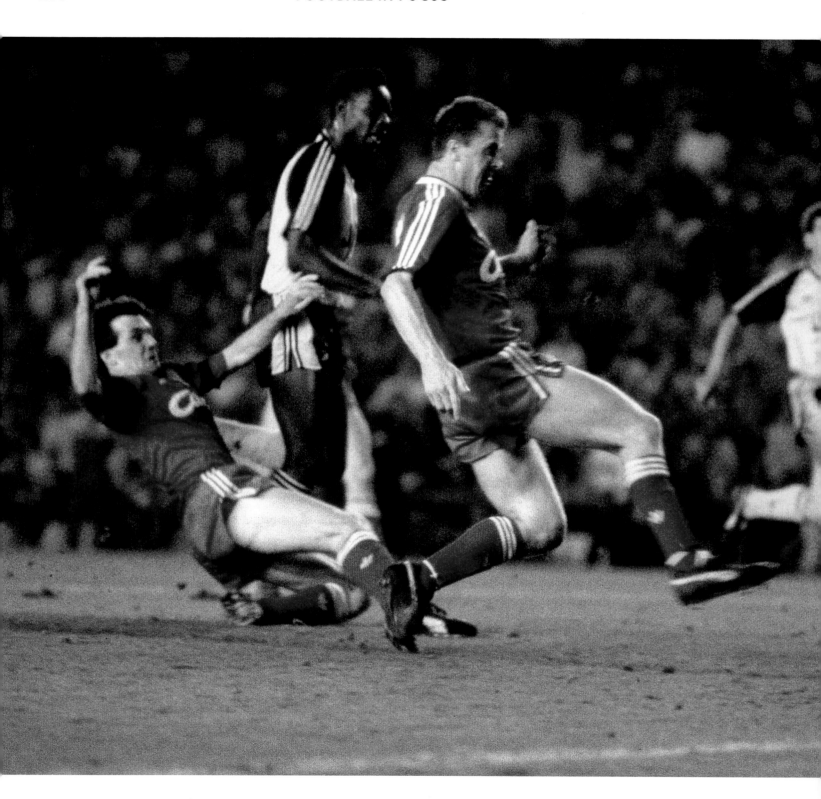

"IT'S UP FOR GRABS NOW"

One of the most famous and exciting title-deciders ever. Arsenal needed to go to Anfield and beat Liverpool by two goals in order to win their first league title for 18 years. Failure to do so would have meant Liverpool retaining the silverware. With 90 minutes on the clock, and Arsenal still only 1–0 up, Michael Thomas bundled through the Liverpool defence to chip the ball past goalkeeper Bruce Grobbelaar and seal the title.

Date: **26th May, 1989**
Venue: **Anfield, Liverpool**

FINAL WHISTLE

Chelsea's Graham Roberts (R) and manager
Bobby Campbell look exhausted after
beating Leeds United 1–0 on their way to
the Second Division title.

Date: **22nd April, 1989**
Venue: **Stamford Bridge, London**

LOOKING UP

The gangly Ian Ormondroyd of Aston Villa drops to one knee in a tangle with Charlton Athletic's Joe McLaughlin. Villa won this match 2–0 on their way to runners-up spot in the First Division.

Date: **13th January, 1990**
Venue: **Selhurst Park, London**

PALACE AT THE ABBEY

Cambridge United take on Crystal Palace in the FA Cup sixth round. Alan Pardew (in red and blue) fights for the ball as Palace win the tie 1–0 on their way to the final.

Date: **10th March, 1990**
Venue: **Abbey Stadium, Cambridge**

THE WHISTLE'S GONE
The referee intervenes as Wimbledon
players (in blue) come piling in, led by
Keith Curle, who scuffles with Tottenham
Hotspur's Steve Sedgley. Wimbledon won
this First Divison match 1–0.

Date: **28th April, 1990**
Venue: **Plough Lane, London**

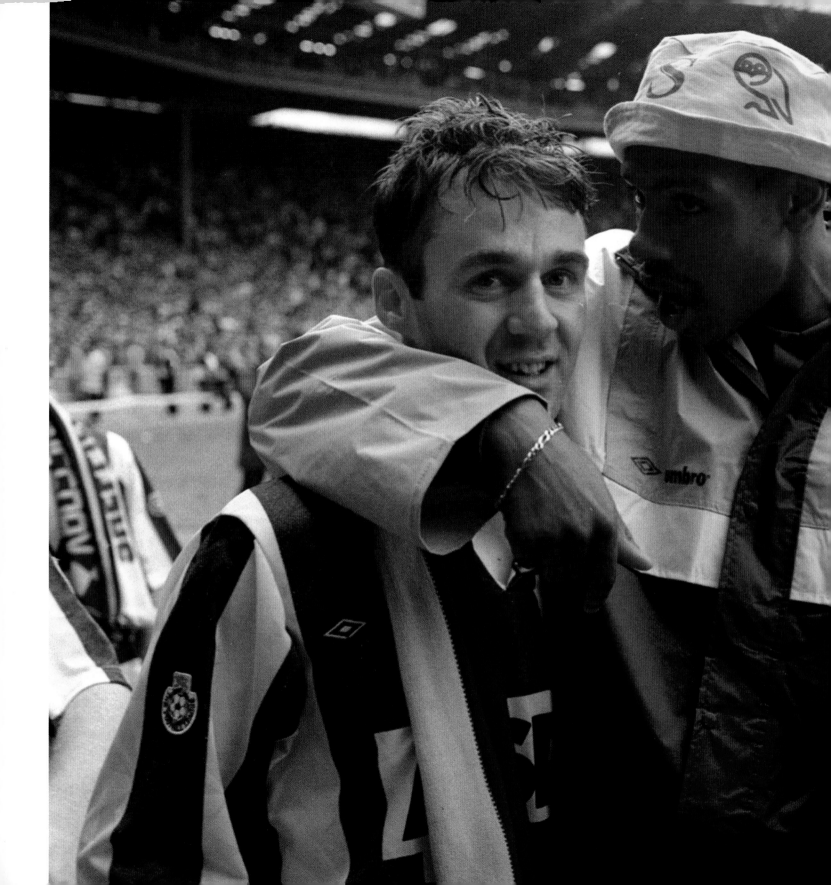

YOU BEAUT

Match-winner John Sheridan (L) gets a hug from team-mate Carlton Palmer during a celebratory lap of honour following Sheffield Wednesday's 1–0 win over Manchester United in the 1991 League Cup Final.

Date: **21st April, 1991**
Venue: **Wembley Stadium, London**

GET THE DRINKS IN

Manchester United's Clayton Blackmore (C) and Brian McClair (second R) indicate what's next on the agenda after beating Barcelona 2–1 in the 1991 European Cup Winners' Cup final in Rotterdam. L–R: Bryan Robson, Lee Sharpe, Steve Bruce and Denis Irwin appear to heartily approve.

Date: **15th May, 1991**
Venue: **Feijenoord Stadion, Rotterdam, The Netherlands**

WIMBLEDON WALL
Various members of Wimbledon's seven-man wall point in every direction as they try to organise themselves for an imminent Chelsea free-kick. Only Warren Barton (L) seems to be watching the ball.

Date: **18th January, 1992**
Venue: **Selhurst Park, London**

MAKING A POINT OR TWO

Tottenham Hotspur goalkeeper Ian Walker (L) and West Ham United's Frank McAvennie exchange hand gestures in a top-tier clash. Walker had the last laugh, keeping McAvennie and West Ham out in a 3–0 win for Spurs.

Date: **1st April, 1992**
Venue: **White Hart Lane, London**

FUMING HAMMERS

L–R: West Ham United's Tim Breacker, George Parris and a gurning Alvin Martin round on Millwall's Malcolm Allen, in a First Division match won 2–1 by the hosts.

Date: **16th November, 1992**
Venue: **The Den, London**

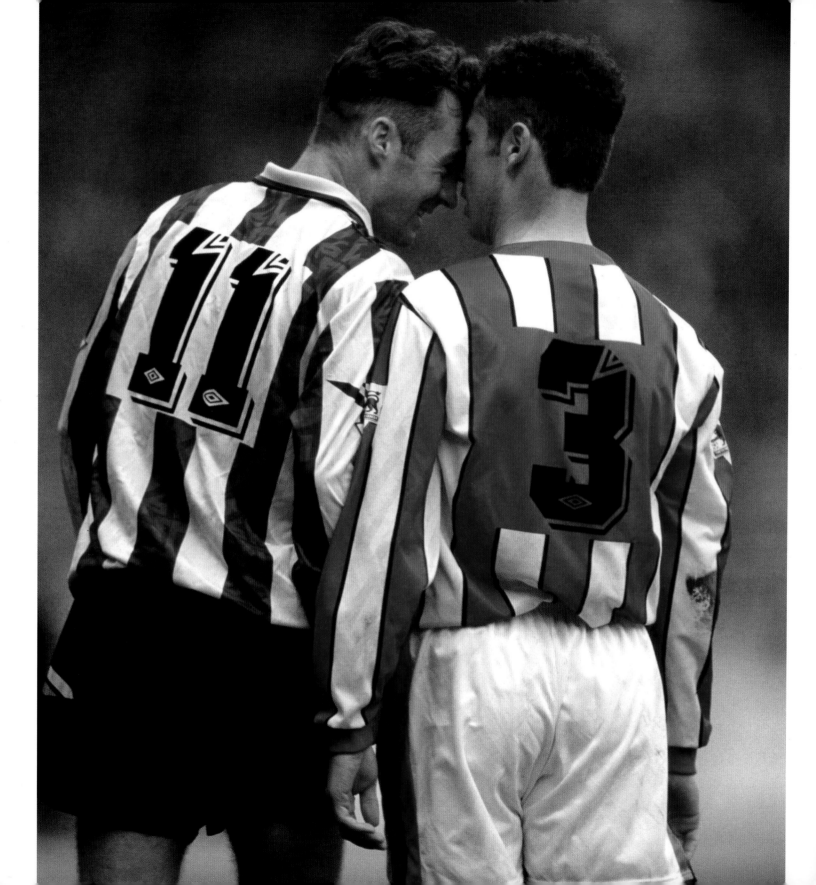

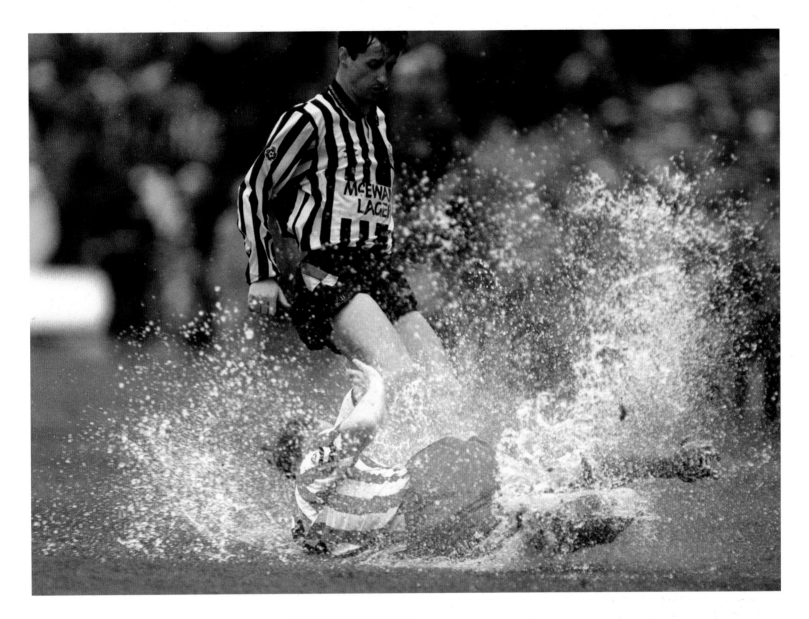

GETTING TO KNOW YOU
Sheffield Wednesday's John Sheridan (L) discusses matters with Sheffield United's Dane Whitehouse during the 1993 FA Cup semi-final at Wembley, eventually won by the Owls.

Date: **3rd April, 1993**
Venue: **Wembley Stadium, London**

MAKING A SPLASH
Sunderland's John Kay manages to avoid drowning while sliding in to tackle Newcastle United's Scott Sellars. This keenly-fought Division One (then the second tier in English football) north-east derby finished 1–0 to the Magpies.

Date: **25th April, 1993**
Venue: **St James' Park, Newcastle**

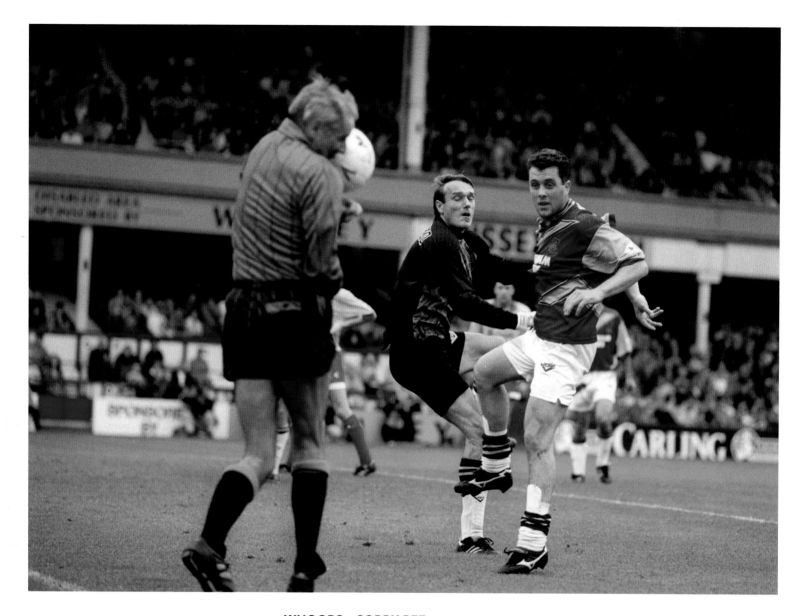

WHOOPS... SORRY REF

West Ham United's Julian Dicks, in a
Premiership match with Swindon Town,
clears a header straight into the face of the
referee, who probably received the biggest
cheer of the day.

Date: **11th September, 1993**
Venue: **Boleyn Ground, London**

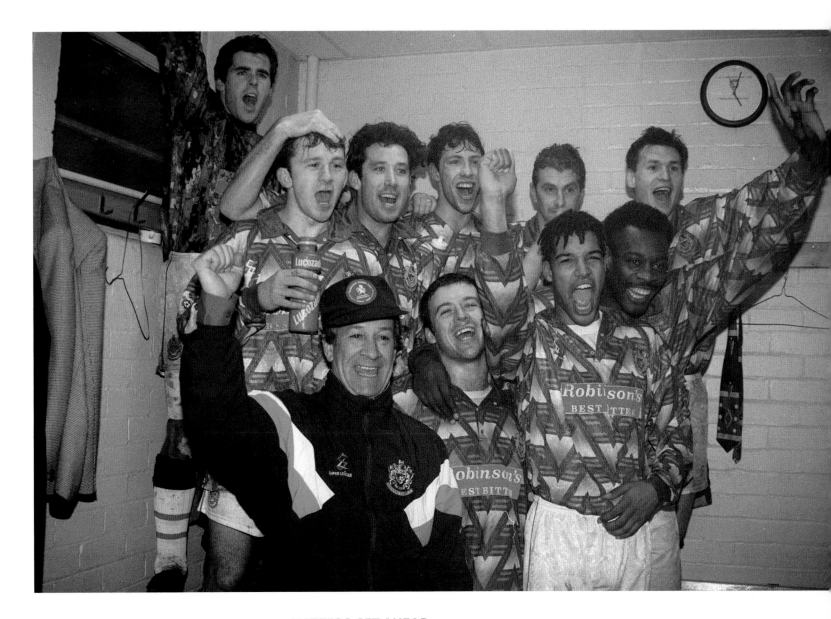

HATTERS GET AHEAD

Stockport County manager Danny Bergara (L)
leads his players in celebration. They have just
beaten Queens Park Rangers 2–1, knocking
the Premiership side out in the third round
of the FA Cup.

Date: **8th January, 1994**
Venue: **Edgeley Park, Stockport**

UP FOR THE CUP
Darren Beckford (C) of Oldham Athletic
celebrates scoring the winning goal against
Bolton Wanderers in the FA Cup fifth round.

Date: **12th March, 1994**
Venue: **Burnden Park, Bolton**

BURNLEY ON SONG

Burnley's Gary Parkinson (R) celebrates scoring against Stockport County in the Division Two play-off final. Burnley won 2–1, thereby gaining promotion to the second tier of English football.

Date: **29th May, 1994**
Venue: **Wembley Stadium, London**

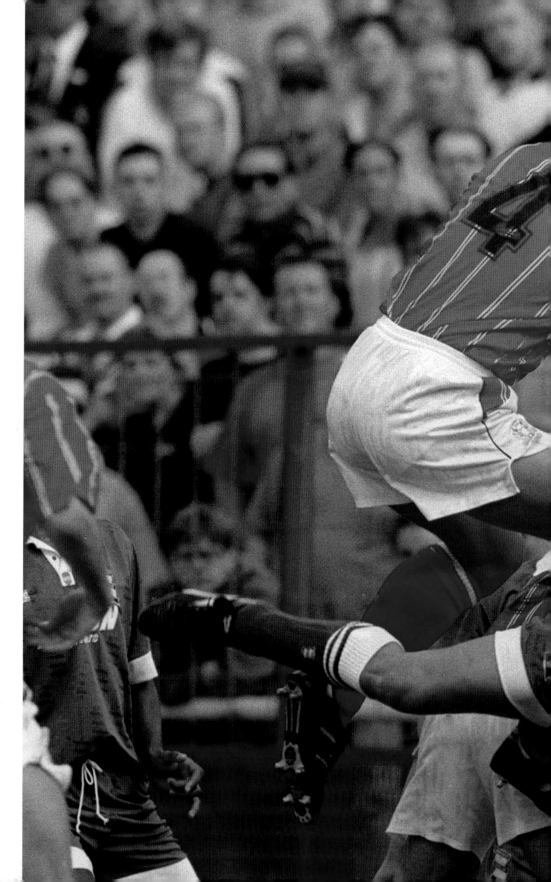

GOALMOUTH SCRAMBLE

Birmingham City's goalkeeper Ian Bennett, in the middle of a congested goalmouth bundle, saves under pressure from Leyton Orient's Darren Purse (No 4) during a Division 2 goalless draw.

Date: **13th August, 1994**
Venue: **Brisbane Road, London**

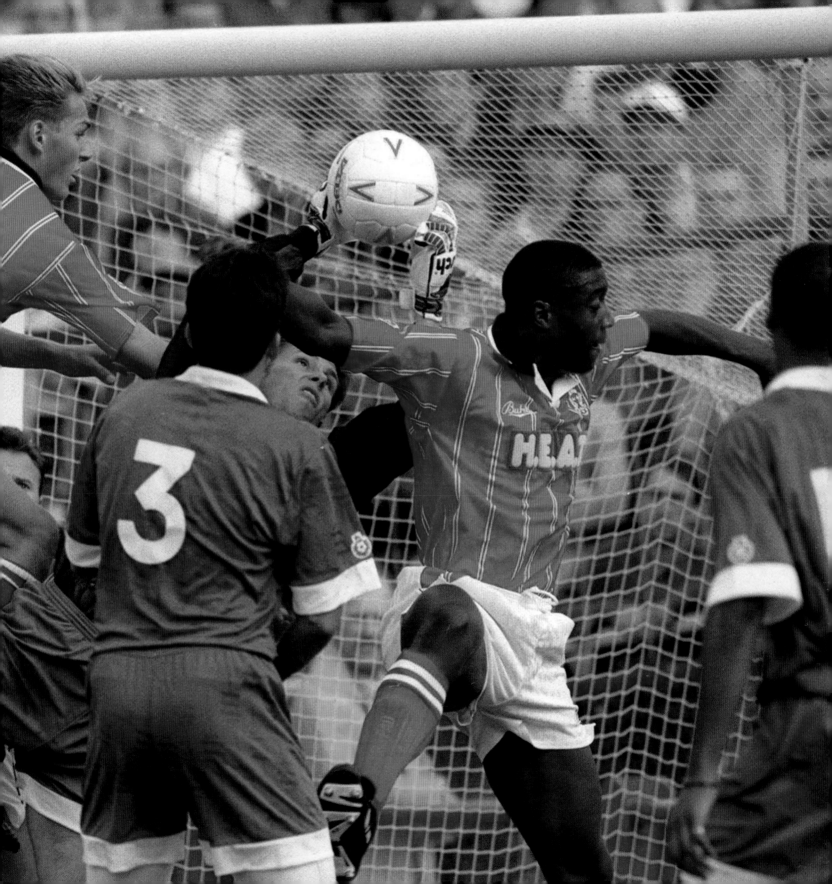

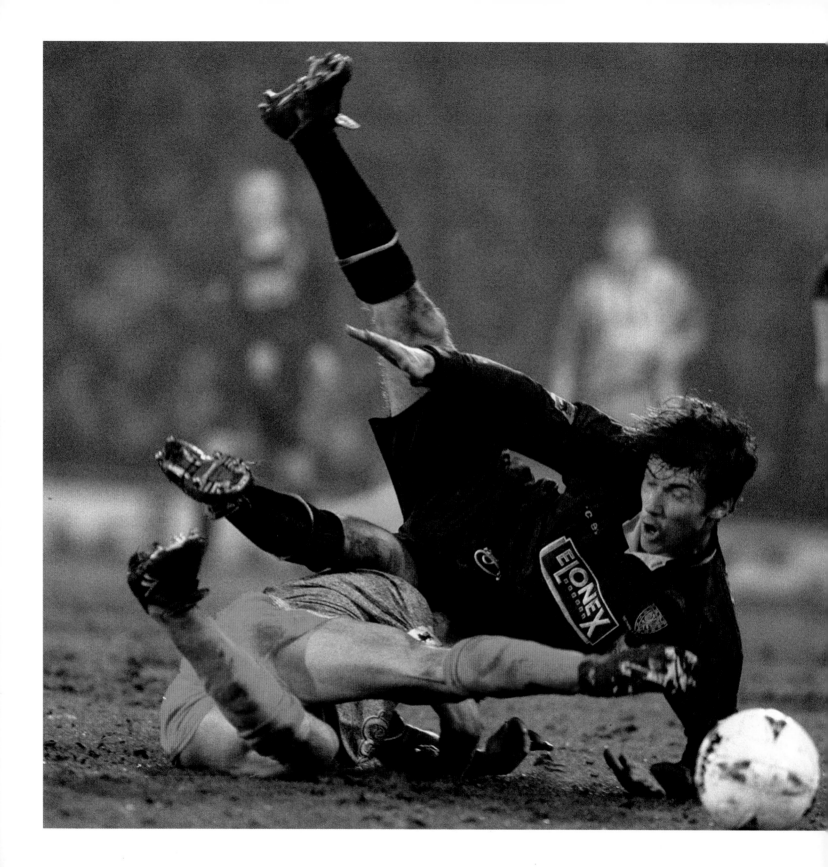

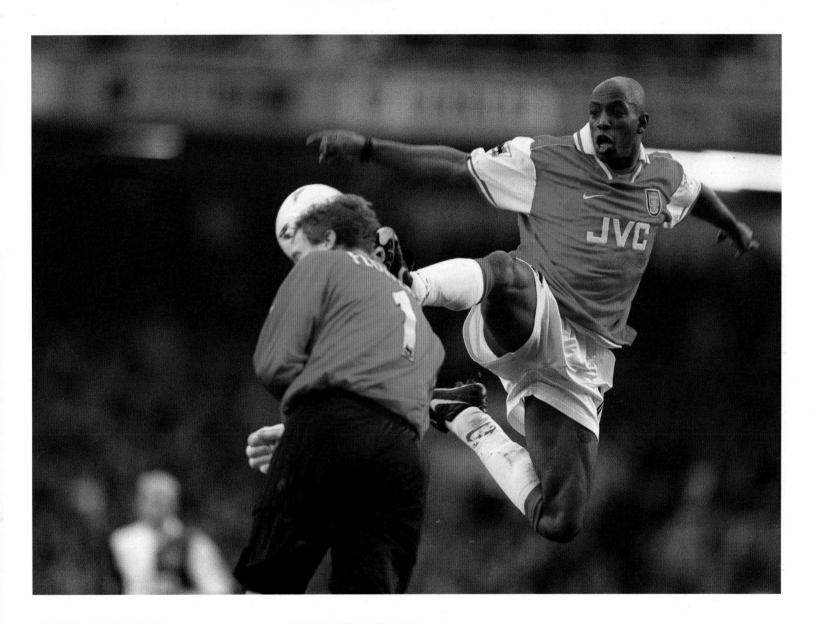

UNWISE CHALLENGE

Chelsea's Dennis Wise (orange shorts) goes in hard on Wimbledon's Kenny Cunningham in a FA Cup sixth-round replay, won 3–1 by the visitors.

Date: **20th March, 1996**
Venue: **Selhurst Park, London**

WRIGHT'S TAKE-OFF

In a scene reminiscent of *Crouching Tiger, Hidden Dragon*, Arsenal's Ian Wright launches himself at the ball. Blackburn Rovers goalkeeper Tim Flowers bravely tries to head it away first.

Date: **13th December, 1997**
Venue: **Highbury, London**

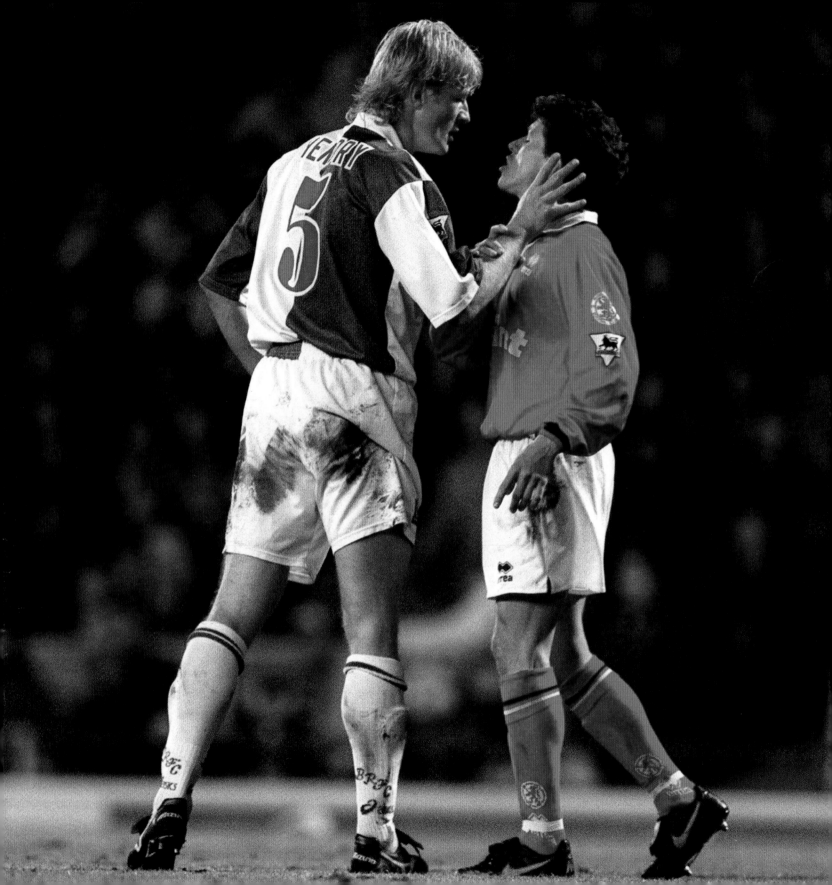

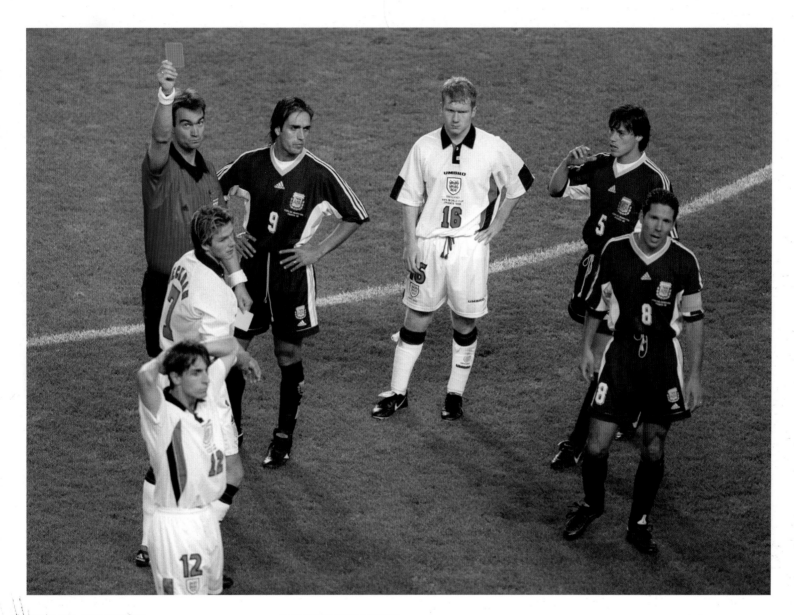

HEATED MOMENT

Middlesbrough's Juninho (R) appears to have bitten off a little more than he can chew. Colin Hendry of Blackburn suggests the tiny Brazilian might like to reconsider the situation.

Date: **8th May, 1997**
Venue: **Ewood Park, Blackburn**

DAVID'S DISASTER

England's David Beckham (No 7) is sent off for petulance after kicking Argentina's Diego Simeone (No 8). Gary Neville (No 12) and Paul Scholes (No 16) can't believe it.

Date: **30th June, 1998**
Venue: **Stade Geoffroy-Guichard, Saint-Etienne, France**

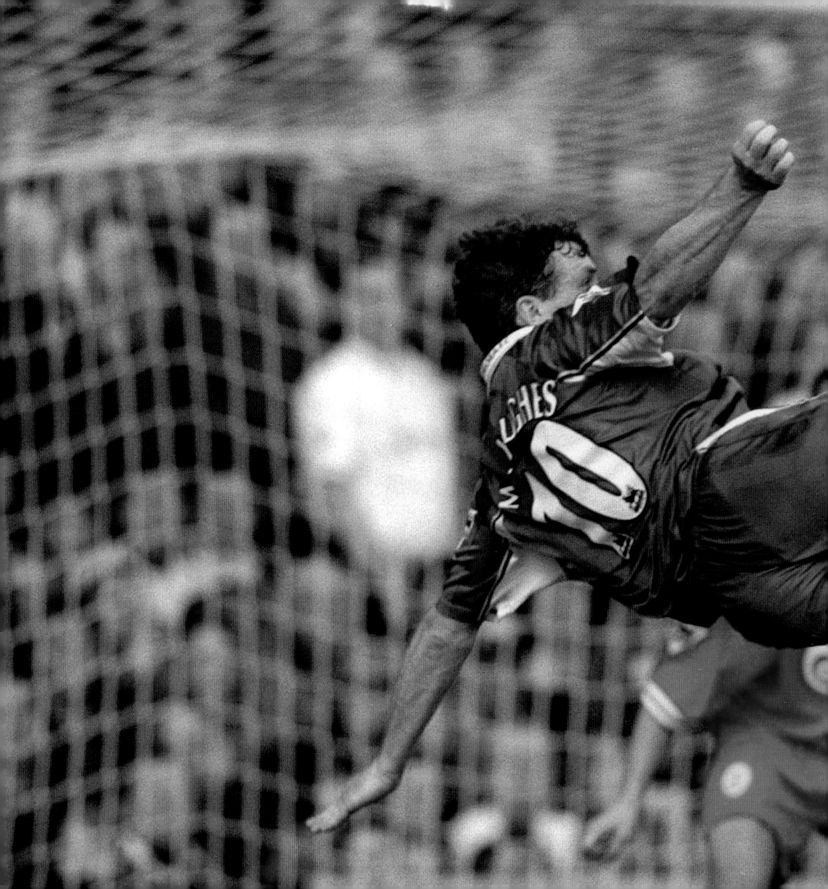

FLYING SPARKS (*previous page*)
Chelsea's Mark Hughes scores his side's
fourth goal against Liverpool with a
trademark flying volley.

Date: **25th April 1998**
Venue: **Stamford Bridge, London**

"FOOTBALL – BLOODY HELL!"
The Manchester United players celebrate
their dramatic two late goals in the 1999
UEFA Champions League final against
Bayern Munich. L–R: Ronny Johnsen, Teddy
Sheringham (scorer of the first goal), Ole
Gunnar Solskjaer (who scored the winner),
Dwight Yorke and Denis Irwin.

Date: **26th May 1999**
Venue: **Camp Nou, Barcelona**

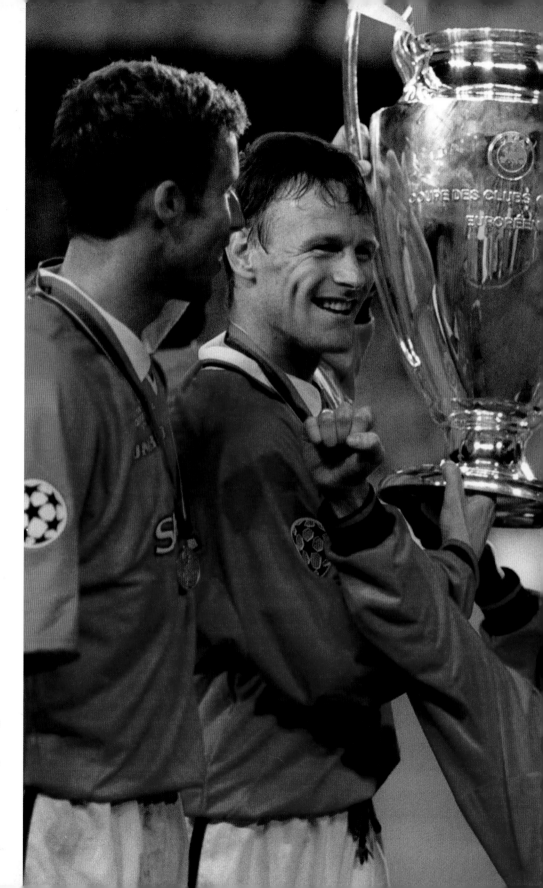

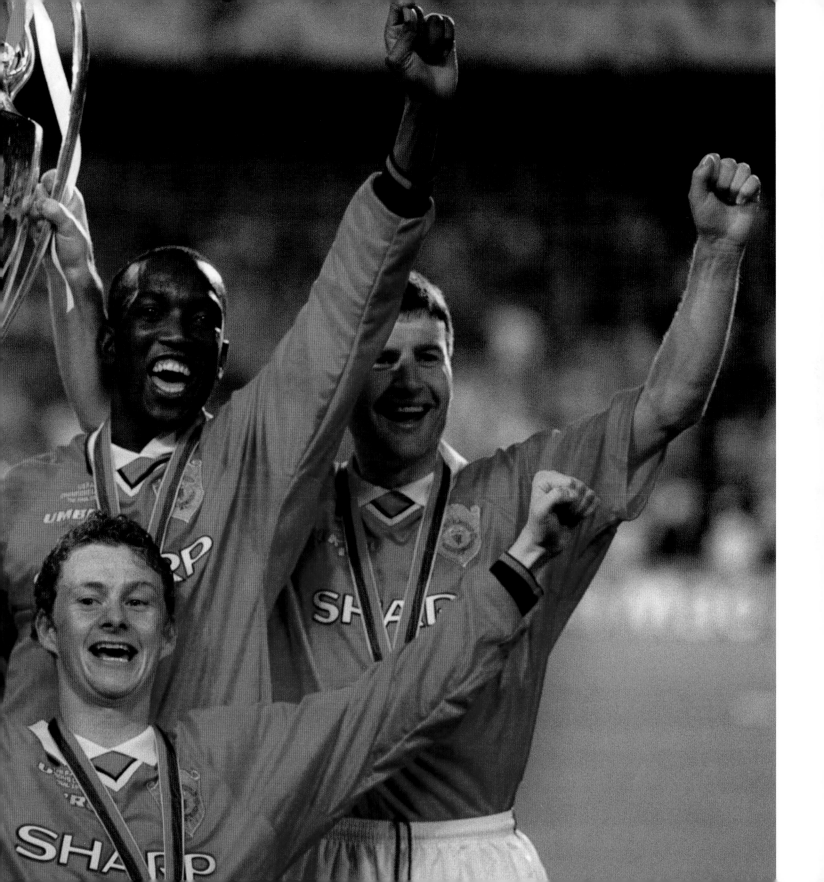

BE PREPARED

Don't let anyone say Motty doesn't come prepared. BBC commentator John Motson inadvertently reveals his player notes before the 2000 FA Cup Final between Chelsea and Aston Villa.

Date: **20th May, 2000**
Venue: **Wembley Stadium, London**

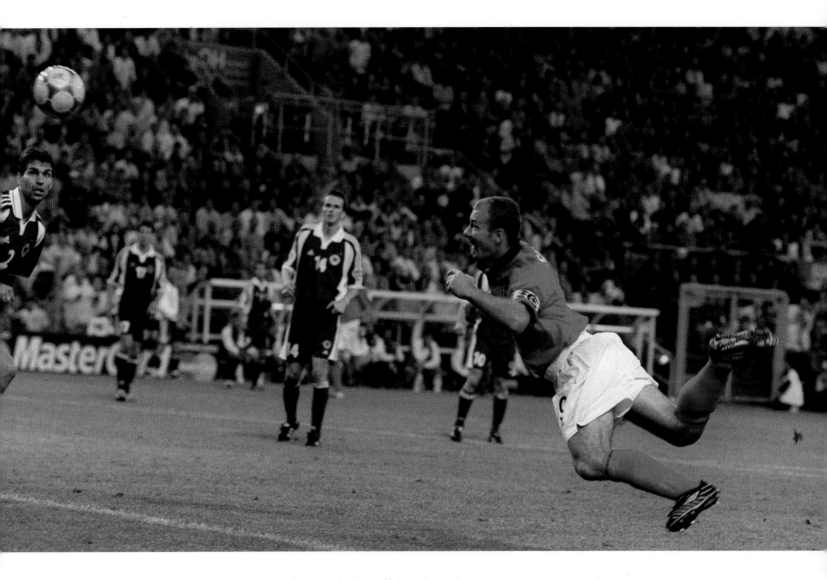

BRIEF MOMENT OF GLORY
Alan Shearer heads England's winning goal against Germany in the Euro 2000 tournament. England won this match 1–0, but lost 3–2 against both Portugal and Romania, and were eliminated during the group stage.

Date: **17th June, 2000**
Venue: **Stade du Pays de Charleroi, Charleroi, Belgium**

BACK TO BACK

Middlesbrough's Gianluca Festa performs an admirable somersault across the back of Wimbledon's Jason Euell during an FA Cup fourth round tie.

Date: **6th February, 2001**
Venue: **Selhurst Park, London**

PILGRIMS AND IMPS

Boston United captain Paul Ellender (L) clears the ball from Lincoln City striker Jamie McCombe, as Mark Greaves watches on. This League Two (fourth tier) Lincolnshire derby finished 2–2.

Date: **11th September, 2004**
Venue: **Sincil Bank, Lincoln**

THE RUTTING SEASON
Stoke City's John Halls locks horns with
West Ham United's Bobby Zamora, in a
fiercely contested Championship match,
won 2–0 by the London side.

Date: **19th October, 2004**
Venue: **Boleyn Ground, London**

HAPPY NEW YEAR

Tottenham Hotspur's Hossam Ghaly
receives a high boot in the face from
Portsmouth's Noé Pamarot – and loses
teeth in the process.

Date: **1st January, 2007**
Venue: **Fratton Park, Portsmouth**

OFF THE SHOULDER NUMBER

Reading's André Bikey pulls on the shirt of Aston Villa's Norwegian striker John Carew as they chase for the ball. The home side, in their first ever season in the top flight, beat Villa 2–0 on their way to a highly creditable eighth position in the final Premiership league table.

Date: **10th February, 2007**
Venue: **Madejski Stadium, Reading**

CARSON MISTAKE

Niko Kranjcar (No 19) scores Croatia's first goal as goalkeeper Scott Carson fumbles the ball. This was a vital match that England only needed to draw to qualify for the Euro 2008 finals, but they made a disastrous start, going 2–0 down in the first 15 minutes. Despite drawing level, England conceded again with 13 minutes left, and lost 3–2, resulting in failure to qualify for the finals in Austria and Switzerland.

Date: **21st November, 2007**
Venue: **Wembley Stadium, London**

BLUE IS THE COLOUR

Chelsea seal their fourth top-tier league title after demolishing Wigan Athletic 8-0 on the last day of the season. They pip arch-rivals Manchester United to the trophy by a single point.

Date: **9th May, 2010**
Venue: **Stamford Bridge, London**

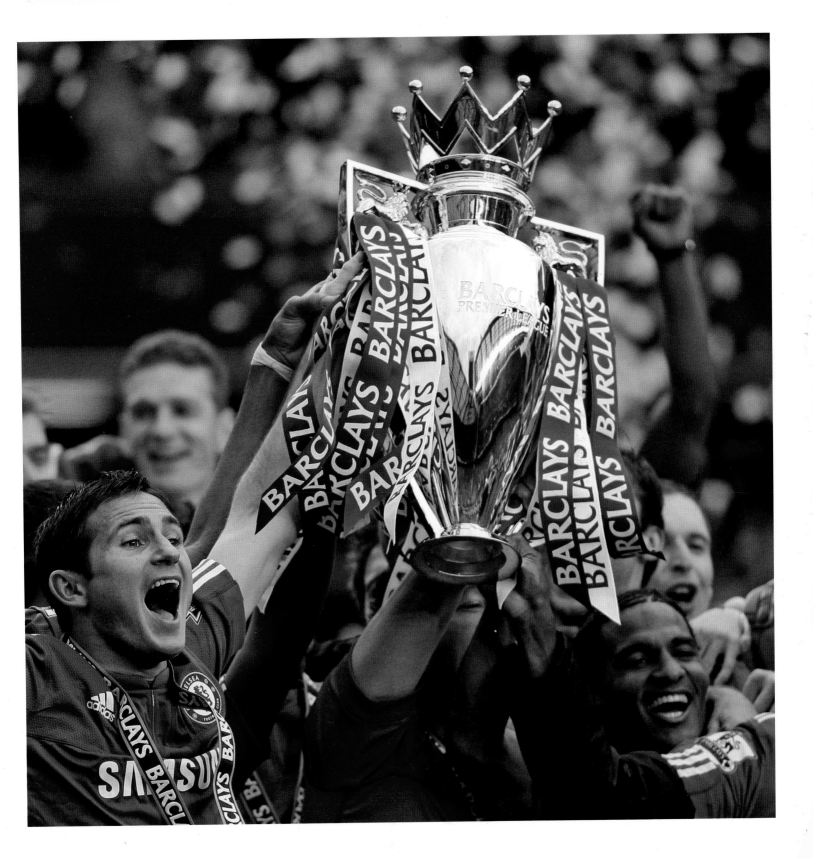

The Publishers gratefully acknowledge Offside Sports Photography, from whose extensive archives the photographs in this book have been selected.

AMMONITE
PRESS

For more information, please contact:
Ammonite Press
AE Publications Ltd, 166 High Street, Lewes, East Sussex, BN7 1XU, United Kingdom
Tel: +44 (0)1273 488006 Fax: +44 (0)1273 472418
www.ammonitepress.com